PRESIDENT ME

PRESIDENT ME

The America That's in My Head

ADAM CAROLLA

itbooks
AN IMPRINT OF HARPERCOLLINSPUBLISHERS

HarperCollins books may be purchased for educational, business, or sales promotional use. For information please e-mail the Special Markets Department at SPsales@harpercollins.com.

FIRST EDITION

Designed by Ruth Lee-Mui

Library of Congress Cataloging-in-Publication Data has been applied for.

ISBN 978-0-06-232040-7

14 15 16 17 18 DIX/RRD 10 9 8 7 6 5 4 3 2 1

This book is dedicated to _____,
(INSERT YOUR NAME HERE)

for all of the devotion and passion, both in and out of the

bedroom. I couldn't have done this without HIM / HER.
(CIRCLE ONE)

CONTENTS

PRESIDENT ME

INTRODUCTION: THROWING MY HAT IN THE RING

Not one stand-up show or live podcast goes by where someone doesn't say to me in the autograph line afterward, "Ace, you should run for president." Well, consider this book my official campaign platform. As you'll see, I have an assload of opinions and a dump truck full of ideas on how to make this country better.

I mean, why couldn't I be president? We're in the golden age of celebrity politicians. We've elected Jesse Ventura *and* Arnold Schwarzenegger. If Carl Weathers runs, we could complete the *Predator* hat trick. Everyone laughed when Donald Trump thought about throwing his comb-over into the ring in the last election. But we live in a country where 45 percent of people believe in guardian angels and think Elvis is still alive. Why wouldn't we elect Trump? He'd certainly make the White House a lot classier—a big picture of himself in the Oval Office where George Washington's portrait used to hang and a lot of gold-leaf toilet seats.

I do have the common-man touch that everyone seems to want these days. Which I think is retarded. I don't want a politician who's anything like me. I want them to think like me, but I don't want them to *be* like me. If that were the case, the president would be watching YouPorn all day. I also hate the "he seems like the kind of guy you want to have a beer with" stuff. I went to school with 190 jack-offs you'd want to have a beer with. I wouldn't trust those guys to assistant-manage a Del Taco, much less run the country. I want Bill Gates in charge—someone who looks like he'd be horrible to hang out with. I don't need the relatable thing. I need the intelligence thing. Joe Six-Pack is great when he comes to your house and runs a snake through your main line. But you don't want him negotiating a Middle East peace treaty. Relatable is useless. When Bill Clinton was asked the famous "boxers or briefs" question, his answer should have been, "Fuck you. What does it matter?" To all these politicians who have to pretend to be the little guy and act like they're not rich or trying to get rich, I say cut it out. When did being wealthy in this country become a bad thing? Fuck that. You know who's rich? Smart people. I want a one-percenter to be president. I want the overachiever. I grew up with the 99 percent. They're not all that noble and hardworking. A lot of them are burned-out losers. I want that guy who has three degrees or amazing business sense and has made a shitload of money. Your school principal isn't supposed to be "one of you." He's there to run the school. Your job is to study and not be a dumb-ass in the hallways. He just runs it the best he can to give you the *opportunity* to get A's. And do rich guys not have TVs? I'm pretty sure they have a lot of them. So they can see what's going on in the world. They don't need to be in the trenches with the little guy to experience the life of the common folk. We should be electing the guy who pulled himself out of that. The president is supposed to *lead*. The president is supposed to be our CEO, not our BFF.

I hate that if you run for president you have to pretend to be in love with the middle class. When it comes to talking to and hanging out with people, the superrich and the superpoor are far more interesting. If you had to sit on a long bus ride with someone (not that a rich guy would actually be on a bus, unless it was the Michael Bublé tour bus), you'd want it to be either Elon Musk or a homeless guy who was having a spirited conversation with a lamppost a few minutes before. You certainly wouldn't want your boring-ass brother-in-law who's gonna talk your ear off about the article he just read in *Insurance Underwriters Quarterly*.

I'm not doing this for me. I'm doing it for you, love of country, and my plan to order the surgeon general and NASA to reanimate the corpse of Marilyn Monroe.

Let's face it. It's a stressful gig, being the leader of the most important country in the world. We're so divided now, anything you do is going to piss off 49.5 percent of the country. Plus, the pay sucks. I made much more on this book than the president made this year. Bad presidents are forgotten about or become punch lines. It must be tough on Jimmy Carter to be watching TV and constantly hear his name come up as the yardstick of shitty presidencies. Worst economy since Carter. Worst energy crisis since Carter. I imagine Jimmy sitting at home one night watching CNN comparing Obama to him and saying, "How many free houses do I have to build? Rosalynn, throw me the remote. What's on HBO? I wonder what this *Argo* is about."

I'd certainly be a breath of fresh air. Every time a politician makes a tepid attempt at humor, everyone thinks he's hilarious. It's about context. When a politician tosses off a mediocre one-liner during the State of the Union or a debate, people think he's a genius. But if you put an actual comedian in office, he'd be the funniest politician of all time. It's like being the funniest guy at a funeral.

More importantly, as comedians, our job is to say what is on our minds. Unfiltered and un-focus-group-tested. That's what drives me nuts

when yours truly and other comedians get gang-raped on Twitter every time we say something controversial. We're comedians, not politicians. We should not be held to the same standard. We're not just allowed—we're *required* to do what a politician can't do. And that's to be honest. Everyone talks a good game about wanting their politicians to speak their mind, but then look at who gets elected—sociopaths, narcissists, sex offenders, and liars. I'm none of those. I'm a truth teller. (I still haven't been caught for the sex offenses.) The essence of comedy is taking an uncomfortable truth and finding humor in it. Taking something horrible like crime, war, poverty, or divorce, and making it funny.

But our leaders can't tell the truth. We won't let them. We've created a society where the politicians aren't allowed to criticize the people. There's no tough love coming out of the White House or Congress. They've gone from leaders and legislators to wedding caterers. If they want to keep the gig, they better give us what we want.

Thus it's gone from "Ask not what your country can do for you but what you can do for your country" to "These rich people aren't paying their fair share. You're working-class heroes, even though you don't work. Why shouldn't you get the same medical attention that Malcolm Forbes gets?" That's how you end up with "Hope and Change" and "Occupy Wall Street." A bunch of people saying, "Come on, Barack, do it for me. Fix my life." The more people that get into that mind-set, the less likely it is for someone to get elected who will act like your dad. Someone who will say, "Enough whining. Get your shit together."

Fixing your fucked-up life is not government's job. Handling the stuff that people can't do themselves—like war—is. One man can't take out a dictator or stop a terrorist attack, unless that man is Chuck Norris. But what one man can do is get a job, raise his kids, and pay his taxes. You always hear politicians on the campaign trail saying, "I will fight for you." Is that what we want, someone to fight for us? Shouldn't we want to do our own fighting so that when we get our first house or start our own business, we can have the pride that we did it ourselves? Shouldn't

we think, "Hey government, don't fight for me! Fight the red tape and retarded regulation so I can get to work." Humans need challenges to overcome, just like a muscle needs resistance to grow. In a zero-gravity environment, an astronaut's muscles atrophy because there is no resistance. The government giving you a bunch of handouts and living your life for you is the equivalent of doing push-ups in outer space. Big government is like the void of space—it's massive, constantly expanding, and if we immerse ourselves in it, we'll simply wither away.

During the 2012 election I was stunned at how many people had the "audacity" to stand face-to-face with a candidate and say, "I'm twenty-two and I'm a student. As I look toward graduation and the job market, I want to know what you're going to do *for me*." As if Obama was going to say, "Okay. Let me get your name. Right after this debate I'm going to personally make sure you're taken care of." If it were me up there, I would say, "I'm not gonna do shit for you. But I am going to clear up the bureaucratic bullshit so *you* can do something for you. It's your choice, I'll clear the path. You decide if you want to stay on the couch and get high or if you want to get your shit together."

And that narcissism, that "me, me, me" meme running amok in our country, is destroying us. Some of it is our pop culture, some of it is our parenting, but a lot of it is our politics. That's why a major plank in my campaign platform is bringing an end to the pervasive narcissism that has slowly destroyed our country. As you'll read, we've gone off the rails as a society and it all has to do with narcissism. But fear not, I have solutions.

I hope the above has served as a fair warning before you read this book. Many of you should prepare your ass cracks now for some panty bunching. Especially if you find yourself nodding every time you read a *Huffington Post* blog by Russell Simmons or Barbra Streisand.

In the past couple years I've been labeled as a conservative, race-baiting, gay-bashing purveyor of hate speech. But I was never considered conservative when I talked about raising your kids, focusing on education, and government waste in 1996, when I started hosting *Loveline*.

Now the poles have gotten so far apart that anyone who isn't officiating a gay wedding at a Whole Foods is considered to be to the right of Rush Limbaugh. I didn't change, the country did. I didn't land on the right wing, the right wing landed on me. I'm just pragmatic. I'm not right wing, I'm just right. I know that nuclear power is less dangerous than coal mining; I know that the country would be better if dads, especially in certain communities, stuck around and raised their kids; I know that freebies from the government keep people stuck in a cycle of poverty and depression.

This has not done me any favors with many of the fine folk here in Los Angeles, the entertainment business in particular. There's a Holly-wood Hipster club that likes to throw around a lot of terms like "school-to-prison pipeline" and "voter suppression" from high atop Mount Pious. This makes them all feel great while simultaneously accomplishing noth-ing. It doesn't fix a damn thing. Sure, they get to smoke weed at parties and talk about what a backward buffoon I am, but in the meantime they've brought no attention to the real issues and they've not taken one fucking step toward solving the problem that they pretend to care so dearly about. Every time someone says "Adam's a racist," "Adam's a sexist," "Adam's homophobic," really what they're saying is "I'm not. I'm better than him." All that finger-pointing is really about patting them-selves on the back. Well, fine, call me an asshole and rip another bong hit. There's a certain freedom in hearing that people think you're an ass-hole but knowing that you're not. It's the opposite of the politician who's banging male prostitutes and knows he's gay, so he's constantly trotting out his family and wearing the flag lapel pin. He puts on a facade. I don't think I'm an asshole, so I don't need any facade. I can speak my mind and know that I don't hate any particular group or gender. I don't have time to hate any particular group or gender.

Ultimately I think the president shouldn't care about any particular class, generation, race, or gender. The president shouldn't even be a per-son. The job should go to a soulless, number-crunching computer that

decides whether to fund a certain program or bomb a certain country based strictly on cold hard logic and numbers. But until Apple comes out with iPresident, I'll have to do. Over the next fifteen chapters (or if you're reading this on the toilet, twenty-eight shits) I'll lay out what each department of the federal government would look like in the Carolla administration. So chuck that Bible, get a *Juggs* magazine for me to put my hand on, and swear me in. I've some work to do and some people to piss off.

AN EXPLANATION OF GRAPHICS YOU WILL FIND IN PRESIDENT ME

Those of you who enjoy my podcast know how much I love the self-satisfied sniff that blowhards do after they feel like they've made a really strong point or clever analogy. Well, I'm no exception. Throughout *President Me* you'll see this (⊙) to show how proud I am of what you've just read. If you hit that graphic and didn't dig what I just laid down, go back and read it again. It's really good.

And to signal when a new law, executive order, or policy is about to be mandated, you'll see this graphic. I pulled this image out of my extensive collection of vintage gay erotica. I remember seeing it . . . perhaps I've said too much.

Let's get into this.

THE VICE PRESIDENT

Maybe it's time we took a good long look at the vice presidency and eliminated it. Lyndon Johnson was the last VP we really needed. Now having one does more harm than good. These days the job is just sitting around having a few too many cocktails and putting your foot in your mouth while waiting for the president to get clipped.

I wonder every now and again if the vice president says to the president, "Ride with the top down, boss. Beautiful weather out there. Why don't you give a couple of the Secret Service guys a night off. They've earned it." I mean, think about it. If you're the understudy, you've got to be hoping the lead falls off the stage on the opening night of *Pippin*. I'm not saying the VP is sitting around with a voodoo doll, but he's definitely the backup quarterback hoping the QB rolls an ankle.

But this change will have to come after my administration. I have plans for my vice president. I'm going to make my VP do all my shit

work. I'll handle all the press conferences where I tell the people we killed a terrorist leader or that we passed some new popular legislation, but the veep is going to be the one telling you we're cutting the food-stamp program and writing depressing letters to the families of dead soldiers.

Since it's a fairly useless position, I'm going to try to get as much liberal street cred as possible and name Michelle Rodriguez as my vice president. She's Latina, female, *and* bisexual. Plus it'll give us a chance to talk about the *Fast and Furious* movies.

THE FEDERAL ELECTION COMMISSION

Elections go on way too long and cost way too much. I have a lot of ideas on how to make them better. It will start with my campaign, and upon taking office, I will institute these new polices for all future elections.

First, let's focus on the fund-raising. Obama came to L.A. about ninety times during the 2012 election, rattling the can in front of Spielberg, Will Smith, Streisand, etc. And every time he did, the entire town ground to a halt. Streets shut down and traffic came to a standstill every time George Clooney dropped a nickel. I have a solution that is win-win-win. When I run for my second term and come to L.A. to hit up Kimmel and my other Hollywood friends, *Air Force One* will land at LAX and just stay there. I'll park it right on the tarmac and have my fund-raiser ON *Air Force One*. The celebrities would get a thrill out of it, and probably drop a couple extra shekels for the bragging rights of saying they

took a dump on *Air Force One*. I wouldn't even have to get off the plane, and, most importantly, the citizens of Los Angeles could drive on their fucking freeways without my motorcade.

Beyond that, I dictate that how candidates raise money is their own business. If you have one corporate sugar daddy who is going to fund your whole campaign, I have no beef with that. That's what I'll do. You hear all the time about a candidate who kicked in $80 million of his own money and lost. If I put more than three hundred bucks into my campaign and lost, I'd go on a killing spree.

That's something you never see during a campaign—a sore loser. Whenever a candidate steps out of the race, they always take the high ground. "Everyone involved in my campaign should be proud, and to all of my supporters, you fought the good fight. But Senator Smith ran a great race and will do a fine job." Fuck that. From now on I demand that the candidate say what's really on his mind in the moment during that concession speech. "You cunts. You let me down, Iowa. I came to your godforsaken state, spent a shitload of my own money, and for what? To lose to that closet case, Senator Smith? You know he's a homo, right? This is bullshit. Not that my dipshit campaign manager helped. He was too busy banging the interns. And my wife behind me? She didn't support me at all. That icy bitch is drunk right now. She never had my back. Though I would like to thank my mistress, who's over there pretending to make a documentary about me."

On to the debates. I don't like them. They feel too canned, too prepared. The candidates are just too ready with their stock answers and question dodges. And no one watching has their opinion swayed by debates. All those debates do is reinforce the talking points that have been fed to each side.

Again, I have a solution—surprise debates! We shouldn't tell the candidates when and where they're going to be. The whole thing should be off the cuff. The presidency is a job where you have to think on your feet. We should be able to see this in action. How great would it have

been if they had told Romney he was going to a fund-raiser and Obama that he was going to a photo op with a business owner and when they walked into the building there was a capacity crowd and we forced them to sit down with George Stephanopoulos and explain the differences in their health care plans? This is something I will excel in when I run for my second term. That's what you need in a president. Having all that shit prepared like candidates do for debates would be like if you went to an improv show and they asked for an occupation and a relationship, someone shouted out "crane operator" and "father and son," and the troupe responded, "Okay, we're gonna go backstage, choreograph and rehearse a scene, and we'll be back in a few days."

Another thing you see out on the campaign trail that I'm calling for an end to is candidates rolling up their sleeves. Oh, I get it. Sleeves rolled up means he's ready to work. But you're not sweating copper pipe, you're standing in an air-conditioned auditorium and for Christ's sake you're wearing man makeup.

And finally, we need to take a hard look at political ads. No more of the attractive, informed housewife in the political ad. It's going to ruin my marriage. You see the woman who is dressed down but is clearly an 8.5. She's just come back from the grocery store and is putting away soup cans while helping the kids with their homework. Her hair is perfect and her house is spotless. Then she says, "Prop 32 *claims* to help endangered marine mammals, but I've read the fine print . . ." Where can I find and marry this woman? Nowhere. Because she doesn't exist. From now on the ads have to be honest. They'll have to show an exhausted husband coming home from work and asking, "Did you vote?" and the wife on the couch reading *Us Weekly* replying, "That was today?"

I'm Adam Carolla and I approve this chapter.

1

THE DEPARTMENT OF COMMERCE

It's no secret that the American economy is in a shambles because we do a fantastic job of consuming products, but when it comes to making those products, we leave that to our friends in Asia. This hit me hard two years ago when I was in my garage on Christmas Eve putting together a canopy bed for my daughter's American Girl doll. Not only was I devastated to realize that my daughter's doll was going to have a better bed than I did when I was a kid, but I noticed all the parts were labeled "Made in China." I thought, Game over, America. The AMERICAN GIRL dolls are made in China. Is there a sadder statement than that? The only thing worse is that I'm now seeing a lot of products labeled "Hecho en China." Our country is now full of goods made by people who don't speak English for people who don't speak English.

Why is all our stuff made abroad? Because it's cheaper and the government (if there even is a government where all this shit is being

manufactured) gets the fuck out of the way. That's not to say I'm down with the child-slave-labor sweatshop stuff, but the massive overregulation we have here in America is not going to make this trade disparity go away. As president, I'm going to get out the big book of commerce codes and take a crab comb to it, because until my administration fixes this, no intelligent American businessman is going to bother trying to compete.

THE TALE OF RED WINE AND RED TAPE

I can tell you this from firsthand experience as a small business owner. Many of you probably know that I hock a little product known as Mangria. For those who don't, here's a quick background story.

I drink red wine every night. It helps knock me down after a stressful day. One night I went to pour my second glass and came up a little short. I only had half a glass left. All of you fellow alcoholics have felt this heartache. You turn the bottle over, and a hummingbird beak's worth of merlot trickles out. I blame the lack of uniformity. I feel like some wine bottles are heavier when empty than others are when they're full, because the glass is thicker than the windows on the president's motorcade. Then some have that inny belly button on the bottom that goes up three inches. That divot displaces two glasses of wine, I'm convinced. You can drop a digit on that thing and your finger will just keep going. Sometimes you grab the bottom and your finger goes up an eighth of an inch, but other times it's like you're finger-blasting Rebel Wilson. I don't want to have to give my wine bottle a prostate exam to figure out if I'm going to be able to get drunk.

So with the half glass and half buzz mocking me, I got mad, went mad scientist, and dumped a little vodka in there. At this point I was looking for function, not form. Well, it tasted like ass. But I wasn't going to waste good booze. There are children in Africa who go to bed every night without a buzz. So I went to the fridge and tossed in some orange juice. Much better. I now had my prototype for a powerful sangria. The

next day when I was discussing it at my AA meeting—I mean, on the podcast—I dubbed it Mangria. It started kind of as a joke, me mixing up batches of the stuff and bringing it to Kimmel's for football Sunday. Then people started requesting it. Eventually, after a lot of talk about it on the show, someone from a winery in Napa approached me about bottling my concoction. As of the time of this printing, we have sold over two hundred and eighty thousand bottles.

This all came through hard work, innovation, and captured opportunities. But it was sure as shit not the result of the government. I built it. All the government has done is get in the way and take money at every turn. It's one big bureaucratic clusterfuck.

First, the shipping is a problem. We're still not able to ship to every state. That is the biggest complaint I hear when I'm on the road. "How come I can't get Mangria in Maryland?" I was on a plane sitting next to a guy from Massachusetts who wanted to try some, but that's one of our no-ship states. You know Massachusetts; it's not a big drinking state. Most of those Sox games are dry. It's like an Amish barn raising there.

And getting it into stores is rough. You have to deal with a completely mobbed-up distributor system that is totally at the mercy of the various state agencies.

Why the fuck can't we get on the same page? I'm pretty sure alcohol has been around for a few years now. And we all love it. Shouldn't we have figured this out after Prohibition ended? It's not like wine is this new product that hasn't been fully tested. People in Mississippi and Minnesota both love wine. Why should I be able to sell my product to one but not the other?

That problem isn't just with the state governments. When it comes to the feds, they really slow your roll. Mangria almost didn't make it to market because of the red tape around the label. Anytime you bottle wine, you have to have your label approved by the Tax and Trade Board of the Bureau of Alcohol, Tobacco, Firearms and Explosives. That's right, the ATF gets to decide what I put on *my* product label. So when we first

attempted to put it out, we wrote a little blurb for the back of the bottle about how it was created. It went like this:

> As a nightly consumer of red wine I was shocked one evening to find I had just half a glass left in the bottle. So I did what any decent ~~alcoholic, ex-con American~~ would do . . . I went to the fridge and the liquor cabinet, then poured, mixed, and measured. Thus Mangria was born.

Simple. Funny. Concise. Rejected. We received the following response from the ATF.

> You may not make statements on your label that may create the impression that your wine contains distilled spirits, is comparable to a distilled spirit, or has intoxicating qualities. "Liquor" must be deleted from your label.

So we reluctantly changed "liquor cabinet" to "booze cabinet." This was also rejected. I wanted to argue the point, because how does the average label reader know what is in my cabinet? I could use it for storing sex toys, for all they know. But there is no appeals process. It's a fresh submission every time. Eventually I just wanted to get it shipped and said fuck it, no back story on the label. But there is no going back. If we shipped even one bottle with that version, it would be our label for every bottle thereafter. So we had to figure it out.

Just so you understand the level of stupidity we were dealing with, they also had a beef with the words "alcoholic" and "ex-con," but we beat them on a technicality by resubmitting it with a thicker line crossing the words out.

About a week later we resubmitted, for a third time, with the following change: "I went to the fridge, the pantry, and the basement lab,

poured, mixed . . ." This time it was approved. Much better. Good job, government. Millions of lives saved.

In a few months, we were trying to release the Mangria white peach and pear flavor for the ladies. So we needed a new label. And when I say "new," I just mean the old label in a different color. But that still had to meet the approval of The Man again.

This time we wanted to add the fact that the product is gluten-free. So the label we turned in read "100% Gluten-Free." The TTB of the ATF came back saying we could not say it was "100% Gluten-Free," just that it was "Gluten-Free." As if there's a fucking difference. Here's where it gets comical. We were also working on getting the mango flavor to market and were approved to label that one "100% Gluten-Free" no problem.

Other than that gluten change and the color scheme, we had submitted the exact same label as the original Mangria. But the ATF decided that this label just wouldn't do now. Yes, the same one they previously approved. We had just given them the old label to try and skip one do-si-do of the retard square dance. The same label that appeared on forty thousand units that had already sold and been consumed, sporting a label approved by the ATF. Seemed like a no-brainer. Except we forgot they are the ones with no brains. How dare we apply logic to the situation?

With that in mind, I decided, *Fuck them, I'm creative. I'll just write a new label.* It follows . . .

At last the swarthy Latin lover that is Adam Carolla's Mangria has found his soul mate—a sweet, fair-haired peach of a señorita with a great pear. But watch out, boys, this blonde bombshell packs a punch.

Well, you guessed it. We were rejected. The problem this time was the phrase "packs a punch." The issue? It "implies strength." We were told we could not state that it "has intoxicating qualities." I wanted to

argue that yes, "packs a punch" could mean high alcohol content, or could mean zesty flavor. But I knew that would fall on dick ears.

And what the fuck? We can't mention intoxication on our *wine bottle*?! That's why people are buying it. Shouldn't it be illegal to *not* warn people that the product is strong? If the label said "Goes down smooth. Will not get you drunk at all," I'd certainly be sued when someone chugged it and drove into an empty swimming pool. In a world full of permanent stickers on my sun visor about proper airbag use (as if I have a choice in that matter) and pictures of diseased lungs on cigarette packs, the idea that we are forbidden by the ATF from stating that our alcoholic product can get you drunk is absurd and barely fathomable. Typical wine comes in at 14 to 15 percent alcohol; sangria, which is stepped on with fruit juice, contains about 9 to10 percent. Mangria is 21 percent. We are being negligent if we allow people to think it has the same alcohol content as regular wine or sangria.

We threw up our hands and just removed the last line. That's the sad part. We just gave up. I feel like we're a bunch of astronauts who crash-landed on Planet Retard and we have to adhere to their laws or the Retardians will kill our children. Seriously. What country are we living in? What about freedom of speech? What about my rights as an artist? I can't write a joke on the back of my bottle of extra-powerful wine explaining that it is extra-powerful wine, but *Piss Christ* sits proudly in a museum in New York?

The thing that really steams my bean is that I work my ass off shilling my invention around the country, but the guy who reaps the rewards is Uncle Sam. The government makes more money on this product than me or the manufacturers. The man just collects taxes all along the way— from me, from the manufacturer, from the UPS guy who delivers it to the distributors, the gas station that filled that UPS truck, and the store that sells it to you booze hounds. He's just making money every fucking inch of the way and contributing none of the work. Every time it comes off the assembly line: *k'ching*. Every time it gets shipped: *k'ching*. Every

time it gets poured: *k'ching*. All they do is say no and they still get thirty-five cents to every dollar we make.

They don't give a shit. They can give us completely contradictory information or tell us to talk to the hand and there ain't shit we can do about it. This is a monopoly. When there's only one cable company in town, they give you an eight-hour window for when they're going to come out. Government is a monopoly too. It's not like I can go to a different mom-and-pop ATF to get my wine label approved.

This is going to make me go wacko like Waco. I'm this close to filling a U-Haul with fertilizer, going to the back of Mount Rushmore, and driving it up George Washington's ass.

That said, I do have new regulations for businesses big and small. Not because I want more bureaucracy, I just have great ideas. If you'll all just listen to me, I can assure you we will get our economy back on top.

BETTER GOODS FOR A BETTER AMERICA

SOCKS: The sock manufacturers are some of the laziest on the planet. I recently sent my old lady to Target to grab me some new ones. She came back with the chub pack, in size six to twelve. What the fuck? Shoes come in half sizes. There are twelve sizes of shoes that would fit in that sock range. I don't think Brad Garrett and E from *Entourage* should have the same sock size. What if this were online dating? "Our gals come in somewhere between 110 and 190 pounds. Don't worry about it—we'll just send one over."

A related footwear complaint is the dress sock. They're too thin. They're as sheer as panty hose. When I put those on I feel like I'm John Lithgow in *The World According to Garp*. And they're always way too long and never wide enough. They're three feet long, but an inch and a half wide. It takes an hour of straining to thread your foot through those things. And if you ever catch a glimpse of yourself in just dress socks and underwear, I don't care if you're built like Herschel Walker, you look gay.

OUTLET MALLS: I'm going to create and enforce new laws for the people who live near outlet malls. Outlet malls are always in the middle of nowhere. You *should* have to drive at least forty-five miles to get that discount. If you live near one, we're going to need to put you into the outlet-mall exchange program. In order to purchase some irregular slacks you must undertake a pilgrimage. I want you to spend a lot of time in the car considering why you're so fucking cheap.

STORES THAT STAY OPEN AGAINST ALL ODDS: There is a store on Ventura Boulevard in L.A. that's called something like "Candles 'N Such." I always see places like that and think, "How do they stay open?" Your business plan is that once a month someone comes in and buys an eight-dollar sand candle? There's never anybody in the place. I'm getting rid of these stores. They are doing nothing for our economy. I'm sure it's just a bunch of rich husbands underwriting them anyway. This is the wife of the executive getting out of the house and having a three-hour lunch with her girlfriends and calling it a business expense. Maybe I'm just envious. I wish my day were showing up at noon, eating lunch, and then closing up at three. That might be my plan for after I finish this president gig. I'll find a rich husband to underwrite my business, then make sure it's a store no one would ever go into. I'd call it "Adolf's Herpes and Bear Traps Emporium."

MEDICINE FOR CHILDREN: We've gone nuts with the childproofing. I spent twenty minutes trying to open some multivitamins recently because of the childproof cap. Don't we want kids to eat vitamins? Why are we making them impossible to open? You can't get kids to take vitamins unless you flavor them like grape soda and shape them like Fred Flintstone anyway, so why do we think they're going to start popping my multivitamins like Skittles? I'm an adult and I can barely stomach these things; they get stuck in my throat, one out of every ten makes my stomach cramp, and they all make my piss stink. It's not like any kid has ever OD'd on zinc. "How'd Timmy die? Childhood leukemia?" "No. Too much niacin."

Even worse is children's aspirin. It's made for children. But if one of my kids gets a headache or a fever, I have to take the bottle down to the garage, put it in the bench vise, and go at it with some channel locks to get the cap off. Ironically, the children's aspirin and the multivitamin are actually good for kids, but are harder to get into than MIT.

Why are we crazily overcautious in some areas but don't seem to give a shit with stuff that's more dangerous? Think about the electric knife you use on Thanksgiving to carve the turkey. It just has an on-off switch. There's no code you have to enter, no combination lock, no safety. You can take this electric stabbing machine with a thirteen-inch serrated blade and just switch it on. You could turn the switch on before you put it away and then next year when you plugged it in, it would immediately kick on. A kid gets ahold of that, he's going to turn the kitchen into a *Saw* movie. Yet if he took that same electric knife and held it to the childproof top on his vitamins, the motor would burn out before he got it open.

DISH SOAP: You always see the ads about how the store brand will only clean this many dishes, but with superconcentrated Dawn one drop will clean all the dishes from the Caesars Palace buffet for a year. Which sounds great except for the fact that the next six cups of coffee taste like you opened your mouth going through a car wash. We need some rules about dish soap. It's *too* concentrated. You rinse the coffee mug once, twice, three times, and it's still foaming. I had to switch soap because what we were using was too soapy. You guys are doing too good a job. Take a week off.

And no more scented soap either. I switched to the natural, unscented soap and now I don't have to inhale the smell of Spring Rain Linen or lavender every time I take a sip. Actually, I have just decided that in my country, there will only be coffee-scented dish detergent. Just another gift from me to you, America.

WD-40: Speaking of scents, this is intoxicating for men. Ladies, we don't give a shit about, or more accurately are nauseated by, your perfume,

but we love this stuff. WD-40 smells like progress. I'm hereby making a presidential decree that the makers of WD-40 create and market a scent for women.

SERVICES THAT NEED MY SERVICE

As you can tell by now, I'm going to be the anti-big-government president. That said, there are many businesses and industries which form the backbone of our great nation that have fallen on hard times, or are tripping over themselves so hard they are in danger of going away entirely. I'm not talking about doing an auto-industry-style bailout, just providing a little guidance from my administration. I'll be sure to give my personal attention to the first one . . . the strip club.

STRIP CLUBS

This is an American institution that is slipping away. I recently went to Jimmy Kimmel's bachelor party. I hadn't been to a strip joint in a while and was quite depressed over what I found.

First and foremost—the music. Strip clubs used to play Grand Funk Railroad, the Cult, and Mötley Crüe. There was a time when bands would write songs specifically for strip clubs, like "Girls, Girls, Girls." This was not what graced my ears at this particular bachelor party. Nowadays it's just nonstop pumping syntho crap that's played so loud it hurts your teeth. I'm in a strip club, not the Matrix. This isn't dude music, its pulsating, grinding techno that some gay guy created on his Mac. The strip club is supposed to be sacred ground. You're supposed to play songs by Foghat. What happened? Do you really want asexual pussies like Moby making strip-club music? They hate strip clubs. He wasn't at the Seventh Veil or Spearmint Rhino last night. He was throwing red paint on old ladies in fur coats. Strip-club music should come from guys like Warrant, who actually spent time there. An hour into the bachelor party

my eardrums were bleeding and I would have performed oral on the DJ for even a tiny sliver of some "Cherry Pie."

I blame the cocktails. That's another thing I noticed. In the glory days of strip clubs you used to be able to get a gin fizz or a couple of fingers of Cutty Sark, Sinatra-style. You drank like Frank. Now it's all vodka with Red Bull, Rock Star, or Monster energy drink. Strip clubs are already full of douchebags. They've now taken that asshole and turbo-charged him. It's a disaster. These guys were eights on the douche-hole meter before, but now they're elevens.

And that's why they like the shitty music: they're simultaneously drunk and beaked out of their minds. What's up? You're at a strip club, there are naked women. Boobies are the only drug you need.

A little side rant: We're completely overcaffeinated as a culture. Remember as a kid when coffee was just for the dad on *Leave It to Beaver*? Now every teenager is carrying a super-grande-venti machiatto frappé. We talk about how we need "energy" but not one single teenager I talk to can string a sentence together. Sixty-five-year-olds need energy, not seventeen-year-olds. They have no lust for life. There's no amount of caffeine that can make up for that. If you like what you do, and have a passion, you'll wake up every day with energy. There's no chemical substitute for enthusiasm. And Red Bull tastes like ass.

And speaking of lust and strip clubs, what happened to the performances? It used to be erotic and slow but now it's turned into *Gymkata* out there. (Google it if you don't know what I'm talking about.) I don't want to see Mitch Gaylord on a pole, I want to see a half-naked chick with a C- or D-cup jiggling *around* a pole. That's what that pole is there for. It was initially installed for when the stripper was so drunk she couldn't support herself. I like to see them a little boozy and having trouble walking in their stripper wedges. Now the chicks are out there doing stuff Bart Conner couldn't pull off. Crazy yoga moves, climbing gym-class ropes, running and diving on the pole and then holding themselves up like a flag at half-staff. It's going to be an Olympic event next

time around, I'm positive of this. I'm seeing striated veins in their arms, six-pack abs, and there's not a boob to be found in the place because they're all built like the guy from Iron Maiden album covers. They have hard edges. And then they take that aggression out on your junk. It's like your lap is a nail and their pussy is a hammer.

At Jimmy's bachelor party I was watching chicks do acrobatics that, literally, included fire. I was thinking, "You are going to hurt yourself." That's not what you want to be thinking at a strip club. It was impressive, but I don't go to the strip club to be impressed. Just because I can't do what you are doing doesn't mean it's going to give me a boner. I've seen twelve-year-olds do one of those cup-stacking competitions. It's impressive, but I don't want to beat off to it. It's like the goddamned Cirque du Soleil in strip clubs now. That's fine if you want to be entertained with your parents. But I'm looking to be entertained with my penis.

Let me explain the entertainment component of strip clubs—NUDE CHICKS. Let's never forget that. In the good old days did anyone ever go to a strip club and think, "Sure she's got a D-cup and is naked two feet in front of me, but why isn't she bending rebar over the back of her neck?"

And how about a little less information, ladies? I want to maintain the fantasy that you're just stripping your way through med school. I don't want to hear about how your ex-boyfriend stabbed you fourteen times or how much you love your kids. (A quick funny/sad story related to this. I went to a peep show once in New York and because I'm hyper-vigilant, I noticed, behind the gal, a stroller and diaper bag. I could barely beat off.)

Here's my promise to you, America. In my first hundred days in office we will bring back Ye Olde Strip Joints. No techno, no Red Bull, no personal information. Just plenty of curves, sloe gin, and "Slow Ride."

While I'm on the subject I also have a new green initiative. Half of the strippers you see in Vegas are from L.A. So there will be no more going from Los Angeles to Las Vegas to hit the strip club. It's a waste of

the Southwest jet fuel. We're setting up a new government website so you and the stripper you'd be ridden by in Vegas can just meet in Van Nuys for the lap dance. You'll just get the info for the apartment she shares with four roommates, all named Tami, and meet her there. It's about energy savings, kind of like a car pool for your cock.

THE HOTEL INDUSTRY

I travel a ton and stay in a different hotel almost every weekend. During this time I've noticed that the hospitality industry could stand to make a few improvements. The hotel business is heavily regulated, so why not create a few more rules that will make travelers happier and thus increase the profitability that my government can wet its beak on? That's what we call a win-win.

This one happens at about one-tenth of the hotels where I stay—just enough to piss me off but not enough that I'm prepared for it. It's probably happened to you too. You check in, get your room number, get your key card, plop your bags down on the bed, grab the remote, and . . . nothing. The remote doesn't work. So you do that move that feels effective, but just might work. You pop the hatch on the back and give the batteries that magic thumb roll. Again, nothing. So then you go up closer to the TV and try the remote again, thinking, "Maybe I'm out of range." Nope. Then you think, "Maybe it's the angle." So you try it with the left hand, then the right hand, and eventually you stand up on the bed and hold it up over your shoulder like you're doing a skyhook. Not that that has ever worked, but my question is, what if it does? So you call down to the front desk and tell them the TV isn't working, and come to think of it neither is the A/C. They then say, "Sir, you need to take the key card and put in the slot behind the door to activate the electronics in the room." Hey fuckwad, maybe you could have said something while you were giving me the card down at the desk. You know, a little heads-up that nothing in the room is going to work unless I slide the card into the

vagina that is conveniently blocked when I open the door to the room. It's like they assume you work at the same hotel as they do. They need to have a huge red arrow that says "Put it in here or nothing is going to work." Or even better, here's the way to eliminate this. All those cards should be shaped like a penis. It would be fun to slide it into that slot, you'd never lose it, and you'd know exactly where to put it.

Okay, so now you know the remote is not the issue. There was no juice flowing to the TV. But the remote is still nothing like the one you, or anyone, has at home. The buttons are confusing and you don't know where the power is, so you just press the biggest button and end up buying *Dolphin Tale 2*. And on this note I'm now declaring that all hotel rooms must possess a DVR. We're ten years into DVRs. Why can't we get them in hotels? I'm constantly watching the news in my room and trying to hit a pause button that isn't there. Plus I'm not spending the whole trip in my room. I'm going to go out and see some sights or do some shows. When I get back to the room I'd like to catch up on my *Real Housewives* like everyone else.

That's if you can find the remote at all. Sometimes it's in the drawer, other times it's Velcroed to the top of the TV. Some of the fancy places store it in an elegant leather book thing, but you think that's the Bible, so you avoid it over the guilt from the copious masturbation you're about to do. Here's my executive order—from now on we put every hotel TV remote on the toilet seat. That way you'll always see it. And while I'm mandating, the maids must change out the batteries on the remote every two weeks.

So you've found your remote, navigated the sea of buttons to turn the TV on, and you're instantly taken to the hotel channel. You know, the station which is just a loop of good-looking people in bathrobes getting massages or having a margarita by the pool with a voice-over telling you to relax, enjoy your stay, and order their world-class room service or an adult movie. Please stop enticing people to fuck on my comforter. I didn't bring my own bed. I'm not sitting in a beanbag in the corner.

Plus, you are delivering a mixed message. You've got the TV imploring you to stain my bed, meanwhile in the nightstand next to that bed is a Gideon Bible saying you'll go to hell for it.

Even more annoying is the video loop of all the other hotels in the chain. They're always nicer than the one you're staying in. I was at the Detroit Marriott by the airport sitting on the edge of my bed watching a slide show of all the other exotic locations—white sand beaches on Waikiki, the Sydney Opera House, the Hong Kong skyline. Meanwhile I look out my window and my view is the ass end of the Detroit airport blocked by an air-conditioning condenser covered in snow. From now on, you can only show lesser hotels on this video loop. Which means if I'm at the Detroit Marriott, I should only be seeing the Marriott in Tikrit, Benghazi, or wherever a Blackhawk was down.

I don't need the local magazine either. You know the superglossy, "looks like it's never been read because it hasn't" magazine sitting on the end table with Kathy Ireland on the cover. It's always a D-list celebrity and a bunch of suggestions for shit you're not going to do. I'm not going to go horseback riding or hot-air ballooning. I have plans. Do you think I just woke up in a hotel room in Sacramento and now need to find some romantic day trips? I came here with an agenda. And if I do have time to kill, I'm just going to whip out the iPad and my dick.

A quick story related to this. I was in San Jose doing a show and had some time on my hands and so I thought I'd put my dork *in* my hands. I took out the iPad to let my fingers do the walking and find out what new and innovative porn was coming out of Stuttgart. As I was looking at the smorgasbord of choices on YouPorn I noticed that the pictures were a little blurry. I thought, "Shit, I need my reading glasses." I can't believe these two things have intersected. I never dreamed I'd be so old that I'd need grandpa bifocals for beating off. If you asked me in high school if I'd still be whacking it after age had wrecked my vision, I would have slapped you. So anyway, I got my reading glasses out, put them on, and went back to work. At a certain point I looked up and caught

a glimpse of myself in the bathroom mirror, pants around my ankles, sporting gray pubes and reading glasses, and thought, "Jesus Christ, Carolla, you have hit rock bottom."

And on this same note, my government will put an end to all theme hotels. These always seem like a fun idea—"Oh, we're in the Jungle Room"—but this is just for obese middle-aged couples looking to spice up their once-a-year anniversary fuck. So from now on there will be no more Western rooms or Caveman rooms. The only theme at hotels henceforward is "No Stray Pubes."

On to the hotel coffee. This drives me insane. You always end up making the coffee yourself because they gouge you on the pot you order from room service. That's even more inflated than the in-room porn. A carafe of mediocre black coffee should not cost twenty-three dollars.

So you use the in-room single-cup coffeemaker. The problem is that next to the machine are two little pouches. They're both silver but one has a light ghost of blue lettering that says "decaf." If you squint and the light hits it just right, you can figure out what the fuck you're about to drink. How many people have been burned by this? The pouch of decaf should be hunting-vest orange.

More accurately, it shouldn't be there at all. I can't stand the light-weight pussy who can't handle a cup of coffee. Why are we at a 50/50 ratio on this? If you had a barbecue, you wouldn't have two ice chests—one full of craft-brew beer and another full of O'Doul's. Starbucks must move less than 10 percent decaf but in the hotel it's 50 percent. There are so many more normal human beings who understand that coffee serves a purpose than these decaf cowards. Need proof? Just go to any self-serve K-cup-style coffeemaker in the hotel lobby kitchenette and notice how the box of regular coffee has, at best, two pods rattling around in it while the decaf dispenser looks like a New York subway car at five o'clock.

There's no federal mandate that says you must provide coffee in the room. This is an added convenience from the hotel. So I am offering a federal mandate:

ManDate

From now on, my administration demands regular coffee only. If you want decaf, fuck off. Leave the hotel and go to Starbucks. I'm tempted with my fuck-you money to buy a bunch of those empty decaf pouches, fill them with sand and diatomaceous earth, and leave them in hotel rooms. Then when people open them they'll find a note that reads, "Fuck you, pussy." Coffee serves a purpose. It is a caffeine delivery system. If you drink decaf you don't need coffee. You can get the same effect from a Fresca. It's never like "We're going to be driving all night. I need some decaf" or "Don't mess with me when I first wake up and before I've had my decaf."

These people are like vegetarians. They don't love decaf, they just want you to know they don't drink caffeine. And to the hotels—why are you limiting me and other regular Joes to one cup of regular joe just to accommodate the handful of babies who can't handle real coffee? From now on you decaf drinkers should not expect the business to accommodate you. If you needed insulin, you wouldn't expect it to be provided. You'd bring it yourself. Are you that delicate? Are you a human being or an inbred poodle?

And while I'm on room service, I'm never sure what to do with the tray. I see it out in the hallway but that feels weird to me. It's not like when you're done eating at a restaurant you throw the plate on the floor. Why is this the practice in a hotel? The Four Seasons in the South of France and the aforementioned Detroit Marriott have the same room-service tray policy. Just slide those half-eaten mashed potatoes out into the hallway. Someone will grab it eventually. In my America, we will bring back the dumbwaiter, a little elevator in the wall in the middle of the hallway where you put your tray and send it down to the Mexicans in the basement.

This "chuck it in the hallway" policy also feels like an invasion of privacy. Against my better instincts I always have to do the math on the guy behind the door when I see his dirty dishes. "Oh, he's an omelet guy. Two glasses—I wonder if he's with his wife or his mistress." Plus, if I see

wasted food I get annoyed. I'm not ashamed to say that I've been more than tempted to grab a couple cold fries or chicken fingers off the spent room-service tray.

And when it comes to room service, why is the tip included? As you might know, I don't like when they add the gratuity at the restaurant if you have the party of six or more. That's just called a tax or a tariff. If you look up "gratuity," the definition is "a gift or reward, usually of money, for services rendered, given without claim or obligation." I understand why they think this is necessary, but this isn't the way tipping works. Sometimes you're going to get stiffed, other times Phil Spector is going to come in, order a Shirley Temple, and leave you five hundred bucks. Kimmel tips around 50 percent, my parents are coming in at 9 percent. So it evens out. But why is a tip included in room service? I'm alone in my underpants. That's just one person, not six. And what if you did have six people in your hotel room for a couple of overpriced, underwhelming burgers? Would you waive the tip altogether just to confuse me? Please, let's get our tip shit together.

And when did we sign off on the supercute novelty "Do Not Disturb" signs? It used to just be DO NOT DISTURB on one side and PLEASE MAKE UP ROOM on the other. Now you see all kinds of silliness. Here are just a few 100 percent real examples—I NEED A MOMENT. MAKE THAT 30 MOMENTS; TRANQUILLITY PLEASE; BRAINSTORM: IT'S REALLY COMING DOWN IN HERE. BETTER COME BACK WHEN IT CLEARS UP; IN THE ZONE. ONE KNOCK COULD BRING ME OUT OF IT; and BUILDING AWESOME PILLOW FORTS. The only thing I'm doing in my hotel room is napping, shitting, or beating off. That's what they should say: DO NOT DISTURB—NAPPING, SHITTING, OR BEATING OFF on one side and PLEASE MAKE UP ROOM—I'M DONE NAPPING, SHITTING, AND BEATING OFF on the other. Also, I know the cleaning crew only speaks Spanish and so do hotel owners, so the cuter you get with the verbiage, the more likely they are to misunderstand the sign and interrupt me during one of those three sacred activities. That said, I'm also doing away with the Spanish version that reads

NO MOLESTE. If I'm going to molest someone, or something, in my hotel room, that is my business.

And while we're on the topic of being disturbed, let's do away with the wake-up call, please. These do way more harm than good. There is nothing louder than the phone in a hotel room. You want to be woken up, but you don't want to evacuate your bowels and suffer tinnitus when it startles you from your slumber. And far too often the call doesn't come at the right time. I've had this happen. I was staying in New York last year and my seven A.M. wake-up call scared me awake promptly at six thirty. You should get a free week's stay at the hotel if that happens. That is an assault. I'd rather have someone kick down my door and rape me awake on time than get called a half hour early.

The only problem with this plan is that fucking alarm clocks in hotels are never positioned the right way. I'm not sleeping on the floor facing the clock, I'm on the bed staring at the fake wood veneer on the side of the clock. This is not helping the anxiety I have about missing my flight if I don't wake up at six A.M. The same anxiety is keeping me awake, and therefore making the alarm clock necessary.

So you attempt to turn it so you can see it from the bed. But nothing hates turning more than that clock. It's like straightening out an old person. I'm straining harder than Gene Hackman trying to turn that valve in *The Poseidon Adventure*. And sometimes you can get the clock to turn but the cord isn't going along with it. It's hanging on to the back of the nightstand like a villager clinging to a tree in a tsunami. Customer Service 101: in a hotel room, all clocks should be visible from the pillow.

Now let's talk about hotel bathrooms.

I miss the "sanitized for you protection" ribbon on the toilet seat. I'm bringing that back. It made taking a shit feel like a ground-breaking ceremony. I expect to see a guy in a suit with a hard hat and a golden plunger. I always had a dickhead fantasy of sliding the ribbon off, taking a shit, not flushing, and then putting the ribbon back on just to leave a little present for the maid. But I never did it. I just loved the feeling

of breaking that ribbon too much. It was like I won some sort of fecal marathon.

Speaking of the fecal marathon: Some of you may know a tale from my previous tome about pissing into an ice maker because the urine countdown had started and I couldn't get into my room. Well, this past year I had a similar incident. I was at a hotel on the road and staying on the ninth floor. I had a very nice suite, but that meant it was at the other end of the hall, as far away from the elevators as possible. I had just rolled in after a long road trip, gone through the usual rigmarole at the front desk, and hustled upstairs to drop a deuce. Well, like the other nine out of every ten times I check into a hotel room, my key card didn't work. Knowing that I was T-minus two minutes until the fecal had landed, I did the butt-cheeks-clenched run to the elevator to go down to the desk and get the card fixed. I hopped in, pressed lobby, and went down one floor. The doors opened on the eighth floor and two blond twin boys with white-trash faux-hawks were standing there. One of them grabbed the left door, the other one grabbed the right. Then they just stood there staring at me like an Alabama version of the two girls from *The Shining*. I asked, "What are you doing?" They said, "Our dad's coming." I asked, "Well where is he?" They said, "He's in his room." I was going crazy. I was thinking, "Were you sent here from hell to force me to shit myself?" I said, "You've got to let the door go." They said, "No, we're waiting until Daddy comes." Even though judging by their haircuts Papa was probably the kind of guy who carries a .38, I pried the door out of their Mountain Dew–sticky fingers and headed down to the desk. I managed to have them replace the key card and get back to the suite just in time to obliterate the bathroom.

Here's what we don't need in hotel bathrooms: I was staying in Utah, and there was a gold-seal sticker on the toilet paper that held the loose end to the rest of the roll. Because we've all dealt with the horror of the next piece of TP flapping in the breeze, mocking us. Well, when I went

to wipe in Utah I tore off the first few inches and realized I had left the sticker on there. I haven't shit for two years.

The hotel bathroom is not only the place where I shit, it is now the place I'm forced to go when I need to smoke. Nowadays the majority of hotels are smoke-free. When you check in you have to sign something that says you won't smoke or there will be an extra $250 on your bill for cleaning. First off, really? One fat Guatemalan chick with a spritzer of Febreze is $250?

I felt the sting of this new policy especially hard in Winnipeg. It was the end of a long night after the travel—a situation at customs which you'll soon read about—the gig, and the postshow autograph signing. It was after midnight when I got to the hotel and it was zero degrees outside, so I was sure as shit not heading to the curb to blow a butt. I went into the bathroom, removed all the towels—they'd be the evidence of my crime because they absorb the scent—and stood over the toilet blowing the smoke into the fart fan. At a certain point I caught a bleary-eyed, exhausted glimpse of this pathetic scene in the mirror and thought that perhaps I should have gone down to the curb to smoke and found the sweet relief of hypothermic death.

I didn't get caught that time, or the hundred times since. But if I ever did get the $250 fine, I would surely fight it, and here would be my argument to the hotel. You're charging me a fee for smoking up the room, but meanwhile you pump porn in so that people can beat off with impunity. I imagine that if you were to ask the patrons of your hotel which they would rather have, the room in which someone recently smoked half a Marlboro Light or the room where a guy made a jizz pentagram on the bedspread, they'd go for the secondhand smoke instead of the left-hand beat-off every time.

In my America, hotels are now 50 percent smoke-free and 100 percent spooge-free, though it will be sad then to see all the guys outside on the sidewalk twenty feet away from the entrance beating off into the

gutter, bumming lube off of strangers. Though as I'll soon be staying only in presidential suites, I'll enact an exception for them. I'd be honored to sleep on Eisenhower's crusty sheets.

And finally there's this.

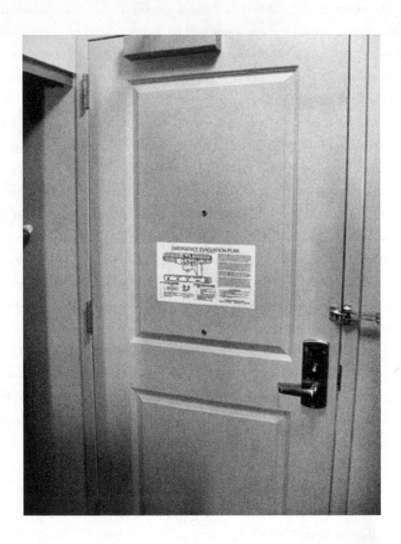

I took this picture in a hotel in Milwaukee. I looked at the back of my door and noticed the peephole. But then I looked just below it and thought, "What is this? That glory hole will work for me, but what about the average-sized gentleman?" I then realized it was a peephole for little

people. At first I was angry about lawyers and how everything has to be constructed to accommodate everyone nowadays, but then I thought, "C'mon, Adam. Quit being an asshole. Midgets can be businessmen, they can travel and use the same hotels you do, and they'll need to answer their door too." But then I thought, "What are the chances another midget has come to rape them? When the midget looks out that peephole, isn't he just going to see the regular-sized person's balls? 'Wait a second, I don't recognize those balls. I didn't order a Denver omelet. Turn around, let me see your asshole.'"

So to recap—hotels will soon be decaf-, room-service-tip-, double-peephole-, novelty "Do-Not-Disturb"-sign-, wake-up-call-, key-card-electronic-control-, and jizz-pentagram-free, all with one stroke of my presidential pen.

THE FOOD-SERVICE INDUSTRY

This is the fastest-growing sector of our economy, because our fat asses are the fastest-growing sector of our bodies.

As a former McDonald's employee, I did plenty of complaining about that company in my previous book. And it's obviously a thriving American business. But I'd like to offer one suggestion. I know the plan is to shut down breakfast at ten thirty and switch to the lunch menu, but you are missing out on millions in Egg McMuffin sales. Especially on Saturday when ten thirty is still hangover time. If you don't make this change, I'm going to do it for you. I'll just roll into Mickey D's at 10:25, order sixty-five Egg McMuffins, stand at the front of the drive-through, and tell all the people rolling up hoping for one after ten thirty, "Here's your Egg McMuffin. That'll be eighty-seven dollars and a blowjob, please."

And I would like to order McDonald's to knock it off with the toys in the Happy Meal. This has created an aspect of our culture that I see, and despise, with my kids. Every day they need a new toy. Every meal,

every event, every trip to the park needs to be commemorated by bringing home a cheap piece of Chinese plastic shaped like a character from whatever forgettable animated movie is out that summer.

Here's a new law for all restaurants, especially delis and diners. Once you serve over seven different kinds of sandwiches or more than two varieties of french fries, you must also offer coleslaw. There's nothing more annoying than going to a restaurant, ordering a nice pastrami or smoked-turkey sandwich, and not having a side of coleslaw to go with it.

Strike that. The only thing worse is when they do have coleslaw but have gone all fancy pants with it. I got some coleslaw the other day with apples and cranberries in it. I've seen coleslaw with golden raisins. Stop trying to make it good for me; it's not salad, it's just a way to feel good about eating mayonnaise and corn syrup. Coleslaw wasn't broken, stop trying to fix it.

And enough with the cold butter and chilled silverware. This is not a luxury. Think about everything that is luxurious—heated car seats, mink coats, massages—all warm. Warm is a luxury, not cold. So why are you giving me frozen butter that is harder to spread than the gospel at an al-Qaeda training camp and an ice-cold knife to do it with? Are we not aware that attempting to spread butter at anything below room temperature tears up the bread? You end up with a crust corral enclosing a golf ball of bread with a frozen butter center.

Just like the theme hotels, I don't need the theme restaurant. Your only theme should be good steak.

The prime example of this is Medieval Times. This is a nerd version of Benihana. You have to sit with strangers and eat mediocre food while watching wannabe actors pretend to be Knights of the Round Table. I don't know anyone who thinks, "The prime rib at Arnie Morton's is

great, but there's just not enough tournament. I'm heading to Medieval Times."

And if you do have a theme restaurant, I don't need the cutesy bathroom door signs. Is anyone frequenting your establishment even though you have shitty food and terrible service because of your hilarious bathroom door signs? You're not seeing too many Yelp reviews reading, "The food sucked and the waitress was a cunt but the bathroom doors said 'T-Birds' and 'Pink Ladies.' Terrific." The food-service industry is full of government codes, so in my administration, we'll be adding one more. Just put MEN and WOMEN on the bathroom signs. I don't need the signs that say CABALLEROS and SEÑORAS at the Mexican joint or a picture of a mustache or a lipstick kiss mark at a trendy place. Don't get clever or abstract. This is a lawsuit waiting to happen. One day I'm gonna have a couple glasses of wine and bust into the ladies' room and have to shout, "Sorry, I had to piss and I didn't know if I was a Doe or a Buck."

TATTOO SHOPS

One American business that is doing just fine is the tattoo industry. This is boom times for them. In the fifties it was just merchant marines and a few actual marines getting anchors or hearts with "Mom" in them on their upper arm. Now chicks and black guys are getting them in droves. There's no way this could have been predicted when Eisenhower was president. Imagine a black guy going into a tattoo shop right after WWII. Depending on which part of the country he did this in, he might not have come out alive. Now you can't be in the NFL without an illegible tattoo on your arm, or, in some cases, face. And chicks getting tattoos? Forget it. They would have been declared hysterical and put into an asylum back in the good old days. I think this started in the seventies, but really broke in the eighties with punk and the nineties with grunge, and now it's game on. There's no way that Marilyn Monroe would have

gotten a tattoo. She was the Pam Anderson of her day. Can you imagine Pam Anderson *without* a tattoo?

But the reason I want to get the government involved in this issue is that I don't think it's a great sign for our future. There are more people under thirty who have tattoos than ones who don't. This makes me shudder. It shows that the next generation has no plans for the future. If you put the barbed-wire tramp stamp on your lower back, you're living for now, as the Pepsi ad commands. You're not thinking about how the tattoo is going to look at forty-five when you're bending over pulling your brood out of the minivan. This "fuck the future" attitude is the cause of many of our nation's biggest problems. Everyone lives their life like a meteor is going to hit the planet next Wednesday. There used to be elders who told us how to prepare for the future. Now, if anyone over forty tells anyone under thirty anything about life, the response is "Fuck you, old man. Go change your diaper."

Last year the city council in D.C. proposed a waiting period for tattoos. I'm down with this notion, and will make it a federal law. I think the waiting period should apply based not only on age but also on tattoo. No matter how old you are, if you want to get Wile E. Coyote on your titty, you're going to have to wait while we check to make sure you're not on government assistance.

Clearly I have all the ideas ready to go when it comes to commerce. I have a million plans for how we, as a nation, can make better products that will not annoy our fellow Americans. Less annoyance equals more opening of the wallet, right? But because I will be president and commander in chief, I will have to focus on other things, like the size of my American-flag lapel pin, and I will need a Secretary of Commerce to put all my great ideas into practice. I need someone who can take abuse, because my new rules and regulations are going to piss off a lot of the business community and also the entrenched political interests that have

created the red tape I'm going to cut once and for all. I am also, as you can see, going to raise the standards for all businesses so they make better products and we will want to buy their goods, not just shit from China because it is cheaper. That's why I'm nominating as Secretary of Commerce Sanjeev Mehta. He works a phone bank in Mumbai, goes by the name Dave, and would be happy to provide you with excellent customer service today.

THE U.S. POSTAL SERVICE

The U.S. Postal Service is on its way out. And I'm fine with it. I don't need mail.

I lived in a house that had a large wooden gate at the end of my driveway—a gate I built myself, by the way. I put a mail slot into the gate with a basket hanging on the inside to catch the mail when the mailman put it through. One day I got a note from the post office saying that I needed to have a mailbox outside the gate next to the street. This was clearly so the mailman could pull up, put the mail in the box, and drive off without having to get out of his weird jeep with the right-side steering wheel. This is clearly more convenient for him, but a major inconvenience for me. If I did it his way, I would have to go all the way down my driveway, use the clicker to open my gate (which doesn't work half the time—don't get me started), and risk getting stuck on the wrong side of the gate in my bathrobe while the van full of hicks taking the tour of the

stars' homes gawk at me. That's the other part: with the box this far from my abode, it's easy pickin's for anyone walking down the street to grab something and steal my identity.

So I left a return note that said for the amount I pay in taxes, the guy can get out of his truck. They responded that I was not in compliance with blah blah blah. I responded with the message that I didn't need this service. My important mail goes to my accountant. So they could kindly take the PennySavers and flyers for shitty sub joints and bring them back to the post office to recycle them, or shove them up their ass for all I cared. They're just going to end up in the garbage or my bushes.

The postal service is dying for the best reason possible—competition. E-mail killed the letter and UPS and FedEx do a better job with packages. UPS takes the doors off their trucks because opening and closing them would add an extra thirteen seconds. I'm sure their uniforms are brown so that they can just crap themselves rather than taking the time to shit. In fact the uniforms used to be white, but rather than slow down their delivery, the drivers delivered a deuce in their shorts. You've never seen a bunch of UPS drivers hanging out, leaning against their trucks, blowing a butt and drinking Snapple. You don't see fat FedEx guys, because they get paid based on performance. Go to the post office and tell me if you notice a difference. You've got a line out the door with one surly Korean bitch behind three inches of Lexan to handle it. If they were doing a great job or were incredibly vital, they wouldn't be considering ending Saturday delivery. Restaurants that are making money aren't saying, "Let's close on Saturdays."

That said, I can't stand the guy who complains about the price of a stamp going up. If I handed you a piece of paper and said, "I want you to get this to Maine in two days, but I can only pay you forty-six cents," you'd punch me in the face.

I feel like the government makes my point about how incompetent and useless they are over three hundred times a day. The latest example was when the Michelle Obama "Let's Move" fitness campaign came out

with a line of stamps showing kids doing activities like running, jumping, and skipping rope. You know, important stuff we need to use our tax dollars to inform kids about. And what kid even deals with stamps anyway? When was the last time a kid went to the post office to be inspired? Plus, a kid that is really into stamps and is unaware of jump ropes isn't going to get off his fat ass anyway.

Stamps used to be a big deal. We'd unveil them at press conferences, debate whether to put the fat or the skinny Elvis on them, kids proudly displayed their stamp collections. Now, if you gave a kid a stamp, he'd put it on his tongue and then complain because he didn't trip out.

Well, the cherry on top of the wasteful retard sundae is that hundreds of thousands of these pointless stamps were recalled and destroyed because they depicted "unsafe activities." And what extremely dangerous activities were these kids participating in? MMA? Russian roulette? Jumping Snake River Canyon on a motorcycle? Nope. Doing cannonballs and headstands. I guarantee every guy who is in a wheelchair from doing a headfirst dive into a too-shallow pool wishes he had done a cannonball instead. If you pushed me off a bridge, I would go instinctively into cannonball mode. That would be the safest bet. But a kid can't do a cannonball? That's a rite of passage.

Or the kid doing a headstand? The problem with that one was that she was doing it without a helmet. I think we all had that neighbor kid who did a headstand without a helmet and caught on fire. It's literally burned into our psyche. Right? Fuck no. Who needs a helmet for a headstand? I would argue the helmet would get in the way and cause more injuries than it prevented.

And as far as the government goes, do we have money or don't we? We're always talking about budget problems but we can literally burn hundreds of thousands of dollars' worth of stamps. If this were a business with a real bottom line, people would be shit-canned for this. But since it's the government, they're playing with house money. There are no consequences.

The government spends a shitload of our tax dollars telling kids to do cannonballs, and then spends even more changing their minds because they're a bunch of pussies. Please, let's have the government shut down again like we did in 2013. I bet we wouldn't even notice except that we'd get less junk mail.

THE DEPARTMENT OF ENERGY

I'm an efficiency expert/weirdo, and I will bring this quality into the White House with me. I see a lot of wasted energy in this country and I'm not going to waste any time addressing it.

People see me going around constantly flipping off lights and think I'm OCD. No, I'm just turned off by lights that are turned on unnecessarily. It's not about wasted money, it's just about waste. Whenever I see someone throwing out food, I just picture all the energy that went into making that food being lost—the diesel in the farm equipment that picked it, the energy in the fertilizer and the whole fertilizer plant, the truck that brought it to the restaurant, the BTUs used to cook it, and the electricity for the heat lamp at the shitty restaurant. All gone because you couldn't finish your taco salad.

That's why I love race cars. There's nothing that doesn't need to be there on a race car. It's all to make it run faster, or to cool it down so it

can run longer, or to provide downdraft. It's all about faster, smoother, more efficient. Every time I go downstairs in my house, I bring something that needs to go to the first floor. It bothers me to make a bunch of trips up and down the stairs. Even when I'm pissing in a urinal, I lament the loss of that energy. That stream of liquid that comes from my cock could be harnessed. That's why my first directive to the Department of Energy will be to put miniature hydroelectric waterwheels in every urinal. It will even be part of my campaign slogan: "A natural-gas car in every garage and a waterwheel in every piss pot." The urinals at the Super Bowl alone could power all the lights and Jumbotrons in the stadium. I even want a device invented so that I can power a flat-screen TV on the interior lid of my coffin with the energy from my decomposing body. Just because I'm dead doesn't mean I don't want to watch *Access Hollywood*.

When it comes to wasted energy, if I come home and the space heater is buzzing in the kids' room while they're at school, I go ballistic. If that heat could be channeled to someone who needs it to boil pasta, I'd be fine with it, but the idea of heating a room that no one is in boggles my mind. I run into this all the time at home. My family puts the kill in kilowatt. I went into the kids' room the other day and the lamp on their end table was on. So I had to do the move where I reached up under the shade like I was some sort of lamp gynecologist. Here's how this usually goes. The light is on, so you have to look down the barrel of the lampshade at the blinding shaft of light while you feel around, and you burn your hand on the bulb in a fruitless attempt to find the switch. So then you think, "I'll go down to the base." You feel the base and still, nothing. So you pick it up, spin it around, can't find anything, and then decide that maybe the switch is three feet down the cord. I hate that shit. I have stayed at hotels where the switch for the lamp was a yard down the cord behind the desk. I shouldn't have to move furniture or slide on a mechanic's creeper to turn my light on. Switch placement should just be uniform. It should be at the base. That way you're not searching

down a cord that's tucked behind furniture and you're not reaching up a lampshade like some perv copping an up-skirt feel on a teenage girl at the mall.

It's more than the petty annoyance of not being able to find the switch. It's the fact that we were illuminating a room that no one had been in for several hours. Worse is that no one was going to be in that room for several hours more. Had I not noticed it, more energy would have just gone into the ether.

This is a chick problem, by the way. They all have the "save the whales" gene and the "save the dolphins" gene but not the "save the kilowatts" gene. Maybe we need dolphin-shaped lightbulbs. I bet Cameron Diaz, despite all her "save this" and "save that," right now has a closet at home with a light on and the door closed.

First Lady Lynette can just skip this next section and we could avoid my being the first president to get divorced while in office. Lynette will not commit to an iron. She just has this weird hot stick with a diamond-shaped head that spouts steam. It's basically a miniature iron attached to a handle the size of one on a toilet brush. She doesn't even have an ironing board, so when it comes time to do the collars on my dress shirts before I go on *O'Reilly*, I'll find her sitting on the floor steaming the collars on the carpet.

And that was where I found the iron-stick one day when I came home, sitting on the carpet. Unfortunately I did not find Lynette sitting on the carpet with it. I passed by it three times looking for her to no avail. Sadly I had to go and check to see if it was still plugged in. Even more sadly, I was right. I touched the iron part and it was hot. So I unplugged it immediately. But just as immediately my waste-not instinct kicked in and I rushed to the closet, grabbed a couple of shirts, and pressed the collars to milk every last kilowatt out of the iron before it cooled down.

The part that bothered me much more than my wife leaving a hot iron on the carpet was the fact that it doesn't have a little light to tell you

it's still on. Shouldn't the thing that can burn down your house have a built-in diode to warn you of that possibility? Irons are some of the least stable objects around. A dwarf could fart and knock over an iron.

ManDate

Just add little LEDs to stuff to let us know the wattage is still flowing. All electrical equipment produced in this country must now include this feature.

The one that really drives me nuts with this is the ceiling fan. I have several in my house. I've got one in the bedroom, one in the office, and one in the workout room. I love them so much I'm thinking about having one installed in my car. But I never know when the thing is on or off. A lot of other items in the house—like the toaster oven or the coffeemaker—have a little red light to let you know if the juice is still running. With the ceiling fan, you only have the noise. So when it comes time to leave the house, you have to pull the chain and guess. You give it that one tug. (*Ka-chink*) "I think it's off, but it's just slowing down. Maybe one more." (*Ka-chink*) At this point the ceiling fan goes into turbo mode. Birds are getting sucked into the vortex. So you then overcompensate and pull it three times but then it's back to where it was when you decided to start the retarded fan dance. Eventually I do what we've all done, I grit my teeth and say, "Fuck it. I'm gonna put my hand in there. I don't care if I burn out the bearings or lose a pinky." I even give it a little push back just for good measure to see if it recoils.

And why does it even have a speed that does nothing? Are we in a 1930s southern courtroom or shooting a Don Henley video in the eighties? Just give me the medium and high settings. I bought this device to move air. I doubt it can do that when it's rotating slower than the Earth.

While I'm on rotation, fans, and waste—what's up with oscillation? I don't understand the point of oscillating fans. You lie down on the sofa for a midsummer's nap, turn the fan on, but forget there's a button which makes sure the air is only blowing on you 8 percent of the time. Why

do I need an option to make sure that the potted plant in the corner and Grandpa's urn on the mantel get as much cool breeze as I do? You're wasting 90 percent of the energy used to run the thing to blow the papers off your dining room table. There's no other place where oscillation is what you're looking for. There's no such thing as omelet oscillation. You don't take a bite of the Denver omelet, then pass it around the table.

There's also the withdrawal. This is one of my few hypocritical moments. Even though I constantly rail about wasting electricity, I'm hooked. I had my bedroom ceiling fan going full blast all summer, but when fall finally hit L.A.—usually two or three days before Christmas—I still needed it to sleep. That whir helps me nod off. That and several tumblers of Mangria. Is there some sort of ceiling fan methadone that Dr. Drew can prescribe—Fanax? Maybe I can just hire someone to stand next to me and make that *hmmmmmmm* sound?

It's not just affecting my sleep; it's affecting my marriage. Lynette is not a fan of the fan. When I turn it on anytime after September 1, she makes a noise that is the opposite of the soothing *whisshhh* of the fan. It's an exasperated *uaaahhhhhh*. I tell my wife that I need the ceiling fan on to sleep, and ask her why it bothers her if she's under the blanket. She'll be bundled up under a duvet with a postage-stamp-sized piece of her face exposed and complain, "My forehead is cold." I'm skeptical of this. There are no nerve endings up there; you could put a cigarette out on my forehead. I have to explain to her that I'm a junkie, I'm hooked on the sound. All those white-noise makers they have at Brookstone don't have the right ambience. They have the sound of waves crashing on rocks, which I guess is good if you're Tom Hanks in *Castaway* and you can sleep on the beach. Or they have the babbling brook or rain forest. I don't know about you but I rarely sleep next to a babbling brook. (By the way, Babbling Brook would be a great name for a female cattle auctioneer.) I need more realistic sounds, the ones I'm used to, to lull me to dreamland. We need the ceiling fan sound on a white-noise machine. It would save millions of kilowatts. (And let's get rid of the term "white noise." I

don't even know what that is. I just assume it's a bunch of attorneys repeating the phrase "at the end of the day.")

One last complaint about chicks and electricity. We'd never have to build another hydroelectric dam or dig another coal mine if women would stop blow-drying their hair. Blow-dryers are deceptively energy draining. You could use one of those things for ten minutes or keep a porch light on for ten years. I know it. Next time your wife is blow-drying her hair, take a walk out to the power meter and see it spinning like a dreidel.

Not only does it use as much power, it makes as much noise as the engine of a 747. No wonder most women can't think. They spend a significant portion of their lives with a deafening device deep-frying their brains. Think about how many hours they spend heating up Aqua Net and blowing hair dryers into their faces. When that hairspray hits the heat it becomes weaponized. Forget secondhand smoke, heated-up hairspray needs a PSA. I think the reason we don't have an equal society where women get the same wages as men and they're all engineers and other unrealistic stuff is because they spend all that time on their hair and not on the brain right beneath that hair. Don't get me wrong; if guys did this we'd be in the same sinking boat.

And this is why all hairdressers are flaky and nuts. They're all on their third marriage, believe firmly in guardian angels, and their best friend is a macaw named Blue Man who doesn't judge.

But again, think about how much power gets sucked off the grid for hair dryers. Twenty minutes every day, times 75 million women. That's why I think President Obama missed an opportunity. He should have forced Michelle to go full Shirley from *What's Happening!!* with her hair. If Michelle just let her hair go natural, all the women of color would follow. Hell, maybe even some Jews and Italians. This could bring the races together. Italians, Jews, and blacks could all dunk their heads in a pool, let their hair dry in the sun, and say, "We're not so different after all." I secretly suspect that this is why the African American community is not

so fond of swimming. Black chicks spend so much time straightening their hair they don't want to fuck it up in the (public) pool. But more importantly it would end the scourge of hair dryers and we'd never have to deal with the fucksticks in the Middle East again.

FOSSIL FUELS AND ALTERNATIVE ENERGY

Here's what pisses me off about the constant "debate" we have in this country about natural gas and fracking. We all agree that we don't want to pour our collective cash into the giant ashtray that is the Middle East, correct? I'm pretty sure we're all on the same page that dumping all of our money in the hands of people so they can have Beyoncé perform a private concert for their son and think it's a great idea to throw acid in the face of twelve-year-old girls for having the audacity to read isn't a great plan.

I understand that everyone on the left wants cars that run on good vibes, but the technology isn't there yet. That's their beef with natural gas. They just don't like the internal combustion engine. They love the word "natural," but when you follow it with the word "gas," they're out. I bet if it had been called "natural fuel" from the beginning and "fracking" didn't sound like something Darth Vader would do, there'd be much less of an issue. But these lefties need to accept the reality that the internal combustion engine is here to stay, so take your life partner's dick out of your mouth and let's talk about the best way to power those engines.

I'm a car guy, so I know that engines can be converted easily to work off of natural gas. They perform exactly the same. In fact, if we switched to natural gas we could get rid of catalytic converters. We'd not only save in gas, but we'd cut $500 from the manufacturing cost of each car and thousands in the disposal of the heavy metals contained in catalytic converters.

Why all the fear? Natural gas is the same stuff that's coming out of the stove in your apartment. Why not in your car? That's the disconnect.

My Prius-loving Los Angeleno friends conveniently forget that the batteries in those cars are being charged by a coal-fired electricity plant. Fracking isn't nearly as dangerous as coal mining. I know we all want a perfect, risk-free fuel, but you know what? Shit happens. Nothing can have a zero risk factor. There's no such thing. So let's just minimize the risk. One way to do that is to get our fuel from home, not from people who then use that money to buy gold toilets and fund terrorism.

Shouldn't we have learned this lesson in the seventies? I lived in California in 1973 during the OPEC embargo. I remember sitting in my mom's VW squareback waiting in rationing lines based on whether you had an odd- or even-numbered license plate. And this was when gas had skyrocketed to *forty cents a gallon*!

At that same time we had assholes like Martin Sheen chaining themselves to bulldozers with their "No Nukes" message. Like fracking, I think that was a nomenclature problem. "Nuclear" sounded scary. It was the same thing we were constantly being told about how the Russians were going to drop on us, so everyone got paranoid, conveniently forgetting that with nuclear power you can have something the size of a tennis ball powering an aircraft carrier the size of Cowboys Stadium, and uses more electricity, for years with no problems and zero pollution.

So because of all that sky-is-falling bullshit we continue to power our country with the black shit sucked from the ground underneath the worst people on the planet.

Except that we can actually get some of it from the second-worst place on the planet—Alaska.

Alaska seems like the most rough-and-tumble spot in the world. Everyone there seems to be running from something in the Lower 48, whether it's the law, the tax man, or their ex. Alaska's where you go to forget your past, especially when you owe your past a shitload in child support. The state motto should be "Love fishing but hate your kids? Alaska." Forget the *Jackass* movies. I'd like to do a hidden-camera show where we get a guy with a salt-and-pepper mustache, put him in an ATF

windbreaker, have him walk into any Alaska bar or honky-tonk after quitting time, and say, "I have a warrant for . . ." and just watch everyone jump out the window. It's never "I was born and raised in Alaska, lived here my whole life." It's usually something like, "My business partner faked his own death and then tried to kill me, but that was before my wife had her gender reassignment . . ." Basically Alaska is the cold-weather Florida. It's Florida without the Jews. The state capital should be spelled "Jew? NO!"

I'm not in love with Sarah Palin but I was completely fine with her "Drill, baby, drill!" message. We can do that easily without screwing with the caribou. And fuck the caribou anyway. What did they ever do for us? Can you imagine the horror of living in a caribou-free world? I can and I'm fine with it.

But now we have guys like Mark Ruffalo picking up the blowhard actor/environmentalist torch from Marty Sheen, except Mark is bitching about fracking. Well, here's my message back to Mr. Ruffalo and all the other actors weighing in on this issue. How about some answers? If you've got some ideas, I'm wide fucking open. But until then how about you shut the fuck up. Ten years ago every celebrity was an expert on AIDS; now they've all become experts on "climate change." We should put all these blowhards in front of windmills and power the country with their hot air.

That's why I'm naming as Secretary of Energy the Dyson vacuum guy. I feel like we need some new brains on this problem. Someone without opinions or the need to blog about them who is just going to crunch some numbers, invent some new technologies, and get us away from the people who burn us in effigy every day. Hell, maybe he can come up with a way to extract natural gas without hurting the environment or losing suction.

I know what many of you are thinking. What about solar, wind,

biodiesel, etc.? I'm fine with all that alternative energy stuff on paper, but it never adds up to shit on planet Earth. Solar might work if you're in the Nevada desert, but what about everyone up in not-so-sunny Seattle? Biodiesel sounds good but I think it will be bad for childhood obesity because the VW microbus you're driving behind is pouring the smell of fries from its exhaust, reminding all the kids it's time to hit the drive-thru. And as with solar, wind power needs to be captured in batteries and we certainly don't have our battery technology sorted out.

ASSAULTED BY BATTERIES

Shit, never mind the industrial batteries for wind and solar, we can't even get our household battery shit sorted out. My house, like many of yours, has the battery drawer. The other day I needed some new batteries in the remote. So I went to the drawer and found that my wife had recently stocked up. Sounds good, right? Except that what I saw when I opened the drawer were literally nineteen nine-volts; forty-nine of the second least useful, the C battery; and forty brand-new, still-in-the-package size Ds. There aren't enough flashlights in the world to need that many Ds. But no AAs. *Zero*. Then just for salt in the wound there was a bushel of assorted small, flat batteries that looked like pocket change. You know, the kind that if you go to Home Depot looking for them they tell you to head over to the hearing aid store.

Not only do I have issues with the batteries, I've got issues with the battery hatch. There's the simple design where you have to push your index finger in and the window just pops open. Then there's the one that takes the micro Phillips-head screwdriver to open. If you took it to an optometrist, he'd say, "Sorry, I don't have a screwdriver that small." Why do the batteries have to be locked away in a vault?

My kids are out of the phase where their toys take AAs; they're now in the AAA phase with all the small electronic stuff. Do we really need AA and AAA? That's like creating a bra size between A and B. Anyway,

there were many nights when they wanted their dinosaur to walk around or whatever and the batteries were dead. After using a steak knife to pry open the battery hatch and figure out what kind it took, I headed to the battery drawer to come up double-A dry. The rug rats were freaking out, so I was facing the moment all men fear. I had to take the AAs out of the universal remote. It's the same feeling as putting a dog down. You're on the verge of tears. "I'm sorry, brother, I've got to power you down. It's Sophie's choice, I don't want to do it, but I have to. As soon as those little shits fall asleep they'll be back in your belly in no time and we'll be watching *SportsCenter*."

My point is that if we can't even figure out the best battery plan for my kid's toy truck, why do we think we can develop it for our national alternative-energy needs? So we remain tethered to the Middle East. It's like we have the greatest arcade in the world but the switch that powers it is on the other side of the planet being watched by a guy who hates us. It's a sad statement that in terms of bad ideas that stuck around way too long, the Berlin Wall has fallen but we're still lining the pockets of the Saudis—if they even *have* pockets in those robes they wear.

WASTING OUR MOST PRECIOUS RESOURCE

But, in closing, the real energy being wasted in this fine land is the mental energy. We're all just wasting our brainpower on Hollywood gossip, pampering our pets, or figuring out ways to get more government checks. If we could all just wake up and take care of shit, I wouldn't have to spend my life turning off your lights and irons, and we could all put our mental energy toward solving our literal energy problems.

3

THE DEPARTMENT OF TRANSPORTATION

Buckle up for some anger. I have a LOT of thoughts about our transportation system and what to do to get traffic moving again. Of course I do. No one who lives in Los Angeles could feel anything but outrage when it comes to traffic-related issues. But it's bigger than that, it applies to our country as a whole. This nation was built on the automobile. Our economy is tied to our ability to commute to work and to move products efficiently. When the government slows us down, it slows down our economy. Our roads are our nation's veins and our cars are its lifeblood and the government is stopping our economic heartbeat.

After Antonio Villaraigosa (a.k.a. Tony Villar) ended his tenure as L.A.'s mayor, Barbara Boxer, one of our senators, had the balls to say that he would be a "terrific" transportation secretary. She actually used the word "terrific." Someone needs to buy that bitch a dictionary. She's off her

fucking rocker. Unless she meant it in an over-the-top way like when an adult with special needs ties his first shoelace: "That's *terrific*, Eugene. Terrific." Is she high? This would be like announcing Chris Christie would do a bang-up job as the head of the President's Council on Physical Fitness. Or maybe he spent so many years humping Telemundo reporters and not focusing on traffic that he's fresh for the job. He hasn't run out of ideas because he's never had any in the first place, like a slot machine that hasn't paid out for ten years. Either way this is another in my long line of examples of "Stupid or Liar?" Barbara, are you a complete bullshitter who is saying this because you and Tony are both Democrats and you want some cred with the Hispanic community, or have you had major head trauma?

List after list names Los Angeles as the worst city for traffic. One named it as not the worst in California, not even the worst in the country. The worst in North America. The entire fucking continent. Nothing in America should be worse than anything in Mexico. But we managed to find something. Go, team!

You want to know another statistic about how bad it is to drive here? Nationwide, hit and runs account for 10 percent of accidents. In L.A. it's 50 percent. Half the accidents here are hit and runs. At first I didn't believe this, but then I realized everyone I know has been hit at some point and the guy has taken off. So if I'm a little fired up about the topic, now you know why. Let me take you through the hit list of traffic-related issues that my Department of Transportation will tackle immediately.

ROAD SIGNS

The first thing my Department of Transportation will do to speed shit up will be to stop slowing shit down. This is especially bad in L.A., but is a pretty universal problem. Drivers spend so much time rubbernecking at stupid road signs and people being pulled over for nothing violations just to fill the coffers of the city government that traffic is constantly slow

or at a standstill. If we could eliminate those distractions, we'd all get to work on time and get this economy going again. This is no joke. Think about all the lost productivity that comes with people going zero miles per hour listening to "Asscrack and Backsack in the Morning" on their daily commute. We should all be out there driving like champions.

Here's one way to tell if you're driving how I want you to—nay, how America *needs* you to. Whenever I drive my dad around, I see him mashing his feet into the floor mat. The old man is using imaginary brakes because I'm driving so hard. When your passenger is trying to stop the vehicle with his feet like Fred Flintstone, this is the ultimate tip of the cap. That's how we all could be driving and should be driving if The Man would stop slowing us down with his bullshit.

When it comes to slowing down, one of the sources of my outrage is the signs warning about construction. I have no beef with the signs themselves. I'd like to know that there is construction coming up. I would just like to know about it *before* it's too late. The placement of these signs is moronic. If you have a sign that says there is construction coming up, it needs to be placed BEFORE the exit you could take to avoid getting mired in it. It does no good to warn me about the construction while I'm sitting in the traffic caused by said construction. This would be like hitting someone in the face with a football, counting to ten, and then saying "heads up."

Another sign that I often see is the unknowingly ironic WATCH THE ROAD. There is a giant electronic sign twenty feet above the road telling you to look at what's twenty feet below it. Which is it? Should I read your distracting sign or do what the distracting sign is commanding me to?

I'm not sure if this has made its way across the nation yet but we have a new sign in SoCal that is both superdepressing and superuseless. All along the roads you'll see digital signs reading HIDE IT, LOCK IT, KEEP IT. We have used taxpayer dollars to remind our citizens to take their phones, laptops, etc. and hide them under the seat or in their jacket and

then lock their car. Thus they'll be able to keep these valuables out of the hands of the animals that roam this city. That's where we are here in L.A. Public-service campaigns about how to prevent assholes from breaking your window and stealing your GPS. I saw one of these signs in front of North Hollywood High, by the way. My alma mater. Good message for the kids: "If you're one of the three students at North Hollywood High who is not already headed for a life of crime and would like to keep your stuff from getting stolen, here's how." This sign should just read FUCK IT. YOU'RE ON YOUR OWN. Hey LAPD, I have a sign I'm going to put in front of your police station that reads PREVENT CRIME. DO YOUR FUCKING JOB.

The other thing we use these digital signs for is to show drivers how fast they are going. You know those ones that say SPEED LIMIT and, below that, YOUR SPEED. If only there were some way *within* the car to tell me how fast I'm going! Maybe I should invent a "pace-ometer" or "speed gauge" of some kind that could go in the headrest. No, wait, in the dashboard. Shit, I'm going to be a billionaire with this idea! Idiots. This is what we're spending our money on, stupid signs everywhere telling me I'm going four miles an hour faster than the speed limit, which was set in 1939? I already know how fast I'm going, thanks. Actually going above the speed limit happens so infrequently in this town that when it does, my mind is blown and I always make note of it.

I used to take the 10 Freeway to the 110 Freeway to the 101 Freeway home from *Loveline* in Culver City every day. But every once in a while when I got to the 10–110 exchange, traffic would come to a standstill because for whatever goddamn reason the 110 was closed. All the traffic would eventually be dumped off in South Central. For those of you not familiar with the area, think *Boyz in the Hood* or the L.A. riots. The thing that drives me crazy is that on the way there I passed three big electric freeway signs with a bunch of the aforementioned bullshit slogans, or worse, nothing at all. There was ample opportunity for me to be warned that the 110 was closed, but I was not. Signs exist to pass on

information. That is their purpose. They could tell me that the 110 was closed, but instead they're used to make sure that I know BUZZED DRIVING IS DRUNK DRIVING. (By the way, I'd argue that if buzzed driving is drunk driving, then sober driving is buzzed driving.)

The granddaddy of all time-wasting, slow-everyone-down road signs are the ones for the Click It or Ticket campaign. This is how fucking stupid our traffic officials are. We've got traffic in entire cities ground to a halt and we're reminding everyone to put their seat belts on. First off, whether you decide to go headfirst through your windshield in an accident is your fucking business. Second, this multimillion-dollar campaign is totally unnecessary because every car produced or imported in the United States after 1973 is mandated to have a light-up placard and a chime that goes off every three seconds when your seat belts are not fastened. If every pair of slacks produced in the last thirty years had a buzzer and a light that went off when the fly was down and somebody floated the idea of Zip It or Clip It, I would crack him with a folding chair. Yet we have lighted road signs all over our freeways telling us to do something that puts our car into an epileptic seizure if we don't. I want to find the guy who came up with this and give him a prison-style beating with a pillowcase full of soap bars. Hold him down, Private Pyle–style, and just beat the hell out of him. We don't need a Click It or Ticket campaign. We need a Move It or Lose It campaign for the road.

Ironically the one sign that would speed everything up is the one that appears in many other parts of the country but not in Los Angeles, where we really need it. A fan from Portland tweeted me a picture of a road sign he sees on his commute. It features two cars that look like they're from the fifties that have gotten into an accident, and reads "Fender Bender? Move Vehicles to Shoulder." I later heard that in Houston they have a similar message on their big lighted signs, the ones that we in L.A. use to tell people inaccurate information about how long it's going to take them to get somewhere they're not heading. ("Oh, it's fifteen minutes to Topanga Canyon? Great. I'm not going there but thanks for slowing

everyone down to look at that message.") In Houston the slogan is "If It Steers, It Clears." This is a simple solution to a ubiquitous problem: a minor fender bender causing major rubbernecking, slowing everything down. Usually it isn't even a fender bender. It's a bumper thumper. No one is hurt, merely two dickheads doing eleven dollars' worth of damage to each other's "Who Rescued Who?" license-plate frames. But they've decided the world must come to a stop while they take pictures of the crime scene. First off, if we are all going to slow down for this nonsense, we should have the right to egg the people when we drive by and see that our commute has been lengthened for no fucking reason. I'm a two-time winner of the Toyota Celebrity Grand Prix of Long Beach. I've seen more than my share of accidents and been involved in a number of them as well. One racer will plow into the wall and the ten cars behind him will then smash into each other. Well, the race is then over, right? Nope. Everyone pops it into reverse, untangles their bumpers, and finishes the race. Or think about the police chases you see on the news. Eventually the cops throw down the spike strip and the gangbangers try to get away with sparks flying off their spinner rims. With that in mind, I think that the two Honda Civics that traded a little paint going 14 mph can pull over to the side and let the rest of us get to our destination.

So God bless you, Portland and Houston and all the other cities that have these signs. In my administration this message will be made into a national campaign. Why, you ask, isn't this nationwide already? I'll tell you. Because it's not something a politician can run on in an election. They can't brag about them like they can about crime statistics. So they don't care. When I had lieutenant governor of California Gavin Newsom on the podcast, I asked him why we did not have these signs in California. Not only did he not have a good excuse, he readily admitted he hadn't even heard of them. You are the lieutenant governor of a state where, and this is a true statistic, $1,300 a year is wasted in productivity and fuel per driver because of traffic. He never heard of them?! This is what government does! This is a larger issue than just slowing me

down on my way to the strip club. This is about waste. We have plenty of multimillion-dollar campaigns that do *nothing*. This is the essence of government. We'll take your money and still do nothing to solve your problems.

Our current government doesn't give a fuck about transportation. They only give a fuck about making money. When it comes to synchronizing the traffic lights and cutting down on that lost time sitting in traffic, they don't have the IQ for that. But when it comes to stuff that makes them money—chickenshit tickets, parking meters, and speed traps—they're all Lex Luthor. They turn into diabolical mad geniuses.

The prime examples of this are the so-called smart parking meters. These were recently installed in Santa Monica, and have sensors to detect when you've pulled away so they can reset and not allow the next person to take advantage of the three minutes you have left on the meter. Why is it that the streetlights are the same ones our grandparents enjoyed while driving their Hudsons but parking meters are something that came out of the mind of Steve Jobs? Improvements that help us are too tall an order, but stuff that makes them money keeps getting smarter? When are we going to say enough is enough? The government is putting its collective brainpower into the metal poles we're being raped with. That's what meters should be called from now on, "rape sticks." There is a news story every month and a half about new parking meters. We're not paying you tax money to think of ways to get more money from us. If there is time left on the meter because I overpaid, that's my money to do what I please with. I have purchased that time. If I choose to pay it forward to the next guy pulling up to the Starbucks, that's my choice. This is theft. The government is stealing the time and space I rented from them.

They know exactly what they're doing. They've done the math on the meters and how much change we carry around. I parked in Hollywood recently, put in a quarter, and got nine minutes. Why nine? They thought of this intentionally. There was an algorithm figured out to determine how long it takes people to accomplish the task they've parked

for; after determining that, they shaved off a minute so people are more likely to go over that time and get a ticket. I'm not paranoid, I just know our government and that when it was time to program the meters they decided to bust out the abacus and figure out how to fuck us.

When they don't have robot rape sticks to do their bidding, the government relies on old-fashioned cunts and dicks known as meter maids. Here's how you know meter maids have quotas. They do their job. Every government employee is slow as fucking glaciers and horribly inefficient at their job. If you need the Department of Water or Department of Power to come out to your house, they give you an eight-hour window. In L.A., you can get a ticket on your windshield during the time it takes to get out of your car to walk around to the meter. Everyone else on the city payroll moves like a tree sloth on a Quaalude. *Except* for the meter maids. They're hummingbirds on a double cappuccino. You think this is a coincidence? Do you think this profession attracts highly motivated self-starters? No. They move so fast because of quotas. And by the way, do you notice I don't refer to them as parking enforcement personnel? That's way too much respect for a job where you make nineteen bucks an hour ruining people's days. And to all of you who say, "But it's not their fault, they're just doing their job," I say, this: *Shut the fuck up*. That defense didn't work at Nuremberg and it's not going to work on me. You think someone got them in a headlock and dragged them out of high school and put them in meter-maid academy? They had choices. They could have taken paths with more dignity. Like crack whore or human trafficker. They chose to do this. Thus meter maids should garner none of our sympathy.

My assistant Matt "the Porcelain Punisher" Fondiler recently got a nice bullshit ticket for not turning his wheels toward the curb when parked on the hill where he lives. Twenty-five dollars. First off, as a car guy, I know that this law is antiquated. The vast majority of cars are now, sadly, automatic. So when it's in park it's parked. It ain't going nowhere.

Fifty years ago most cars were stick shifts and if it wasn't in gear there might be a rolling problem. But with a modern automatic there is no way to leave a car in gear and get the keys out and walk away, so there's no fucking way the car could roll down the hill. The superbullshit part was that this was on the weekend. For what else do you have city employees working on the weekend? Go ahead and attempt to get the Department of Public Works to come out and turn your power on during a weekend. Fat fucking chance.

The government clearly isn't interested in catching criminals. They're interested in collecting cash. Let me give you two examples. My buddy and writing partner Kevin Hench was driving to work via Laurel Canyon Boulevard one day and off to the side he saw a motorcycle cop with a radar gun and a walkie-talkie. This dude was clocking speeders and then radioing up to his cohort on the top of the hill, who was then pulling over the supervillain in the Hyundai Sonata who dared to go over the speed limit trying to get to work on time. That's how bad it's gotten; cops don't even bother to chase anymore. They have a two-man sting operation.

Then, on a recent trip up the 101 Freeway to a vintage race at Laguna Seca, I passed at least seventeen cops. The California Highway Patrol was out in full force. None were chasing down Bonnie and Clyde. They were parked off the side of the freeway in tall grass, lying in wait. Like a lion about to pounce on an unknowing gazelle. I wouldn't be as pissed if they were out trying to capture drug runners or a guy with a teenage runaway duct-taped in the back of his van and just happened to nab me while I was going ninety. But they were just hiding in the weeds like a sniper. These are the heroes we need more of? This is why my taxes go up? To pay for more guys to attempt raping my wallet instead of catching the guy attempting to rape the chick jogging in the park?

But here's how I knew there were so many cops hiding and why I never got a ticket. Radar detector. I had one on my dash and it was

going off like a fucking pinball machine. I recommend these for everyone. First, there's the practical reason. These things cost the price of one speeding ticket, probably less if you factor in the 10 percent hassle charge of getting pulled over, showing up for a court date, and shit like that. For the price of one ticket you'll save yourself from getting ten and you'll get everywhere you need to go a hell of a lot faster. I think you should be able to rent them when you get the SUV from Hertz. Because, be honest, you do a lot more speeding when you're not in your own car or on your own turf, right?

Second is the symbolic reason. These cops are sniping us with their radar guns. Well, turnabout is fair play. You've got radar. Okay, I've got radar too. How do you like it? This is a cold war, motherfuckers, and we didn't fire the first shot. We used to call cops pigs, but when they look at us they see piggy banks. If you're going to be pussies so that you can raise money, why don't you just put on a skirt and sell some fucking cookies like the Girl Scouts?

Because I know the states still need this chickenshit cash cow and would fight my administration's reducing the police force used to pick our collective pockets, I'm going to require the auto industry to include radar detectors in all new models.

As president, it's my job to pay attention to the issues that affect all Americans. You always hear politicians and folks in the media say, "This especially impacts the children . . ." or "This is really bad news for the Latino community . . ." Well, traffic is especially bad for rich white guys. You never hear enough about how things are impacting them, or us, since I am not going to pretend that I'm not rich, or white. I'm going to be the Al Sharpton of rich white guys and bring awareness to our cause. Think about it. If you're making nine bucks an hour, who cares if you're late? Nowhere you're driving to can be that important. Those dishes are going to get washed and that hedge is going to get trimmed. Plus you're

out under ten bucks for that time spent in gridlock. When guys like Jimmy Kimmel are stuck in traffic for an hour, that's millions of dollars lost. Plus rich white guys drive more expensive cars that are capable of higher speeds. All of that horsepower and the money spent to purchase it is being wasted by going slow. But if you spent two hundred bucks on something between a rusted-out Vega and a donkey with three legs, it's not like it could get far north of ten miles an hour anyway. So who gives a shit if you're stuck on the 405? It would probably be a relief since you're driving on retreads anyway. It's safer for you to stay at eight miles an hour. But for rich whitey it's a tragedy.

CARS

ManDate

My administration would also like to require some changes to cars themselves, for safety, efficiency, and just for fun.

First we need to get rid of airbags. I know what you're thinking. Airbags have saved countless lives! True, but maybe we've come to rely on them too much. People would be much more careful behind the wheel if instead of airbags out popped spiked Prussian helmets. Right now if we T-bone a UPS truck we act like we'll slide back into mama's womb. You know who doesn't text while driving—uninsured Mexicans behind the wheels of gardening trucks. They can't afford the ticket or the accident and they know they don't have airbags to stop them from going through the windshield. If there was something a little more painful slamming into us when we got into an accident than a pillow softer than a hooker's bosom, we might pay more attention when we fucking drive.

Or even better, how about a little Russian roulette? Some cars will have airbags, others will have a water balloon full of moose jizz. You'll never know what your model features until you get in the accident. Let's see how safe everyone starts driving then.

Next I'm going to remove the mandate that all cars have that glow-in-the-dark trunk release. Since 2000, all cars have been required to have a glow-in-the-dark T-handle that a person can pull to release the trunk latch if they accidentally get locked inside. I don't know how drunk or clumsy you need to be to lock yourself in a trunk, but if you've done this I either want you put down for your own good or I want to party with you. I guess it's intended for when your estranged drunken dad abducts you and starts heading for the border, so you can grab it and let yourself out. But if you take a close look at it you'll see why this bothers me.

First off, I can do the fleeing math. I don't need the help. I've got the BTK killer sitting in the driver's seat, I'm not going to let myself out and sit patiently on the bumper for the police to come. Second, this is one in a long line of mandates that doesn't make sense in certain vehicles. Take the Lamborghini Aventador—it has the trunk in the front and is only big enough to hold two loaves of bread, yet it would still be mandated that this handle be installed. The Chinese guy from *Ocean's Eleven* couldn't fit in that trunk yet this must still be on there? Dumb.

My Department of Transportation will also mandate that crash-test dummies need to be fatter. I've seen all that slow-motion footage of test wrecks. The dummies in those crashes have a far smaller body mass index than most Americans. This could tie in well with my get-rid-of-airbags

decree. Most Americans are now coming with their own airbags in the form of triple chins and panises. And now that I think about it, why are crash-test dummies always white? Let's get some brown ones in there. Especially for the DUI simulations.

Next up for elimination—the miles-until-empty gauge. This seems like a great idea—your car telling you how far you can go on the gas in the tank. Everyone has been waiting for this thing since cars were invented. But it's so wildly inconsistent that it does far more harm than good. You start your car up in the morning and it says thirty-one miles left. "Okay, I can make it to work and back," you think. But then as you back down your driveway it drops to nineteen miles. So you think, "Okay, I'll have to fill up on the way home." Then it stays at nineteen miles for your entire commute but as you pull up to your parking spot it drops to three. Meanwhile you know that the closest gas station is four miles away. Uh-oh. Then as you start up your car at the end of the day, the display shoots back up to eleven, but when you pull out it drops back to zero again and you shit yourself as you hypermile it to the next gas station. Of course you get there with plenty to spare because you can circumnavigate the globe with this thing on zero. Where do you get those extra miles from? Do they get added in for good behavior? Is it a gift from the gas fairy?

ManDate What really needs to happen, and what I'm going to mandate as president, is that every gas tank should have a heel in it. Like the heel of a boot. This will be a reservoir containing exactly one gallon of gas. No more, no less. Do with it what you will. Drive home or drive to the Grand Canyon. You know what your car gets gas-mileage-wise. I know you have one gallon once you hit E on the tank. You do the math yourself.

I also strictly forbid the use of all steering-wheel covers. The entire

point of a steering wheel is grip. Covering it in fake sheepskin or shag carpeting, as my mom did in the eighties, isn't going to help you grab the wheel in case of a skid. Plus, they look stupid.

And finally, as far as car names, I'm going to require a little more truth in advertising. No one who lives in Malibu has ever driven a Chevy Malibu, nor has anyone who's been to the French Riviera driven a Buick Riviera. There has never been a celebrity behind the wheel of a Chevy Celebrity. And if you drive a Ford Esteem you cannot possibly have any for yourself. But it turns out 89 percent of male escorts do drive an Escort.

DUMB-ASS DRIVERS

The major problem with our highways and byways (and by the way, on the "byways," do we need both? I think just highways will do) is not the cars or the road signs or even the cops. It's the drivers. Everyone is tuned out, distracted, and apparently not very interested in getting to where they're going in a timely fashion.

I know profiling is a dirty word nowadays, but it can save your life. It's the greatest gift we have as humans. There are sea snakes that take on the color of the poisonous ones so the other creatures of the deep will fear them. They've taken on the *profile* of another creature. We need to be able to assess quickly, by appearance, what is a threat and what is not. But there's too much of a racial element to it these days, and people are scared to admit they do it all the fucking time. Well, when it comes to driving you have to profile too. There are certain tells that make it clear when someone is a shitty, tuned-out driver that you need to get around. I saw a guy in front of me recently who had his gas cap open, with a stuffed animal sticking out of it. I pulled into the next lane and got past him with gusto. Another telltale sign that the person in front of you is going to maintain a full ten miles below the speed limit is when you can't see their head above the headrest. That means they're either old, Asian,

or are the cholo who drives with his seat fully reclined. Either way, stay away.

You also have to factor in make, model, and year of their vehicle. There is a stretch of the 110 Freeway on my way home from LAX that is a rolling museum of some of the shittiest, least road-worthy cars imaginable. We play a game every time I'm driving this run on the way home from a gig on the road. My driving companions and I try to identify cars that cost less than five hundred dollars. Sadly it's not a very difficult game. These are not just eyesores, they are a hazard on the road. I was recently stuck in gridlock. When I got to the source I saw that it was a stalled-out, twenty-five-year-old Aerostar minivan with a baker's dozen of Mexicans inside. It included a primered fender held up with a tampon string. It had stalled out in the left lane and the cops were running a zigzag traffic interference around it so it could be cleared. If you're driving a piece of shit like that, you have to drive in the right lane so you can easily pull it over in the inevitable event it throws a rod. When you have a car that's driven the equivalent of a trip to the moon and back and your radiator hose was formerly attached to a lawn sprinkler, you should be fined if you break down. We need to start shaming these traffic jams waiting to happen. That's a new law in my administration. All drivers of cars that cost less than eight hundred dollars according to the *Kelly Blue Book* shall be painted with a scarlet *S*.

Here's a handy list of warning signs of the worst people on the road. Some are tuned-out menaces, others are just assholes. *Be alert*, and if you see this on a vehicle close to you, *get away now*.

STICK FIGURE FAMILY: I hereby decree that you are allowed to accelerate to ramming speed every time you see a minivan with a silhouette of the family and their names on the rear window. We get it, you didn't pull out. Is that information you really think I'm interested in? I know you're a parent. You're driving a Plymouth Voyager with two hundred thousand miles on it; do you imagine I'm behind you thinking, "Who is that gay

entrepreneur?" Even worse is the theme family. Oh, you're into snow-boarding? Oh, you've got cats? Oh, they've all got Mickey ears, they must *really* love Disney. You know what I love? Driving more than fifty-three miles an hour. How about a stick figure depiction of your family moving the fuck over and letting me get to work on time?

COP AUCTION MOTORCYCLE: One time I was driving home from *Loveline*. Because I did this drive all the time I knew the traffic patterns. Drew and I were talking to each other on our cell phones as we would often do on our commute home and I said to him, "What's with all this traffic? It's never like this." There was a wall of cars, like a rolling start at a NASCAR race. I looked down the road a little and saw a motorcycle cop. All the L.A. drivers who've been traumatized like a battered wife and were scared shitless to pass were slowing down to fifty-two since the cop was going fifty-three. But because of my hypervigilance, I could tell something was off. So I started to thread my way through the crowd. When I got up close on the guy, I saw, as always, that I was right. The first thing I noticed was that he wasn't wearing cop pants. This was just some douchebag who bought the bike at the cop auction.

This should be illegal. This is impersonating a police officer. He had the black-and-white Moto Guzzi, the two-tone helmet, and a leather jacket. When they auction off these cop bikes they should have to be painted orange like a squirt gun so people don't get confused and start driving like Grandma when he shows up.

More importantly I want this guy drawn and quartered on the floor of the Staples Center. And I want his soul to go to hell. And if hell has a sauna in the basement that's where I want this bag of shit to go. These guys know what they're doing and they need to be destroyed.

A little side note on motorcycle helmets. As president, I'm not going to enforce helmet laws. If you want to spread your brains on the pavement, that's your prerogative. But for those who are going to wear a helmet, I'm banning the flat black color. I've never understood why this is even an

option. It's not just the heat absorption boiling your cranium, but why are you trying to make yourself invisible to girls who are texting while driving?

MOTORCYCLE INTERCOM COUPLE: I understand riding a motorcycle and carving up a canyon, but the guys who turn their motorcycles into Winnebagos are a breed of cat that I can't get my head around. They've got a loaded Gullwing and retractable training wheels and they've got their 250-pound old lady in the trailer attached to the back with the helmet intercom system going. There are guys in Hummers that get better gas mileage and have worse surround sound systems. I could not imagine having a bucket on my head with a direct voice line to said bucket on my wife's head for a six-hour trip to San Francisco. I'd steer into oncoming traffic or jump off and roll over the cliff of the Pacific Coast Highway into the sweet relief of silence on the rocky shore below.

CALVIN: You see a lot of Calvin from *Calvin and Hobbes* on the back of cars and pickup trucks. On the back of one truck he's dragging a cross, on the next one he's pissing on the Chevy bow tie. The kid's got a lot of range. Either way, whether you love God or hate Chevy, how about you keep it to yourself and stop using poor Calvin to do your white-trash bidding.

And since we're beating up on the honkies right now, the guy who tries to turn his average workaday pickup into a monster truck is a special kind of asshole. I call out whitey on this one in particular because white guys go high with their vehicles while Mexicans go low, but white guys are going way too high in my opinion. In general pickup-truck guys tend to be the worst offenders in the "hey, look at me" category. People who drive pickups really want you to know what they're into, whether it is the Jet Ski in the bed or the gun racks on the back.

ANNOYED HEAD SHAKE: You've all had this happen. You're slowly and cautiously backing out of a driveway but there's a van or a cube truck parked to one side and you can't see oncoming traffic. Then as you get farther out

you see someone coming, so you hit the brake. They go past you without any incident, but as they pass you get the slow down with the head shake. You know that "what kind of animal would attempt to back out of his driveway during daylight hours?" look. As if to say, "What's wrong with you? No traffic cones? No motorcycle cop waving traffic through? No guy in an orange vest holding a flashlight? You're just flying out of your driveway willy-nilly at the breakneck speed of zero miles per hour?!!!"

I like it when the head shake continues well beyond the point you could view it. As this dick drives off into the sunset you can see him still shaking his head. He'll be doing that until he's safely parked in his spot at work fifteen miles away. Shit, he'll probably be doing the shamey-shamey-shake all through his day at the funeral home or Kinkos. This has got to be confusing for the people a little ways down the road who are walking their dogs or delivering mail and don't know why he's pissed off. "Why is this guy disapproving of my mail delivery? I'm just trying to put food on the table for my family." Maybe this is why mailmen "go postal," they're constantly feeling judged by guys who are still shaking their head at me, the monster who attempted to back out of his own driveway.

REST-IN-PEACE WINDOW DECAL: This is something we see on the roads of Los Angeles that you readers in Wisconsin probably aren't hip to. What I like to call "the rolling memorial."

Now, I don't want to tell the Latinos how to grieve but here's how us white folk do it. We bury our loved ones, shed a couple of tears, then we get together, have a couple of drinks, and talk shit about that person. Then we move on. I lost my grandmother a few years back, I didn't duct-tape her urn to the roof of my Audi.

Plus we do not do a lot of flattering math when we see these. When we pull up and read *In Loving Memory of Chuy 1992–2011* and think, "Jeez, he was only nineteen," this is not followed by the thought "War hero. Must have died in Afghanistan." Nope. It's usually "Gangbanger" or "Tunnel collapse, muling drugs in from Tijuana."

The point is, I'm depressed enough as it is. It's Saturday and I'm sitting in bumper-to-bumper traffic. I just passed a mural on the side of the freeway covered in graffiti and I'm listening to Lady Gaga on the station I used to do morning talk on. I'm sorry to hear about Chuy's untimely passing but what the fuck do you want me to do about it? Should I pull up, roll my window down, and say, "I didn't know Chuy personally but judging from the rear window of your Ford F-150 he seemed like a hell of a cat. Please accept this floral arrangement I bought from Chuy's cousin when I was getting on the freeway."

MULTIPLE BUMPER STICKERS: There is a simple equation with bumper stickers—the more you have the crazier you are. Half the messages on bumper stickers, like the memorial decal, are something I can do nothing about. For example, "Bring the POWs Home." Who do you think is driving behind you, Chuck Norris? Do you expect me to call my wife and say, "Gas up the Huey and pull the sleeves off my shirt, I'm bringing

our boys back home!" And it's not like I'm going to pull up alongside you and say, "You've probably not heard an alternative viewpoint on this but a lot of those guys signed up for it, they weren't drafted, and many were having sex with underage Vietnamese girls. Just saying."

Worse than the "Nothing I Can Do About It" bumper sticker is the "Fuck Off and Die" bumper sticker. I've literally seen a bumper sticker reading "Fuck Off and Die." I don't even want to get into the head of this guy. My question is for the woman living with him. Why is she not stopping him? Like when my stepdad showed up for a funeral in a red Members Only jacket. Why didn't my mom say, "John, we're going to a funeral, not a NASCAR event. You're one beret away from being a Guardian Angel. Go find something black and attempt to be a human." More importantly if the government can hand out chickenshit tickets for no front license plates, shouldn't telling me and my family to fuck off and die be a traffic offense? That's hate speech.

There are different variations on this theme, all of them telling you you're an asshole but really showing that they are, like "I'm a Bitch, but I'm Not Your Bitch," "Expensive but Worth It," and my favorite of all time, "Yes I Do, but Not with You."

VANITY PLATES AND NOVELTY LICENSE PLATE FRAMES: A lot of times vanity-plate guy is also the bumper-sticker guy. But there's something slightly worse about vanity-plate guy. Bumper-sticker guy could have slapped those on there when he was drunk or bought his piece of shit with the bumper stickers already applied. Vanity-plate guy went to the DMV and paid extra to let you know a little something about himself. Vanity plates usually fall into two categories. Half of the time I end up asking the person I'm driving with to help me decode them like I'm on *Wheel of Fortune*. There's a ton of this in L.A., directly tied to the narcissism of show business—"CR8IV," "INTHBIZ," "4CTOR." Except the only thing any of these creative geniuses has ever written was their stupid

vanity plate and the only thing they've produced is outrage in me. I recently came across someone who apparently lives in the hills near me because their vanity plate read "HILDWLR." And the frame around that plate said "On a Clear Day I Can See Forever." I've got to admit mixed feelings on that one. I don't know if I love this person or hate them. Either way, I quietly want to be them. Kind of like how I want to be the person who taps the shoulder of the guy who's got twelve items in the ten-items-or-less line and says, "Excuse you?" Don't you feel like these people are happier than you? I have the same hilltop view but I don't care about it nearly that much. I wish I got the same pleasure out of my success as this person and wanted to proclaim it, literally, from the hilltops.

But that person was actually successful, they lived in the hills and drove a nice car. I've seen a bunch of bedazzled license-plate frames lately. Just eight bucks' worth of fake plastic rubies hot-glued around the frame. Are you trying to fool us into thinking you're classy with something you purchased at a kiosk in the mall? "Wow, she's so rich she has a king's ransom attached to the back of her Taurus!" Just like the chick dating "Fuck Off and Die" bumper-sticker guy, I want to interrogate the boyfriend of this chick and find out why he lets her leave the driveway. I recently pulled up behind someone with a license-plate frame that read "Not Spoiled, Just Well Taken Care Of." She was driving a bone-stock Camry with cloth interior.

Then the other day I was on the 134 Freeway and got behind a middle-aged woman in a sea-foam-green Prius. First off, I don't understand that color on a car. That color is only good for guys like Robert Blake to wear as jewelry when they get into their seventies. But even more egregious than the color choice was the license-plate frame. It read "My Other Car Is a Yoga Mat." What is so noble about yoga that we need to know about you and your special relationship with it? Were any wars ever won with yoga? Did yoga save any children's lives? Why do I need to know what you're into? As the great Dana Gould said on the podcast

when I told him about this, "I like masturbating but you don't see me with a license-plate frame that reads, 'My Other Car Is a Blurry Fist.'" We get it, you do yoga and are therefore better than me. Just drive, bitch.

And that's the point with all of the above. Why do I need to know you? Do you think I give a shit that "Tennis Is My Racquet" or that you're the "World's #1 *Dr. Who* Fan"? Is any of this helping us get to where we need to go—literally or symbolically? How is your bumper sticker helping you get ahead on the road of life? I'd like to convene a panel of very successful people to have a sit-down with the "Fuck You" bumper-sticker, stick-figure-family-decal, and novelty-license-plate-frame people. I'd moderate it. I'd ask, "Bill Gates. How many bumper stickers do you have? None, okay. And your net worth? Thanks. Bill Gates, everyone. Up next, Richard Branson. Richard, what do you drive? And how many bumper stickers do you have? None as well? Interesting. And net worth? Thanks. Okay, now the guy with the decal of Calvin pissing on the Yankees symbol and the light-up-skull license-plate frame. What's your net worth?"

Not only are these people losers, they're dangerous. They're so concerned with you getting to know the real them via their car exterior they've forgotten the point of a car is to fucking drive. And we need to fix that. As you know, I'm a big proponent of shaming. Your car's horn is a mobile shaming device. It lets the idiot in front of you know to wake the fuck up and get going. I'm even into the "honk-through," where if I'm the third car in line, the douche at the tip of the spear is refusing to turn right on red, and the guy in the middle in front of me won't honk, I give him a blast from the horn to attempt getting him to honk at the zombie at the head of the line. I had this happen recently where the guy was sitting at a green arrow. Not just a right on red, he had a green arrow telling him to go, and he was still sitting there. When I honked at the guy in front of me he flailed his hands like "What do you want me to do?" I want you to honk, you asshole. Let's get going. I eventually leaned on the horn so it was blaring nonstop like I was in a car accident and my

lifeless corpse was laying on top of it. What I'm saying is that if someone honks at you, you're supposed to react in some fashion. It means something is wrong. Just sitting there until the light turns green as if you were deaf is not the plan. And that's why I'm furious with Union 76 gasoline, who now has a billboard campaign all around Southern California telling drivers DON'T BE A HONK-AHOLIC. They have cute little phrases like GIVE A HOOT, DON'T TOOT, WHY THE LONG BEEP?, and BLAST TUNES, NOT TOOTS. Bullshit. Honking is an incredibly useful tool, especially here in L.A. We need twenty times more honking, not less. People here are driving around texting while high on prescription medications. Honking is necessary. It is a right. It is American.

That said, just like the right to bear arms, it can go too far. That's why I've come up with an idea I think will make people's lives a lot easier, would aid our great nation, and wouldn't cost a penny. We need a double honk. The honk that takes back the honk we just laid out.

Not too long ago I was behind a big SUV. It was a Denali with a smoked window in the back and I couldn't see through it. We came up to the light and the driver of the SUV wasn't venturing out into the intersection to turn left. But I didn't want to honk because I couldn't see around his mammoth SUV or through his window and thus couldn't tell if George Clooney was in front of him in his Smart Car. So we just sat there and the signal went from green to red and I realized there was no Clooney, no one in a Miata, no clown car. Nobody turned left. This guy was just zoned out and the signal cycled. I thus gave him the "C'mon, buddy, wake up. We both could've made that one" extend-o honk. He clearly felt bad because when the signal then changed to green again, he not only went into the intersection, he went WAY into the intersection as cars were coming down the hill toward him at a fast pace. It was dangerous. He was trying to thread the needle in between a Winnebago and an M1 Abrams tank. I wanted to hit the horn again so I could tell him not to worry about it and that he didn't need to get T-boned because of my honk but I thought that would just make it worse.

That's why we need the take-back honk. Nine times out of ten when you honk at a guy you get flipped the bird. But every now and again you find the guy who is so racked with guilt that he attempts to commit hara-cari. So how do they know it's the take-back honk? We agree on it, as a society and a culture, like we did with the peace sign, the middle finger, or the Macarena. So henceforward the quick double "toot-toot" is the take-back honk. The honk withdrawal. If we get on the same page about this the next time I do it, the Denali in front of me it won't end up in a ball of flames.

AN AUTOMOTIVE CALL TO ARMS

Let me end my discussion of traffic issues with a story. You know how politicians always choose some random Joe Six-Pack to tell a story about to illustrate a big sweeping idea? Especially during town halls or big speeches? Well, I'm not doing that. I'm going to tell you a story about me, Joe Twelve-Pack. Something happened to me that should happen to no American. As president, it will be one of my goals to make sure that our transportation system is fixed so that this fate never befalls one of you.

Driving used to be cool. Think of all the songs written in the fifties and sixties about cars and driving. You could learn more about engines from the Beach Boys' "Little Deuce Coup" and "Shut You Down" than four years at a trade school. How about now? It makes me sad when I come across young men who have no interest in cars or driving. The world has turned upside down. Girls today will say things like "I'll blow the guy underneath the bleachers but I don't want to *date* him." And guys will actually utter the phrase "I'll drive in a pinch, but I'm not interested in getting my license." I think it's because they're spoiled. When I was a kid I wanted to drive because I wanted to flee. I had nothing to keep me at home. Kids today don't want to drive because in their room they have sixty-inch plasma TVs and a laptop with their social networks and all the porn their cocks could desire.

Even sadder is that one of these "I'm not into driving" guys is in my own family. My sixteen-year-old nephew Casper was staying with me for a couple of days and I had been teaching him how to drive. He had a learner's permit and had only driven two times. I wanted to make a man out of the kid and that means getting some time behind the wheel of a car with some real horsepower, in this case 510. I took him out on the freeway on the way back from the podcast. When I asked how he felt about it, he said, "I'm scared."

I decided Casper needed a little more time in the captain's seat and since this was over the Fourth of July weekend—we were going to an event and Uncle Adam was probably going to have a little too much Mangria—it was a perfect opportunity to teach him the very important skill of designated driving. But when it came time to leave the beach, head through the canyon, and go back to the Carolla compound, Casper balked. It was too dark and he didn't feel comfortable. I felt a little too "comfortable" but did the math and decided that a buzzed me was still a better driver than a scared teen with too little experience and too much power under the hood.

We eventually got onto the freeway and at a certain point I felt the familiar rumble of a flat tire. We had a blowout. Because L.A. is such a piece of shit the freeways are constantly full of nails, broken glass, pallets, mattresses, hooker corpses, and other debris. (Ironically we had taken my wife Lynette's car because mine had a slow leak from a screw in the side-wall of the tire and I didn't want to risk it.) So I pulled off onto a street to change it. As with all things in my life, when it rains it pours. I had fucked up my back earlier that week and there is nothing worse for a bad back than changing a spare tire. Leaning into the trunk, undoing all the mechanisms, lifting a twenty-pound tire without being able to bend your knees followed by a lot of squatting, yanking, and wrenching is a chiropractor's description of hell. So I really needed Casper to step up to the plate on this one. I asked him to grab the lug wrench. His response made my heart sink. "The what?" I swallowed the vomit that had just come up

and showed him what it was. I then told him to put it on the lug nuts. Again, "The what?" After I woke up from my trauma-induced coma I told him, "Okay, just hold your phone up so I can use it as a flashlight." This was about ten at night. He had no problem with that.

This being a German car made in 2012, it doesn't come with an adequate jack, just a cheap little piece-of-tin shit. Sadly they don't even expect people to change tires anymore, so they don't bother giving you the equipment you need. Well, this jack did half the job. It lasted long enough to get the car up and get the tire off, but then it popped out, leaving the whole car pretty much flat on the ground (what I didn't realize until later is that the rear passenger-side tire was blown too).

We were parked across a residential driveway and of course if I block someone's driveway for ten seconds, that's when they pull up. And it's never a guy named Murph who has a garage full of tools and is going to pitch in and help out. It was an Armenian who when I asked if he had a flashlight said he didn't. I was thinking, "I bet if I offered you ten grand to produce a flashlight you'd go back into that house and find one damn quick." He wasn't a bad guy and he even went into his trunk to get his jack, which, of course was the exact same jack I had. We tried anyway. No go. By now, my buzz was completely gone.

So I told Casper to call UberCab. But they needed an account number, billing address, etc. It's now midnight and pitch-black and I don't have the zip code or mailing address of my money manager where all of that shit goes. So we tried calling Audi Care, the car is under my corporation's name. I told Casper to just call a regular cab while I backed the car up to clear the driveway. I did this—making the most horrible sound a car guy can hear as the bare brake rotor ground against the pavement. But as I got out, just to really rub it in, I looked up and saw the "No Parking 10 A.M.–12 P.M. Street Sweeping" sign. (Later, when I told Lynette about this nightmare, she asked, "Why not leave a note telling them you couldn't move the car because of the tire?" I thought, "How quaint. Thanks, Aunt Bea. It must be great to be you, to think that this

is going to work with the L.A. parking gestapo." I could have a rusty piece of rebar going through me impaling me on the hood of the car and they'd work around my blood and dying moans to leave a ticket on the windshield.) So, having no real option, we left the car with the intention of getting up early and getting back there before the meter-maid vultures started picking at the carcass. Casper and I took a cab home, got in about 1 A.M., and I had a highball to soothe my aching back, bleeding knuckles, and broken soul.

The next morning the alarm went off. Ugh. Brutal. I woke Casper up but he said he didn't want to go. He even had the balls to say, "I'll be here when you get back." I made him get his ass up, explained that he needed to come so that we could go, jack up the car, fix the tires, and he could follow me back home. When I finally convinced him, we grabbed the floor jack and two cans of Fix-A-Flat from my garage and headed out. My bad back was still screaming, by the way. We got to the crippled car, I jacked it up, sprayed the Fix-A-Flat, and we were on our not so merry way. But not before I gave Casper a lecture about the drive home. He was still nervous about going on the freeway alone, and since letting a kid with a learner's permit drive alone is quite illegal, we agreed to take Ventura Boulevard back.

Let me explain how crazy this is to those of you not from L.A. We pulled the hobbled car off the freeway on Tampa Boulevard and needed to get back to my house off of Barham Boulevard. This is a fifteen-mile trek running completely parallel to the 101. On the freeway it'd take you twenty minutes with average, a.k.a. shitty, L.A. traffic. But on Ventura with average, a.k.a. shitty L.A. traffic, jaywalkers, and more stoplights than exist in the entire state of Iowa, you're looking at about an hour.

So I told Casper to stay right behind me, I even pointed out two cars and said, "That is the distance. That is the follow length." I warned him that with all the lights on that street, if he's not right on my ass, I would lose him. He said he understood. I got in the damaged car in case the tires went bad again; Casper was in my car. Immediately he got

a football-field worth of length between us. I know I usually drive like a madman but I was keeping it cool, and he was just driving like an old lady. I kept looking back in the rearview, leaning out the window, giving him the "go go go" signal, and eventually the "bring it in" signal, closing a gap between my two hands while steering with my knee. I was only going about twenty-seven but I kept leaving him in the dust. So what was already going to be a long frustrating ride down Ventura turned into the Trail of Tears.

But let me take this story and make a broader point, because it covers so many of the things that make me angry about our country and our transportation system. You have a generation that has been so beaten by the way our system treats motorists that they've decided to give up on the idea of driving entirely. You've got a government so criminally unfocused that there is enough debris in the road to blow two tires in one shot yet has laser accuracy when it comes to ticketing cars in the street-sweeping zones. You've got a citizen unwilling to help his fellow citizen. And finally there's me giving Casper my "keep it tight" lecture and about seventy thousand "bring it in" hand signals to no effect. That's my life in a nutshell. I constantly tell people the right way to do things and they give me the "got it, boss" and then proceed to ignore me.

And that is why I'm naming MMA legend Chuck Liddell as my Secretary of Transportation. As you've read, I've got a lot of ideas on how to get our cars, and our country, moving again. I just need an enforcer. Chuck is going to be a very hands-on Secretary of Transportation, personally delivering some ground and pound to all the dickhead drivers and city traffic officials trying to fleece their citizens.

NASA

As budget cutter in chief, I hereby declare NASA gone. I'm going to put all of that money and brainpower toward fixing problems here on Earth. Let's figure out how to get a car from L.A. to Vegas without stopping for gas first, and then we can focus on a manned mission to Mars. I just don't really give a shit about space. Space used to be cool and interesting in the sixties. Astronauts used to be guys with buzz cuts named Buzz who shot down MiGs in Korea. But now it's a lot of short Asian chicks who run a nursery growing sprouts on the International Space Station. If I had the chance to go, and as president I would, I'd skip it. I've seen too much IMAX footage of space. I feel like I've already been there. I just don't think I'd care. If I got on Richard Branson's space plane, I'd instantly start complaining about the fiesta mix on the flight.

Don't get me wrong, I'm into the technology. The space shuttle is an amazing feat of engineering. It weighs 172,000 pounds—that's eighty-six

tons (or for you brothers, thirty-five Escalades), has a wing span of a mere fifty feet, and manages to enter the atmosphere in South America and glide to a safe landing in the California desert on a strip the size of a starlet's pube patch.

Though I do think we could do a better job naming the shuttles. The last one was called *Atlantis*. Why would you name your spacecraft after an underwater city? What does that have to do with flying through space? And the bottom of the ocean is not the image you want to conjure up when thinking of a space vehicle. You should hope that the thing doesn't end up where its namesake city is.

We recently retired the shuttle. And when we did, we missed an opportunity. First off, it should have been parted out to the American public. They paid for it. But not you, welfare queens. You didn't put anything in there. But guys like me who paid a shitload in taxes should have been able to go in there and get the ashtray or something.

But the real lost opportunity was when the old shuttle *Endeavor* was hauled through L.A. to place it on display at the California Science Center. They shut down a bunch of streets and towed it to its new home at the museum. If I had been president then, I would have dictated that instead of taking it straight there, the shuttle should have been taken for a spin down the 405 Freeway, and right up to the Mexican border, for a victory lap. I would have just parked it on the American side of the border at Tijuana and said, "See this? This is what happens when you study. Maybe if you lighten up on the drug running and putting heads in duffel bags, you might get one of these yourself. Drop the machete and pick up a mechanical pencil. Oh, and this is old technology. We're done with it. We're mothballing this one. It's grown tiresome going into space all the time. Have you ever been? It's awesome."

4

THE TSA AND THE FAA

As your president, I would order some major adjustments to air travel. My Transportation Safety Administration will speed up security lines and my Federal Aviation Administration will address my problems with pilots and planes.

One of the reasons I'm running for president is because I have lived as a citizen of the city that to me epitomizes all that is wrong with America. Much like the traffic in L.A. motivates me to fix our entire transportation system, let's not forget the clusterfuck passing itself off as an airport known as LAX. Rated as the most inefficient airport as far as security, and ranked number one for most stolen luggage in the country, LAX is the jewel in the shit crown of Los Angeles transportation. Having to fly in and out of that disaster nearly every weekend would make anyone want to run for president in order to fix our air travel system.

Let's start with the TSA and airport security.

(And to all you political junkies thinking, "Wouldn't the Transportation Safety Administration be the purview of the Department of Homeland Security? Shouldn't this go in that chapter?" I say fuck off. You try writing a book.)

AIRPORT SECURITY

The newest among my many complaints about airport security is that now, when you step into that scanner, not only are you probably getting cancer, there are two footprints to tell you where to stand. But they look like shoe prints from the 1940s. They have a heel and sole mark. It's the print from the shoe a reporter would have worn during Prohibition along with a hat bearing a tag that said PRESS. Please, TSA, don't insult me with your old-time wingtip shoe print. I don't see a lot of guys who look like Fred MacMurray about to get on the flight. Plus you've already made me take my shoes off. Why are you taunting me? You've painted shoes to imply a utopia where we're treated like adults and get to keep our shoes on. Every time I'm standing in that tube I find myself angry. "Man, look at that. That fake guy got to keep his shoes." So as president, I'm sending someone from my TSA out with a can of Krylon to paint over every single one of these shoe prints.

If the TSA hadn't already ordered the removal of the "backscatter" type of scanner, I would have. Not only because it sounds like porn terminology ("We'll do some DP and finish with a backscatter") but also because it raises privacy concerns. These were the type of scans that made everyone look like naked ghosts. Manning that station is the one TSA gig that when the manager comes up to you and says, "It's time to take a break," you'd be like "No, I'm good, boss. The Pepperdine women's volleyball team is on their way to Denver. I've got a Lunchable. I'll work through." As much as I don't want the TSA agent to judge my junk, I can't help but wonder how much money it must have cost multiplied by the number of airports in this country taking these out must of have

cost. These aren't slot machines. They weren't paying for themselves. I hope we had the brains to sell them to countries that respect their citizens even less than we do.

Speaking of respect, in a Carolla administration the TSA would treat the citizens with a fuckload more of it. I might just be extra-jaded because my home airport is LAX—ground zero for rude, incoherent, condescending, light-in-the-IQ-department screeners. I travel the country extensively and have had emotional whiplash from the screeners in other airports. I was going through Logan in Boston and was cheerily greeted with a joke and some talk about the Pats by three different people named Sully. At LAX, on the way out for that trip, when I asked the heavyset woman of color—I know, shocking—where the first-class line was, she grunted at me. Not "Right over there, sir," not even "Over there," not even "There." It was a guttural "Unnghgh." I couldn't even get a second syllable out of the cunt with the grunt (my favorite Dr. Seuss book, by the way). I'm in the middle of a maze of ropes, like a cattle auction, and she grunts at me like I'm the architect of the goddamn airport and should know exactly where I'm going. I have a first-class ticket. I'm not wearing a ski mask. How about a little fucking respect? I asked my traveling companion, Mike August, what the fuck was going on. I said, "Who's in charge? Don't they have supervisors?" He replied, "Yeah, the chick who was grunting in that position eight months ago." Sad but true.

When they're not being rude they're being redundant and condescending. You probably already know I'm obsessed with the extra verbiage that cops and other authority figures throw out. This goes for the supersingsongy airport security guy too. I'm okay with the part where they tell you to take your computer out and empty your pockets. But they don't just say, "Empty your pockets." Oh no. They work in security so they have to say it ninety-seven different ways. "Please empty your pockets. That means everything out of your pockets. All items must be removed from your pockets." As if there is some confusion. And I don't need the list of all the potential items that I could have in my pockets.

"That includes change, ChapStick, sunglasses, hard candy, old-timey pocket watches, pocket fisherman, Hot Pockets . . ." Are we going to break it down into specific coins too? "All nickels, all dimes, all quarters. If you have any of the Sacagawea dollars you need to remove those as well and place them in the tray." Then it continues. "That means both your front and back pockets, completely emptied of all items." As a kid, did you think when you grew up you'd be spoken to as if you were still in preschool? When did it become okay to treat adults this way? And what do these guys do when they get home? "Honey, I'm going to need you to pass me the salt. Not the pepper. The salt in that glass shaker in front of you. Not paprika from the spice cabinet, the white granular substance that is in front of you currently on the dinner table . . ." I'm just saying, I'm not an idiot or a four-year-old. You had me at "empty your pockets."

If I was a terrorist I would show up at McCarran Airport in Las Vegas, pull up a chair, and just watch the endless maze of dejected travelers waiting in line, removing their belts, their shoes, and their dignity. I would sit there with a satisfied, victorious boner like an arsonist staring at his forest fire thinking, "Look what I've done. Look what I've created."

I call out the Vegas airport specifically because it is uniquely horrible. When you factor in the time to get through there and get a cab to your hotel, it's faster to drive from L.A. to Vegas than it is to fly. At certain times of the year it might be faster to walk. The C Gate at McCarran Airport in Las Vegas is a little slice of Ellis Island right in the middle of Clark County. There should be a plaque that reads, "Bring Us Your Morbidly Obese Degenerate Gamblers and Weekend Strippers Yearning to Be Drunk." Plus walking through the Vegas airport wearing earbuds is depressing. I know everyone thinks about Vegas as a party and a good time. To me, because I've studied a little psychology and know human nature, when I see a guy chain-smoking and feeding nickels into the slot machine and sucking on the oxygen tank behind him, I think, "Buddy, give me a hit off that oxygen because I'm gonna jump off the top of the Luxor. Looking at you, I am fucking depressed."

I'm also convinced that those hieroglyphics the TSA agents scribble on your boarding pass are either meaningless doodles they use to kill ten seconds to make it seem like they're doing something, or are secret codes to their buddies later down the line that translate to "Check out the fake tits on the chick behind the guy with the unibrow."

But as commander and idea man in chief, I've come up with a way to make airport security fun and profitable for all Americans. This is an idea I'm in love with. Are you paying attention TV executives? Consider this a pitch. It's a competition reality show. We've all seen the guy who's late for his flight, just made his way through security, and is rushing to get to the gate and trying to get himself together after taking off the belt, emptying his pockets, taking out the laptop, losing the shoes, removing the hat, and being grunted at by Mo'Nique's angrier sister. Well, this show is about families competing to see who can get their shit back together while on the move and dodging other passengers. You have to get from the end of security to your gate in the fastest time. Imagine it. Mama's yelling at the kids to get their knapsack packed up, Grandma loses a shoe on the way. And then when they get to the gate the judges start giving them the once-over, twice. That's when the scrutineering begins. (And yes that is a word. Like "behymen.") They're taking a look at Dad's belt saying, "You missed a loop." Then Mom starts yelling at Dad, "This is why we practice, Bill." It'll be great. It's *Family Feud* meets *Wipeout* in an airport. I call it—*Terminal Velocity*.

I now have some directives for the airport itself, once you get past security.

First of all let's address the jetways. These are the telescoping covered bridges that we all get herded down and then stand in like cattle while we wait to get on the plane. From now on they must have temperature controls. I don't think that's too tall an order. I just flew six hundred miles per hour in a vehicle with free Wi-Fi and satellite TV to get to this cigar tube, I don't think a little temperature control is out of the question.

It's always somehow ten degrees hotter or colder than the ambient temperature outside inside of these things. How the fuck is that possible, and could you possibly have a worse advertisement for your city? You're welcoming people to your town after they've been stuffed on a plane for several hours and their first impression is that they're either walking into an oven or a freezer?

A connected little side note to all the local cabdrivers who pick me up at the airports when I'm doing out-of-town gigs: You're not likely to have my ass grace your metropolis again if, when I comment on the extreme temperature, you say, "That's nothing, you should come back in August when it's really hot" or "You should have been here in January when it was really cold." I shit you not, in the same year I went to San Antonio, where I was sweating through my shirt and got the "This isn't that bad" comment, and to Winnipeg, where the temperature reading on the cab was literally one degree, and was told, "This winter has actually been pretty mild." At the same time don't inform me that if only I'd planned to come there three weeks from now, the leaves would have turned and it would be gorgeous. Why are you telling me something that's not on the menu? You know I can't enjoy it. I'm not coming back in three weeks. And don't tell me what I just missed either. I don't need to know that I was one day late for the Thirty-second Annual Big Titty Blowjob Festival.

Next up, everything on the other side of security should be a 24/7, international-waters, duty-free orgy. I can't stand when I'm on the road and I've gotten up at 4 A.M. to get the first flight out and there is nothing open at the airport. I want a goddamn Bloody Mary. Yes, it's 7 A.M. here but it's 10 A.M. where I'm going, so why the fuck not? It's an international airport. You've got people coming from China and Australia and God knows where else and everyone's body is on a different clock. There should be places to get breakfast, lunch, or dinner and, of course, booze, at all times. If I could get on my plane, which is a mere thirty feet away,

I could get that Bloody Mary. So why not at your bar? It's a bar, right? And the one time I attempted to break long-standing Carolla tradition and purchase something from the duty-free shop—I think it was a case of cigarettes the size of an accordion—I was shut down because I didn't have an international ticket.

That said, there are a lot of stores at the airport that we can do without. I was at the Detroit airport recently and noticed a Swarovski crystal store. Who is this for? Most of the people passing through that airport are stretching their budget to pick up something at the Cinnabon. Are there a lot of CEOs doing their Christmas shopping at the Detroit airport? I suspect this is why the city is bankrupt.

I tell you one store the airport does need. I call it the Lazy Dad Store. This is the place where all the tuned-out lazy fathers like me can grab something for their kid on the way home. The store would have different sections with items sporting the name and theme of all major cities. So when you arrive home in Chicago from a trip to Phoenix and you've forgotten to pick up something for the kids, before you leave O'Hare you can hop to the Phoenix section of the Lazy Dad Store and get them a pencil case with a cactus and a Road Runner on it.

As far as traveler behavior at the airport goes, when did it become a youth-hostel/hobo flophouse? Whenever there's a delay we all become cats and the airport is our living room. People started sleeping at the airport. Back in the day a guy would just tip his trucker hat over his eyes and lean back a little. Now the airport is a tent city with people using hoodies for pillows, draped across three chairs or laid out on the floor. I'm not talking about leaned back, I'm talking sprawled out. Shoes off, eyes closed, sweatpants on, boner up. I don't know if there's any other public space where you'd be so comfortable letting people watch you sleep. When my wife drags me to Target and I've got a half hour to kill, I don't curl up in the housewares section. Could you imagine doing this at Sears? "Honey, you shop, I'm going to bivouac in the husky section."

I swear I went to the airport bathroom once and saw a guy stretched out on one of those Koala changing tables.

And the plane you're about to get on is a flying sleep machine. There is nothing you can do in that confined space other than sleep. If you want to lean back with your eyes closed, that is the perfect venue. Collapsed like a rag doll in front of the bathroom so I have to step over you to take a piss is not a good plan.

Plus the airport has a hundred bars in it. There's no better place to kill time. There's a TV showing the game, there's beers on tap. Go in there, you idiots, and cut the shit.

And finally, I have a new law for all airport decor. Do not freak me out or bum me out before I get on the plane. Just before you get to security at Burbank airport you are greeted by this:

Do you know who that dude is? That's right, Amelia Earhart. Famous lesbian/aviator. Best known for two things—eating pussy and CRASHING AIRPLANES. Nothing instills confidence in the flying public like a large bronze depiction of a woman who ditched her plane in the Pacific never to be seen again leaning against a part that broke off upon impact. Sure, let's rub her for luck before getting on the twenty-seven-year-old Southwest regional jet. The only saving grace is that I don't think the majority of people know who this is when they see the statue. I imagine a lot of people tell their friend, "Yeah, I'll pick you up at the airport. Let's meet next to that statue of the dude with the paddle."

A side note as I closely examine this picture. Let's talk about the placement of the velvet rope. If you can stand outside of the velvet and lean against the object the velvet rope is protecting without touching said velvet rope, then the parties involved, you have done a piss-poor job of velvet rope placement. And how is this protecting anything? You have three tons of bronze lesbian. Do you think there are some mischievous teens who are going to pull Mom's minivan up to the curb, try to run in and steal the statue, and go, "Damn, a velvet rope. Didn't see that one coming. Let's just go to the park and light a hobo on fire."

PLANES, PILOTS, AND PASSENGERS AND HOW THEY PISS ME OFF

There are many changes my FAA will make to planes themselves, the pilots, and more importantly the passengers' behavior in the cabin. This stuff has always driven me nuts as a passenger. Once I'm president, I'll finally get the chance to fix them.

First up, pilots. What's up with that giant leather rolling briefcase, fellas? I have to gate-check my backpack but you can roll something the size and weight of a microwave on board with no problem? It's like two

leather cinder blocks stacked up with a handle. Those things don't exist anywhere else. What do you guys keep inside of those anyway? It can't be that important. And how much shit do you need?

As the agency that oversees pilots from now on, my FAA mandates that they get all of their crap into a fanny pack. You're just going to flip on the autopilot and start talking shit about the stewardesses anyway. Attorneys appearing before the Supreme Court don't lug that much stuff.

As far as the in-flight announcements, there will be no more of this "If you look out the left side of the plane you can see the Grand Canyon" bullshit. Besides the fact that only half the people are on the correct side, the wings block most of the view, and if you're in the middle you have to push aside the guy who's asleep in the window seat to see it. Only 15 percent of the passengers can take a gander at the landmark. And, oh boy, it's the Grand Canyon! Never seen a picture of that before. The announcements are never like "If you look to the right you'll see an oil rig on fire and, those of you in the aisle seats, Cheryl the stewardess is going to pull her top over her head."

I also don't need to know how many knots the wind is coming out of the northeast at when I land in Burbank. There's nothing I can do with that information. "Oh, the northeast? Damn. I lost a bet to the guy in 21C. I said northwest." Pilots do this because they know that we don't know what the fuck knots are. And guess what, pilots, we don't care.

Also cut it with all announcements coming from "the flight deck." Not anymore. I decree that we now must return to calling it a *cockpit*. I know this is because the female pilots and stewardesses didn't want to work in something called the *cock*-pit. I don't get it. Anytime you want to give me a job in something called the "titty-room," I'm there.

Plus I really don't need to know where the crew is based. No more, "On behalf of your Atlanta-based crew . . ." It's not like the passengers

are thinking, "Oh, Atlanta. Good people down there." Again, this is not information I can use. Just wake me up when I get to my destination or when you start serving booze.

And please stop apologizing. "We know you have a lot of choices when it comes to air travel. Thank you for choosing Delta." It's like you're admitting your airline sucks. I don't do that at the end of my shows. "I know you have many choices in comedy. I want to thank you for coming here instead of seeing Dom Irrera at the Laugh-ateria."

And finally, enough with the first names on the pilot announcements. It's part of the "everybody's a winner, there's no ranking" bullshit going on in our country. I want my pilots to be Captain Gilmour and First Officer Winters, not Captain Bill and First Officer Dan. These guys are in charge of my life, I don't want the guy who I could smoke a joint with. Between the first names and the "we know you have a lot of choices" apology, I'm not feeling very confident when the plane gets up in the air. Maybe that's the point. If we all fear that the flight crew has no idea what they're doing, we're more likely to double down on the in-flight booze.

Now, on to the passengers. I understand, but don't appreciate, that every flight has gone from business to casual. Remember when people would dress to travel? I'm not talking about a bow tie and a pocket square, but they didn't fly like it was laundry day and they were heading down to the coin op. I've flown Southwest and seen a guy wearing cutoff sweats and flip-flops. It's not a Kenny Chesney concert in your backyard, you're leaving the state. Why aren't you at least wearing something with pockets? Don't you feel weird getting on a plane in a hockey jersey and huaraches? Part of the problem is that flights now are so cheap. You can get to Vegas for forty bucks. The people that were formerly taking a Greyhound or riding in the back of a pickup truck are now sitting next to you on an airplane. But the bigger problem is people have no regard for their fellow passengers.

And to that point, here are some new in-flight rules. Violating any of the following will now be grounds for opening the emergency door in midflight and tossing your ass out at thirty thousand feet, per my presidential decree.

1. **IF YOU'RE IN FIRST CLASS YOU MUST DRINK.** More than once I've had the guy next to me on the plane who doesn't drink. I hate this because it really shines a light on my alcoholism. I have to assume he's an air marshal or a terrorist because it's insane to turn away free booze. This, by the way, is why I'm going to name Alec Baldwin as my TSA director. I've never flown with the man but I'm pretty sure that he'd strictly enforce my mandatory getting-shitfaced-in-first-class policy.

2. **NO MORE USING THE BACK OF MY SEAT AS A HANDLE TO HOIST YOURSELF UP.** I'm trying to take a nap and the jerk-off behind me is yanking my headrest backward to get out of his chair. That's the small piece of real estate I'm renting to sleep upon, not the handle Grandma uses to get off the toilet. Here's my solution: All planes will now have the dangling loop strap you used to see on subways for people to steady themselves. They'll hang from the top of the cabin so you can lift yourself with that instead of my hair.

3. **ALL SEATS MUST RECLINE.** The closest I've ever come to being raped is sitting in that nonreclining last-row seat on the Southwest flight and having the seat in front of me lean back into my knees. I don't see why we can't just move every seat up a sixteenth of an inch so the back row can recline. Well, that nonreclining back-row seat is now illegal in my America. The problem is that the airlines are losing money and want to cram as much humanity into their vessels as possible, just like the slave ships of old. But unlike those Nubian warriors, we're getting fatter by the day. And ruder. This is a terrible combination, especially in a flying tin can.

4. **RESPECT THE AREA AROUND YOUR SEAT.** Even when you're not literally spilling over into my seat, everyone has become so narcissistic and horrible that they have no awareness of the limited space on the plane. I was flying back from Phoenix not too long ago and I was in that weird row near the exit door that only has two seats—an aisle seat and a middle seat with space on the left for the door. I sat in the aisle seat. The guy next to me was sitting with his legs spread out like they were the Hatfields and McCoys. It was like his balls hated each other. The space you have is clearly delineated by the split on the seats in front of you. This dick had his knee way past the Mason-Dixon line. I'm six two, so there's not a lot of room to begin with and he had the whole open space to the left for his overage. It wasn't like he was asleep or had his earbuds in either; he was wide-awake and taking up residence in my space and could hear me steaming. I decided, "Fuck it, I'll open my legs too," and pressed my knee against his as a signal. No response. I was thinking, "Are we seriously not going to have a conversation about this? Do you not feel the warm thing with a pulse mashed up against you?" I pressed more flesh with this guy than I did any of my high school girlfriends and he never budged. Remember when just clearing your throat was enough to shame someone? You have to hit people with an oar now. I feel like I'm in a staring contest with someone who has no eyelids.

It is nice when you can pit the fat guy against the rude guy. I was flying once with Dr. Drew and we hadn't booked seats next to each other. So when we got on the plane I asked the guy who was preventing me from being able to do a Bloody Mary–fueled complaint fest in Drew's ear the whole flight, "Excuse me, could you swap seats with me so that I could sit with my friend?" He just said, "No." No explanation. Just a straight-up "no." I then went to

my seat one row back. As I buckled in I saw a fat guy come wad-dling down the aisle. And when I say fat I mean if John Goodman ate Adele fat. The plane was rocking back and forth with each step. As he walked toward the row containing the cock who wouldn't switch seats with me I thought, "Please, dear God, let him sit next to that asshole. Please." It may be the one prayer that God ever answered because the guy plopped his ample carriage down next to the dick who now was regretting not moving. I shouted up to him, "Good. Enjoy." I'm not sure if the larger gentleman knew what I was talking about but the other guy got the message.

5. IF YOU'RE IN COACH, STAY IN COACH. I know a lot of you are think-ing, "Fuck you, Richie Rich." The truth is the vast majority of time I fly Southwest or JetBlue (of course, all of this is going to change once I am president!), neither of which has first class. But when I'm flying with an airline that does, I want the benefits that come with the extra cash I coughed up for the ticket. Having a lower passenger-to-toilet ratio is one of those benefits. I can't tell you how many flights I've been on where people from coach (or as us folks in the upper crust like to call it, steerage) push aside the mosquito net that passes for a curtain to come shit up the first-class head. I was on Virgin Atlantic recently and they had a magnet-tipped velvet rope separating the classes and someone came up, pulled the magnet from the wall, and waltzed right up to piss all over our seat. It's sad that we'll eventually get to the point where airlines have to hire a big black guy with a clipboard to work as a first-class bouncer.

6. YOUR BAGS GO IN YOUR BIN, NOT MINE. There is complete and utter lawlessness when it comes to the overhead compartments. I've had to gate-check luggage because someone put their stuff in my bin. Shouldn't this just be a given? The space above YOUR seat is YOUR space. The bin above MY seat is MY space. Why should I have to walk down fourteen aisles swimming against the current

like a salmon, fighting with the drink cart to get my neck pillow? This is a tightly controlled environment, they tell you when you can sit, when you can stand, when you can piss, and when you can drink. Yet enforcing this rule seems to be a nonstarter. When you rent a car you rent the trunk as well, correct? What if you got the car at Hertz and it was just full of someone else's shit? What if the dealer was just like "Yeah, I'm not sure whose hockey equipment that is. Sorry."

This is the micro version of the macro "narcissism is ruining us" argument I laid down at the beginning of this book. These are the same people who are asking the politicians what they are going to do for them personally, not the country at large. Nowhere is this scourge more evident in air travel than in the rise of dogs and bare feet on planes.

7. **KEEP YOUR FUCKING SHOES ON.** I shouldn't have to say this, but on my last three flights I've had bare feet come poking through between the seats. When did we get so simultaneously casual and disgusting? I blame this on the taking off of the shoes at airport security. We're so used to being barefoot now on the airport floor we just keep the shoes off on the plane too. So after mashing your bare feet into the used gum, sweat, and dirt on the security-screening-area carpet (ironically the world's most disgusting surface is the one we're forced to tread on barefoot), you then wipe them all over the seat I'll be occupying? No. And every now and again I'll see some special aeronautical assholery where the guy has somehow pulled off a yoga move and gotten his bare feet on the wall or ceiling of the cabin. Since I've been complaining about this, people have been tweeting me pictures of these atrocities. One was a guy turning the overhead light switch on with his toe, which is worse plane behavior than anything the nineteen hijackers did on 9/11. That guy should be raped with a rolled-up *SkyMall* catalog. One of the best pictures a fan sent was the guy at

a major airport—you could see the moving sidewalk in front of him and a 777 in the background—in the full downward-facing-dog yoga position, which in this case should have been called the Downward Facing Douche. His shoes were off and he was . . . wait for it . . . shirtless. He was in a major metropolitan airport, not the shitty detached garage he converted into a yoga "studio." If you count socks and shoes, he was wearing less than a third of his clothes. Someone should have taken a running start from behind him and kicked him in the nuts like they were going for a fifty-five-yard field goal.

This is not just an annoyance. This is a safety risk. The point of the "laptop case must be safely stowed safely" bullshit is because that case can get in the way if there's an emergency. What about the bitch in 28F who's taken off her UGGS and placed them in the aisle and has her bare feet on my seat. Is this not an impediment to me getting to the emergency exit? And is there a worse plan for you than to be barefoot when the plane catches fire or if we need to make an emergency landing in the winter? You'll be standing on the frozen tarmac of O'Hare in your bare feet. You'll be shoeless like John McClane in *Die Hard 1* but in the setting of *Die Hard 2*.

If you tried to go barefoot on a ride at Disneyland, they wouldn't let you. Why on a plane post-9/11? There are no laws on this because we could have never imagined this world. If you went back a century and tried to convince lawmakers at the time that this is something their successors would have to consider, they would throw down their top hats, shout "Poppycock!," and swing their pocket watch at your head.

Do you remember back when bare feet were disgusting? Back when we had something called a civilization? This barefootedness has crept up on us. We didn't make Dr. Scholl the surgeon general. This is just us becoming more narcissistic. Every time you go to the Starbucks or the smoothie place, you'll see the ass clown with

his bare feet on the table. I'm putting my bagel there in twenty minutes, man. What's your plan? You gonna put your tootsies up on the table, lean back, and grab a little shut-eye? The world is not your living room. I'd like to pick my nose wherever I want and on a hot day I'd like to just be in my Jockeys, but we have a society. So slide your feet back into your Crocs and stow them safely under the seat in front of you or I'm going to stow a size-twelve steel-toed work boot up your ass.

There are only two bright spots to all of this. First, if you're one of the many millions of males out there with a foot fetish, it's game on. This is the Golden Age. You must be walking around with a constant erection. Every flight and every Starbucks has turned into your Playboy Mansion. Second, this gives me an excuse to include my Crocs joke. Wearing Crocs is like getting blown by a guy. It feels great until you look down and realize that you're gay.

It occurs to me to that this non-shoe-wearing is the domain of rich white people. Blue-collar people don't do this. They might end up on a flight wearing a mustard-stained wife-beater, but they still have the dignity to keep their shoes on. This is the hipster dude working on the MacBook Pro while sipping a double-skim, light-foam, extra-hot soy latte or his performance-artist wife who boards the plane with her "service" dog because she has irritable bowel syndrome.

8. **JUST LEAVE YOUR PETS AT HOME.** That's my biggest plane pet peeve, and it's a literally a *pet* peeve. I was on a flight from Dallas to Tucson in first class and the woman next to me had a little mutt with her. If there's anything that says "first class," it's inhaling dander and dog farts for six hours. I put on an Academy Award–worthy performance, asking this woman about her dog, saying that I was interested because my wife and I were thinking about getting

another dog, but really I just wanted to make fun of her onstage that night in Tucson. I asked her what her "service dog" was for, and she said anxiety. Bitch, that's what the airport Chili's is for. Have a couple of "service beers" before the flight like me and other normal people. We all have a little anxiety before getting on a plane. I paid a bunch of extra money and I can't even get a Bloody Mary before the flight takes off, but this cunt can bring Benji on with her because she has a note from her doctor stating that she's a fucking nut job? It's a great society we've crafted. We've decided to bend over backward for these bat-shit bitches. That's what this is, a personality disorder. We should create a separate airline for these people—Narcissistic Personality Disorder Airlines. "NPD Air. Come fly the crazy skies." And how about that note from the doctor? Here's my rule—you should have to get a note from *my* doctor to bring your damn dog on board.

Ten minutes later, as the flight from Dallas was still boarding, the anxiety dog was standing in the aisle when another service dog came on board, heading to coach. This one was a seizure-alert dog. By the way, I asked Dr. Drew how a seizure-alert dog works, and he had no idea. When I wouldn't let it go, he thought for a while and said, "The dog, it can't predict a seizure, but maybe it would alert someone if the owner were having a seizure?" I'm not sure how that would go. The little shit would run up to first class start tugging at my pant leg, and I'd say, "What's that boy? The woman in 26B is having a seizure?" No, I'd kick the thing back into coach. But sure enough the seizure-alert dog and the anxiety dog started going at it. They were scrapping in the aisle of first class. I was about to ask the stewardess to break a hundred so I could throw down some money like Michael Vick.

Here's why this makes me want to rush the cockpit and bring the plane down. Fifteen minutes after we took off, I looked over at the lady with the anxiety disorder and she was fast asleep with her

canine companion sitting atop her ample gut. Meanwhile, I was getting yelled at by the stewardess for having my backpack on my lap. My backpack. This was a threat *so* great it had to be stowed under the seat, but two feet away her furry fart machine—which was the exact same size as my backpack—was happily breaking wind and spreading Lyme disease.

And now I'm seeing "Service Animal Relief Area" signs in airports all over the country. No smoking and no shampoo over 3.5 ounces, but there's a place for your pooch to take a shit after a long flight. Our founding fathers would never stop vomiting if they saw this. Like all problems in our society, I have come up with a solution: I'm going to have Dr. Drew write me a note that says I have a disorder and I can only fly when accompanied by my service pelican, Gilligan. Then, he'll just roam up and down the plane gulping down these little service dogs.

Other animals must be pissed when they see how we treat dogs. Possums must be like "All we do is get chased around with brooms. We're furry, we don't bother anyone. WTF?" My dog has a better life than 99 percent of the people on this planet. That's why coyotes eat little dogs: envy. They're scavenging out of Dumpsters, while Paris Hilton's dog gets carried around in a purse and onto a first-class flight.

There is a celebrity factor to this. I think it started with Richard Belzer a few years back. He was the celebrity-flying-with-dog pioneer. Then Kristin Chenoweth was in the news last year making a stink because American Airlines would not let her fly with her service dog. And dear, dear friend Illeana Douglas told me on the podcast about how she flies with her "emotional support animal." I also saw an episode of TMZ with Jane Fonda leaving LAX with her lap dog. This silliness always starts with celebrities and then spreads to the common folk. That's why I have another reality show to pitch. This one is probably good for a network like

Spike. When they test the structural integrity of jet engines, they use air cannons to shoot whole chickens into the impellers. My new show takes the lap dogs from celebrities on flights, puts them into air cannons, and fires them into the engines. I call it *Your Dog Is Fired*.

It isn't even just lap dogs anymore. I've seen people traveling with full-size German shepherds. People are now buying extra seats for Marmaduke-size mongrels.

This is the one time I think lawyers are going to be helpful. We're eventually going to get to the point where someone gets bitten, or there's an emergency and someone trips over a schnauzer, and then there will certainly be a lawsuit. That's the only way this is going to cease. And to that end, what about all the people who are freaked out by dogs, all the people who have been bitten? What if your anxiety prevention dog is provoking theirs? Can they sue you?

And that's the real point. I love my dog. You love yours. But I don't love yours and you don't love mine. The narcissism that allows you to think that your convenience and comfort is paramount and trumps everyone else's . . . We get it, you want to bring your dog everywhere. Just because you *can* do it doesn't mean you *should*. How about a little golden rule for your golden retriever? If you wouldn't want *everyone* doing it, don't fucking do it yourself.

What really concerns me is that this service dog idiocy is going to spread, just like the bare-feet epidemic. I already see it creeping in everywhere. Before there were just blind people who had the dog with the handle, and that was it. There were no emotional-support dogs, no fear-of-flying dogs. Now everywhere you look someone has a dog with them. Dogs at restaurants and in the mall. At some point soon I'm positive I will step in dog shit at a movie theater.

Yet ironically, and get ready for another antigovernment rant

here, the one place you can't bring your dog is the beach. This is the one public place I want you to be able to bring your dog. I was at the beach on the Fourth of July and saw the sign that tells you what you can't bring on the beach. It gets two feet longer every year. I found it ironic on the day celebrating our independence and liberty that we were being told by the government all the things we were not allowed to do. In the not-too-distant future our society is just going to get into a state where our kids have to pass through a detector like they have at airport security that will determine if they're wearing enough sunblock. Eventually we'll just have a sign that says FUN with a big red *X* through it. Of course among the list of no-no's like NO GLASS BOTTLES, NO SMOKING, NO FIREWORKS, NO KITE FLYING, was NO DOGS. Do you realize we now have a world where dogs are *encouraged* on aircraft, but if you bring one on the beach to toss around a tennis ball, you'll get ticketed? Do you like this direction for our society? I don't. I understand that every now and again you're going to step on a glass bottle and that's okay. Maybe put out some more receptacles instead of prohibiting the public—the people who own the beach and maintain it with their tax money—from enjoying it. I was at Hampton Beach Casino in New Hampshire doing a gig with Dr. Drew, and a fan came up to me afterward and pointed out the irony that we were in the state whose motto is "Live Free or Die," yet mere feet away on the beach there was a sign prohibiting dogs. Sixty-plus years ago many good men died on beaches at Normandy and Iwo Jima so that we could all enjoy the beaches of Malibu and Santa Monica. By not allowing citizens to bring their mutts there to toss around a Frisbee, you're trampling on those heroes' corpses.

5

THE DEPARTMENT OF HOMELAND SECURITY

Since 2011, that idiotic color-coded terror alert chart has been gone. That was the beginning, middle, and end of my argument for how dumb our government is. The idea that we come out with a safety system to let the public know what the threat level was, but then picked random colors to convey the threat level, is just moronic. There is no inherent order to colors. If I just laid out blue, orange, yellow, red, and purple on a table, you couldn't put them in an order unless you were trying to make the Romanian flag. For ten years we'd say, "It's a yellow alert," and everyone would ask, "What's that, guarded?" If you always need the explanation, what's the point in the fucking color? This is the worst color-based decision since UPS went with "What Can Brown Do for You?"

But now we have a hole to fill. As president, I would like to present a plan that is clearer and a lot more fun. I present to you my Baldwin-brother terror alert chart.

BALDWIN BROTHER TERROR ALERT CHART

DANIEL BALDWIN	**HIGH**	Attack imminent. All interventions have failed.
STEPHEN BALDWIN	**ELEVATED**	Threat can be contained but likelihood of religious-based attack elevated.
ALEC BALDWIN	**ON GUARD**	Things are usually okay but could go off unexpectedly.
WILLIAM BALDWIN	**LOW**	Pretty stable, nothing noteworthy. Forgettable, really.

A lot of my lefty friends got their panties in a twist over the Department of Homeland Security and the NSA listening in on phone calls when that whole Edward Snowden thing happened. I didn't give a shit and I still don't. I've got nothing to hide. If The Man wants to listen to me bitch on my cell phone about the myriad things that annoy me every day, they're not going to hear anything they couldn't hear just by downloading the podcast. And if they want to check my Internet browsing, they're just going to find a lot of searches for vintage race-car auctions and "big natural tits."

I think the government should be monitoring what's going on here at home. In fact, as president, I'm going to take it one step further. I'm going to commission a squadron of those predator drones we're using overseas and start raining death from above on some of the assholes here in the States.

Here is my list of people who deserve a drone strike. They may not be building any pressure-cooker bombs, but I consider all of them

domestic terrorists. If you're listed below I'd suggest heading to Canada as quickly as possible because I'm going to be sending some smart bombs to eliminate some dumb people.

CAMOUFLAGE WORKOUT GUY: I was at the YMCA to watch my son play some hoops and saw this jag-off. He was chugging away on the elliptical in full camo and combat boots. Like he was going to war on calories. When you're "in-country" you should wear camo, not when you're "in-lobby." You just look like a nutty white supremacist. Camouflage by definition has to look like what you're trying to blend in with. If you were attempting gym camouflage, you should be wearing a sweat-stained burnt-orange carpet. And the gym is a pickup joint. All you're saying to the coed on the treadmill next to you is that if she goes home with you, the sex is definitely going to involve a serrated knife.

YOGA MAT GUY: Speaking of working out: I saw this asshole on a flight.

This is the same type of guy who puts the Yakima rack on his Subaru or keeps the ski-lift pass on his jacket year round just so you know what he's into. He's got to strut around with the yoga mat rolled up over his shoulder like a quiver for the world's gayest archer. Here's how you know this is for show. He was flying to L.A. That's the fucking yoga mat capital of the world. He didn't need to bring it with him, they hand one to you when you get off the plane. It's not like anyone in Los Angeles is saying, "I'm looking for a yoga mat," to someone who responds, "Well, I know a guy who knows a guy who can hook you up. You'll have to meet him at midnight and bring cash."

"WHICH SEASON IS IT?" GUY: This is probably yoga mat guy's roommate. I see plenty of these shitheads in L.A., especially in the fall and winter. He dresses like it's cold and it's hot at the same time. The other day I saw a dude in UGG boots, cutoff shorts, a tight T-shirt with a scarf, and the beanie the guy from Spin Doctors used to wear. Is it winter or summer? Are we in Nova Scotia or Ecuador? Make up your mind, asshole.

Then I have to check my own outfit. What am I missing out on? I don't get it. Are certain parts of your body different temperatures? Are your balls smoldering hot and your neck icy cold? Which is it? You're wearing Daisy Duke's shorts and Mike Nesmith's hat. Pick one and go with it.

CHICK WHO FEEDS A HORSE BY HOLDING AN APPLE IN HER MOUTH: I know you're very impressed with yourself and want me to be jealous of the connection you're having with your horse. I have news for you. You could cut off a homeless guy's arm and staple the apple to it and the horse would just as happily eat it. You're not the horse whisperer, you're just an asshole.

PERSON WHO PLAYS THE NAME GAME: This happens all the time when I'm signing autographs after my shows. I get the person's name, she says it's Catherine. I ask, "Is that Catherine with a *C* or a *K*?" and she replies,

"Do I look like a Catherine with a *C*?" No, you look like a cunt with a *C*. How the fuck would I know?

I shouldn't have to ask at all.

In my America there will only be one way to spell any name. Catherine will always be with a *C*, Brian will always be with an *I*, Steven will always be with a *V*. And there will definitely be no Tarras with two *R*s like the one I met after a show in Reno, or Sera with an *E* like I met at the El Portal Theatre in L.A. I know what this is all about. It's parents trying to make their kid feel unique and special but what they're really doing is dooming them to a life of people fucking up their name and getting annoyed with them. Cut the shit. Your kid's not going to get into Harvard because you gave them a "special" name which consequently a hundred other white people in your town also thought was unique. Just fucking name your kid Dave and let him go out and carve a life for himself.

A close cousin to this public enemy is the guy who changes his name later in life. This jack-off decides at age forty to go from Chris to Christopher, or worse, Topher. Sorry, it's too late. You have two options, Chris or Douchebag.

BRACELET CHICK: I think there's a ratio—for each bracelet you add, you get 10 percent angrier. Let's ask ourselves this question: Which Janeane Garofalo did we like more—the zero-bracelet, funny, vivacious Janeane or the angry, skinny political one with a snow tire's worth of vulcanized rubber on her arm?

Or there's the bitchy postmenopausal friend of your mom with the huge wooden bracelets. It looks like she's wearing the plank from a tall ship around her wrist.

And what about showering? Do you spend an hour taking them off

beforehand or do you have to cover your arms with a garbage bag so they don't get moldy and give you a staph infection? At least with the Livestrong bracelet you just keep it on for a few days at the office until everyone knows you're better than them. But really, who are you trying to appeal to? Do you expect Ted with the corner office to think, "I was never attracted to her before because of her huge ass and sunken chest, but now that I see the eighteen bracelets dangling on her wrist I've got to make her my wife"?

BRACELET DUDE: Worse is the guy with bracelets. We are in full-tilt bracelet mode these days. I was sitting around on Sunday watching *Catfish*, as I'm apt to do. Both dudes on that show wear bracelets. Eighty-six percent of males under forty have bracelets now. Married men, single men, doesn't matter. If you're married, what are you even doing? Who is this bracelet for? Are you trying to attract your wife? She's obligated by law to blow you. It's on the books, look it up.

What about the assholes who wear bracelets? This isn't getting you any closer to vagina. This is a turnoff, trust me. I've talked to women. I don't know why I need to be saying this. Chicks need to man up and get the word out.

This has even invaded my own home. My son came home the other day and he was wearing a bracelet. We were doing our usual wrestling around and the bracelet fell off. So I started teasing him, "Oh, Natalia must have lost her bracelet because a little boy wouldn't wear one." And then I saw that he was wearing a necklace too. So I said, "I'm going to come over there and snatch that necklace your girlfriend bought you." And he paused, looked at me very seriously, and said, "My *boyfriend* got me this necklace."

GUY WHO LOOKS AT DING ON THE SIDE OF MY CAR AND ASKS, "WHAT HAPPENED HERE?": A fucking meteor. What do you think? Someone opened their door into me or I did something stupid. Either way, fuck off. This is the

same guy who wants to know how you got a zit, like you're going to say, "Well, I do this thing where I tape a canned ham to my face before I go to bed." To all of you assholes who do this, there are only two stories— the "I'm an idiot" version or the "the guy in the Costco parking lot is an idiot" version. But the real idiot is you for asking in the first place.

FERRET-ON-SHOULDER GUY: This is another asshole who needs you to see him. So he wears a ferret around like a scarf. You see a lot of these guys on Venice Beach, shirtless, with the ferret or a snake. Every now and again they'll double down on the creepitude and put on the Rollerblades. Because what you need is a large rodent or an anaconda coming at you at 35 mph atop a leathery shirtless dude.

GAY GUY WHO SUNBATHES NAKED ON APARTMENT LAWN: He's claimed the eight-by-eight-foot patch of sod in the front of his apartment building as his personal tanning booth. He's the forty-four-year-old set decorator who's waiting for his parents to kick off so he can own his first home. If he were really interested in a tan, he'd go to the roof, but then how would everyone driving by get to see his balls? God forbid this asshole get into his Prius and drive to the fucking beach. Hey dickhead, next time you are at the Rite Aid picking up your lube, why don't you grab a bottle of Mystic Tan and call it a day.

HOLIDAY JOGGER: This is the cockhole who decides he can't live one day like a normal person drinking and eating with friends and family. Doesn't matter if it's a holiday, he's got to get his jog on. The worst offender is the Thanksgiving jogger. Doesn't matter that rest of us real Americans are about to vomit up turkey with all the fixin's so we can make room for meringue, this guy has to get joggy with it.

I saw one on the Fourth of July. It was balls-hot out and I had a belly full of ribs and Sam Adams and this douchebag came sprinting by, shaming me.

I spotted the Halloween jogger too. She was bobbing and weaving through packs of kids dressed as Ninja Turtles and Power Rangers while she was dressed as a bitch with body dysmorphic disorder. It's fucking Halloween. Put down the sneakers and pick up a Snickers like a normal person.

A quick tangential Halloween-related mandate . . .

 ManDate In my neighborhood, the minivan will pull up and all the kids from the crappy neighborhood will cascade out. They cut in front of my kids, bogart all the Reese's, pile back into the minivan, and head back to their hood. It may sound cruel but I now mandate that you are forced to trick-or-treat in your own piece-of-shit neighborhood so you can see just how bad it is. There'd be a neighborhood council meeting at 8 A.M. the day after every Halloween to talk about fixing your combat zone. I bet your neighborhood would get a lot better real quick after a night of watching your kid step over a dog's corpse to be greeted by a toothless pedophile handing out candy corn from 1969.

But while I'm still down for a drone strike on the moving targets that are these joggers, I have a better solution that can make some money for my administration. My government will produce and sell a line of holiday jogging apparel that looks like street clothes—sweatpants that look like jeans and running shoes that look loafers. That way, as you jog by on a holiday, you're not shaming us. The only caveat is that at the time of purchase you must agree that every two hundred feet you'll shout out your dog's name. As you're chugging along you have to call out "Scrappy!!! Come here, Scrappy!!!" That way, if I'm holding my sixth beer in one hand and a pulled pork sandwich in the other and I see you jogging by, instead of thinking about my impending coronary, I'm thinking, "Look at that poor son of a bitch. He lost his dog. Wait till those Fourth of July fireworks start. The dog's gonna freak out and he'll never see it

again." The outfit will even come with a severed leash. This would work, right? It's genius. Or rather JEAN-ius.

I love predator drones. I'd like to decorate them like we did with the P-51s in WWII. We should put pictures of pinups on them just to further piss off the radical fundamentalist Islamic zealots who are being lit up in their SUV convoys. I also like the irony that the deity they pray to five times a day does nothing, but our unmanned eye in the sky is raining fire down on them. It's like a vengeful God that's assembled in Palmdale, California.

Beyond my list of targets, I don't have a ton of notes for the Department of Homeland Security.

Keep on keeping on. That department just needs a good manager to gather all the information, analyze it, delegate tasks, and be prepared for some long days and unexpected shit-hitting-fan action. That's why, as my Secretary of Homeland Security, I nominate Patriots coach Bill Belichick. He's clearly a good manager, can think on his feet, and has experience secretly taping and analyzing his enemy's patterns.

I could have gone with any NFL coach, by the way. Think about how much better football coaches are at their job than politicians. They study. There's a lot of sleeping in the office after watching hours of game film. Unlike the president, once the season starts you won't find these guys anywhere near a golf course. They're exquisitely driven and have to be the best because they're competing with the best. If a coach goes four-and-twelve, he's out. Then you have politicians who get up there and say, "At the end of the day there are a lot of hardworking people who are looking for jobs." Meanwhile the only jobs they're creating are for themselves. They're just campaigning all the time. Coaches keep their jobs by being good at them, not by spending all their time telling everyone they're *going to be* good at them. Coaches get reelected because they get results, not because they promise results. I don't care how many playoff

or Super Bowl appearances you've made, you're always a back-to-back six-and-ten season from being shit-canned.

Ultimately I'm not that worried about terrorism. I think we can handle it.

I want to explain something to all the wannabe terrorists reading this. We don't hail from a piece-of-shit nation like you do, where if you blow up one outhouse the whole country ain't right for the next five years. You think we think like you think. But we don't. We're too big and too powerful. You cannot fuck us up. We're better than you, we have backup plans. Take down the towers and we're up and running the next week. It's not like our credit cards didn't work on 9/12.

We don't pray to Allah five times a day, we go to fucking work. We have brains and we have books. We don't commit honor killings or throw acid on girls for learning to read. We have a civil society and thus an infrastructure that can handle your shit.

So try taking out the new Freedom Tower at Ground Zero. We'll build another one. And in the meantime we'll be fueling up the predator drones.

VOTER ID LAWS

I'm constantly accused of being a racist. One of the reasons is because I am. Also I'm completely for so-called voter suppression. I don't think asking someone to produce a valid ID at the polls is a hate crime. I understand that yes, there are going to be more minorities who can't produce ID, and yes, the people pushing this rule are always Republicans trying to keep people who aren't voting for them away, but these motives aside, it's still a good idea. I'm not into "big government" but I do think, post-9/11, anyone should be able to produce a government-issued photo ID when requested. This is compulsory. This is the bare minimum. Whether you're driving a Maserati or a tractor, if you get pulled over you need to show it to the cop. What can you do without an ID nowadays? Not much. You can't get a credit card, you can't get through airport

security, and you can't check a book out of the fucking library. Why should you be able to vote?

And who's the racist here? No one said *all black people* need to have ID. It's not a racial issue. The people making it a racial issue are the ones who are saying or, more accurately, thinking but not having the balls to say about those who don't have ID, "They're not up to the challenge of securing an ID. They're not capable of completing the simple task the rest of us accomplished as teenagers." Good job, asswipes. Way to help them feel helpless. Why not demand something from people and have them rise to the occasion? I don't think standing in line at the DMV for an hour and getting your picture taken is too tall an order. Whether you're black, white, Hispanic, or Asian, I think that if you can't get it together to obtain photo ID, we don't need your vote. Your ID doesn't matter, it's your IQ I'm worried about.

I'll take it a step further. As president, I'm directing the Federal Election Commission to require not only ID at the polls, but also a recent pay stub. If you're on welfare, you're not contributing to the economy. So why should you get to vote? You're just going to vote to get more free shit anyway.

But while I want all voters to have ID, I don't want the candidates to be identified. From now on, all voting will be blind voting. When you step in the voting booth you'll just see a list of positions on issues. No names, party affiliations, or pictures. We do way too much voting based on "he looks like me" and "her last name sounds like mine" in this country.

In the greatest example of balls/sociopathic behavior from a politician ever, former L.A. mayor Antonio Villaraigosa chastised the Republicans during the 2012 election, saying, "You can't just trot out a brown face or a Spanish surname and expect people are going to vote

for your party or your candidate." This is a man who was referred to as Tony Villar all the way through junior high, high school, and during his time at an unaccredited law school where he failed the bar four times before giving up. He then combined his name with his wife's to become Antonio Villaraigosa and was quickly elected mayor of a heavily Hispanic city. The idea that just because someone's grandparents were from the same fucked-up part of the world as your grandparents and should thus know exactly what you need and will force the government to provide it for you is narcissism of the highest order. It all smacks of a big "Fuck all those people with other ancestry, fuck the melting pot, fuck the idea that we're all in this together. What about ME? Gimme gimme gimme."

And when it comes to voting for your own, Mexicans, my question is this: How's that working out for you? I've taken a look south of the border. Mexico is a piece of shit. It's the fucked-up hellhole you fled from. The people in charge there sure look a lot like you and have similar last names. So what is your fucking logic? Let's keep that party rolling here in the States? You're only in this country because you voted for your own and your own were crooked leaders in the pockets of the drug cartel, so you decided to get the hell out of there. President Carolla won't pander to get the Italian vote. You aren't going to hear me promising a Fiat in every garage and chicken Parmesan in every pot.

This "vote for someone like me" bullshit extends beyond race. I loved when Barbara Walters had the ovaries to ask Chris Christie about his weight, and if he thought it might affect his chances of being elected. I actually think it would help. Fat is the ultimate race here in America. There are fat honkies, fat brothers, fat Jews, fat Mexicans. We're a morbidly obese rainbow. I think Chris Christie would get elected in a second, if I wasn't running. That being said, there would have to be some institutional changes. We'd have to make it the Circle Office instead of the Oval. Ovals are too narrow for his girth. And we'd have to scrap the

current 747 we use for *Air Force One* and convert a C130 cargo transport. I'd love to see President Christie waddle down that giant back door.

The one place this comes into play is with women. We talked a good game when Hillary was running and Sarah Palin was involved. But we've all seen enough episodes of *The Bachelor* to know chicks are too competitive to vote for one of their own.

6

MY ADDRESS TO THE UN

The following is a transcript from President Carolla's first address to the UN General Assembly in New York.

PRESIDENT CAROLLA: Mr. President, Mr. Secretary-General, fellow delegates, ladies and gentlemen. Each year the nations of the world come together in this assembly hall to recommit to a vision of peace, stability, and partnership for a more harmonious globe.

And so far, you've sucked at it. The world continues to be as fucked up as it ever was. Good job, assholes. So I stand before you not as the president of the United States but as a parent, coach, and drill sergeant. Get your shit together.

(MURMURS FROM ASSEMBLY)

I'm starting with you, Middle East. First, let me make one thing clear. It's not your people. The inhabitants of the Middle East are hardworking and family-minded just like you and me. The problem is your leaders. Who evidently are imported from countries where everyone's an asshole. I hope my sarcasm is translating. Whenever someone tries to pull that "it's not the people, it's the government" bullshit, ask them what country the fucking government's from? What part of Norway did Iran's leaders come from? How good can the people be if they elect or don't rise up against these corrupt dickheads?

It's said you can judge a nation by how they treat their prisoners, but who gives a shit about prisoners? I say you can judge a nation by how they treat their bitches . . . I mean women. The more evolved you are as a nation, a culture, or a man, the better you treat the ladies. Here's how it works. The average man weighs fifty pounds more than the average woman and would win in a fistfight. You guys use the same logic a bully uses on a weakling— might makes right. Us evolved nations realize that just because we could kick the shit out of our wife or a neighboring country—are you listening, Mexico?—doesn't mean we do it. Every country in your region is a misogynist nation and thus a bully nation. And the only thing bully nations understand is carpet bombing. The other way you can spot your misogynist nation is that all the men have huge, woolly beards. You all look like Rick Ruben minus the cool sunglasses. Chicks hate these, but who gives a shit about the chicks? Right. That's a tell. The bigger the beard, the shittier the nation.

Another way we can tell you're dicks is how you treat your dogs. A dog in America has a better life than any person in the Middle East. And a dog in L.A. has a better life than any person in Detroit. We have an entirely different attitude toward dogs. It's part of the bully mentality that permeates your region. This animal, like a woman, is smaller and weaker, so you can kick it with impunity. Bad day herding goats? Kick the dog. Blow off a finger building an IED? Kick the dog. Camel broke down in traffic? Kick the dog. You also have a lot of canine-related insults in your culture, "You are a

dog," "Your mother lies down with dogs," etc. In my country, if someone is "your dog," that means you like them. Randy Jackson uses the word "dog" as a compliment in every third sentence. Allow me to give you Middle East dictators a lesson on how to insult Americans. You use a lot of "imperialist" this and "Zionist" that. Just go with "douchebag," it'll be a lot more effective.

Take guys like Gaddafi. Wouldn't a group of completely sane and rational people rise up against an asshole like Gaddafi if they didn't kind of agree with him? How did that crackpot stay in power so long? Eventually enough sane people finally rose up, killed that guy, and dragged his bloated beaten corpse through the streets. The photos and video were all over the Internet. I didn't check them out, though. He was hard enough to look at when he was alive. He looked like Fergie and Manny Pacquiáo had a kid, raised him in a fruit-drying machine, and then dressed him in Jermaine Jackson's wardrobe.

And by the way, when you depose a dictator, you really don't need to take to the streets chanting and dragging the remains of your fallen leader. We abandoned that a few centuries ago. We have these things called elections and courts to get rid of our corrupt and incompetent leaders. You ought to give those a shot. Let's take a look at the ratio of bodies dragged through the streets to space programs. How many carcasses have you dragged through the streets vs. satellites sent into orbit? When you're jumping up and down and swatting at a body with sandals, that's never good. Think about it, we see all this footage because you capture it with a cell phone that was designed and made in a country that spends a lot less time dragging bodies through the streets. Next time you're considering a cadaver parade, just ask yourself, "What would Switzerland do?" I enjoyed the news reports saying the Libyans poured into the streets to celebrate Gaddafi's death. I'm pretty sure you were already there. It's not like you were pouring out of your luxury condominiums. I feel like you're always on the streets. Generally, that's a bad sign for a country. Whether it's the kids selling Chiclets in Tijuana or the Turkish bazaar where you haggle over the

price of some goat meat, the more stuff that is sold on the street the worse the country.

I know what you're thinking. We did take to the streets when Seal Team Six put a bullet in your beloved bin Laden. But that was only fair. That was our time to take to the streets. Not counting the blacks when O.J. went free. We had to watch you burning American flags when the towers fell or some hostage was taken or a Blackhawk was downed. So fuck off. And by the way, all those flags you love burning are made in China, so go nuts.

And let me address the pervasive idea that chanting "USA! USA!" when we smoked bin Laden only served to inflame you and was a recruitment tool for making more terrorists. Fine by me if that's the case. If we create more terrorists, then we just need to make more drones to kill them. It's a great business model.

You came pre-inflamed because of your retarded religious beliefs. No amount of ass kissing from the West is going to convince a poor eighteen-year-old Middle Eastern male that life wouldn't be better if he strapped on a suicide vest, blew up a pizza parlor, and went to paradise for his seventy-two virgins. I'd like to undercut that motivation a little bit, not by convincing you that America isn't the Great Satan but by pointing out that those seventy-two virgins aren't going to last you through eternity in paradise. When I was twenty-one, seventy-two virgins wouldn't have lasted me two months. And then you have to think about whether or not they stay virgins. You'd have to make the first one the whore and use her for eight years before moving on to the next one. Eternity is a long time, brothers.

Plus it's not like all seventy-two die of natural causes. You've got to imagine there are some horrible burn victims in there. And a fair amount of virgins are that way because no one wants to fuck them. You could end up with someone who looks like Susan Boyle; a fifty-two-year-old virgin spinster who died when one of her seventeen cats knocked a curling iron into her bath.

I'm just sick of America having to get out of its La-Z-Boy and police your shit. So I make this declaration now. We're out. Spiral into nuclear war, I don't give a damn.

And the rest of you normal nations, it's your fault. It's like we're all out to dinner, everyone is ordering surf, turf, and surf again but we always pick up the tab. I wish the rest of you would fucking step up. We need an alliance of sane countries. These guys have a lot of big talk about Allah's swift sword on our neck, but we have the power, the industrial might, and the technology. America has to be the world's police because these guys are nuts. I just wish we had a partner. We need the Danny Glover to our Mel Gibson.

Seriously, when are you going to knock it the fuck off? You guys are always fighting with your neighbors. It's pathetic. I'll watch an old episode of *Saturday Night Live* from 1975 and hear Chevy Chase start "Weekend Update" with "Trouble in the Middle East." Nothing ever changes. Is it the heat? Canada never starts shit with us. Is it because they're cold? The molecules in ice move slower than the ones in steam, right? It's the same thing with you assholes. You live in the world's largest sand trap in the world's worst golf course. It's hot, there's no water. Maybe if you moved to a colder climate you'll literally chill out.

And to all the assholes, American or otherwise, who talk about Iran and nuclear weapons and say, "Why can America have nukes but they can't?" Because we're not insane. We don't want to wipe Israel off the map. We're not into genocide. And by the way, when it comes to that, it isn't genocide. It's jealous-cide. The Jews are so much better than you. That's why every couple hundred years someone attempts to round them up and kill them. You envy them. Jews work together, they draft each other like a great NASCAR team.

(CONFUSED LOOKS FROM ASSEMBLY AND SPORADIC WHISPERS OF "WHAT IS THIS NASCAR?")

You're all out shooting each other and fighting over which version of the bullshit you believe about Muhammad is true. Meanwhile the Jews are building universities, hospitals, and satellites.

Which leads me to Israel. What the fuck are you guys doing in the middle of those homicidal, anti-Semitic, misogynistic, religious zealots? I know what your answer is, it's your land, you won it fair and square, and you are not going to move. That's like saying, "My roommate's a paranoid meth head. Twice a week I wake up and he is standing at the foot of my bed with a machete." Then, when someone says, "Why don't you move out?" your answer is, "And lose my cleaning deposit?"

(AUDIBLE BOOS FROM PALESTINIAN DELEGATION)

Shut the fuck up. You know it's your fault. I hear a lot of talk about how all anyone wants is peace, but the side of the fence where it's only Jews looks pretty good. The other side looks like a thin slice of hell. Face it, they're a better culture than you.

I don't really have a foreskin in this fight but I do have a solution, Israel. You guys pack up and move to Baja. It's got plenty of seaside deserts. You'll love it. Here's the plan: Mexico usually gets drunk and passes out about eight thirty in the evening. You sneak in under the cover of darkness and take over before they sober up. The only real difference between the Sea of Galilee and the Sea of Cortez is world-class sport fishing. And you could get that country's economy back on its feet in no time. They need accountants; ironically Mexico's short on bean counters. And don't worry about the "Sacred Land" stuff; once you get established in Baja, you can send some Mexicans back to your land to scrape off the top six inches of soil, spread it out over the peninsula, and start fresh. Once your old neighbors realize they are out of Jews to kill, they'll start killing each other.

Before you get outraged and have the Anti-Defamation League after me, let me remind you that I can say this stuff. My stepgrandfather was Jewish, and before I was president I was in show business, so everyone thinks I'm Jewish. I love Jews. They're family-oriented and focus on education. And unlike other cultures, Jews do their funerals the next day after

someone kicks it. You don't drag it out like the Irish. I went to a Jewish funeral not too long ago for my uncle Gabi and it was pretty darn efficient. I did have to put on that temporary white yarmulke for visitors, the one that looks like a coffee filter. I love seeing the guy with the custom velvet yarmulke. That's like the guy who has his own bowling ball. He's a pro.

But let me end with a compliment. Another thing I like about Jews is that you are a careful people and responsible people. Here's how I know. You handle a lot of fire, but I never hear about you setting yourselves ablaze. You're constantly kindling the Sabbath candle; if you're Hasidic you've got the giant beard and *payos*, and a long prayer shawl with fringe. You're a human tinderbox. You're leaning over to blow out the menorah with what are essentially fuses dangling from your heads. You are the world's most flammable people but you've got a fire safety record that would make Smokey Bear proud. Mazel tov.

(SPARSE APPLAUSE)

Okay, where are my Russians? You are easily the most fucked-up white people on the planet. And that's including Florida. You're still suffering from a communism hangover. That shit went on for way too long.

America should have woken the fuck up in 1961 and smashed you. Why did it take until Ronald Reagan to call you guys evil? I blame America and the "you can't judge" children of the sixties. My mom had your back, not because she thought your horrible oppressive form of government worked, she just hated Gerald Ford.

The Berlin Wall was the greatest advertisement against communism. Take East and West Germany out of the equation. You just have group A and group B. Where group A lives is all gray and bleak, they've got cars running off two-stroke engines, they're lining up for stale bread, and there are armed guards keeping them on that side of the fence. Everyone in group A

is killing themselves to try and get where group B lives. We couldn't do the math as a world that the ideas where group A live suck?

So, Russia, ever since the wall came down, you should've been in apology mode. Like a husband that got busted cheating. "Yes, honey, I would like to watch *The Notebook*. But not until I finish baking you this lasagna." Between the Berlin Wall, the gulags, and Stalin, you should never stop apologizing. You should constantly be making us lasagna. If you took Hitler's body count and matched it up against Stalin's, Stalin comes out on top by at least eight million. That reality should not get lost in history.

But let me pay you one compliment. Your athletes are impressive. Not just in their respective games; they've got a brain in them, unlike ours. Like Wladimir Klitschko . . . He's *Dr.* Wladimir Klitschko, who speaks three languages and plays chess. Look at our sports icons. We've got guys like Karl Malone who can't string a sentence together, arrogant boneheads who change their names, like Metta World Peace and Chad Ochocinco, or the guys who think every play they complete is a direct result of Jesus intervening. And your tennis players are hot and smart. There's no way a hot American chick would go to tennis camp and get up to practice every day at five A.M. She'd look at a mirror on her sixteenth birthday and say, "Fuck that. Where's the Hawaiian Tropic competition?"

Speaking of unlikely intelligence, where's India?

(INDIAN DELGATION RAISES HANDS)

Here's something I don't get. Your culture seems to be the most poor and downtrodden but constantly cranks out the most doctors and neurosurgeons. Every doctor you see in L.A. is from India. I don't understand. Which is it? Usually cultures don't have that kind of range. Half the country is in med school, the other half is living in a bucket of feces. Real slumdog shit. In our country, when one group is consistently poor and uneducated, we make excuses based on race. You're all Indian. Lift your slumdog

brethren up. No one is keeping you down. What's your excuse? Where's your spokesman? You need an Aziz Sharpton.

And Japan—I don't get you either. You're either very reserved, studious, and businesslike or completely off the rails. There's no in between. You're either jumping off a building because you got a B-minus on a calculus test or you've got spiked hair and are driving a slammed Acura. And the tattoos. You've either got none or you're covered in them, including the eyelids. What's up?

And sexually you guys are twisted. You're giving the Germans a run for the fetish money.

(OFFENDED MUTTERS FROM GERMAN DELEGATION)

How about some good old missionary-position sex? Not everything needs to be a bizarre anime-based fantasy where you're doing something weird to a schoolgirl with a fish. I know it's overcompensation. Let's face it. You and the rest of Asia are coming up a little short in the pecker department.

(INDIGNANT SHOUTS FROM CHINESE, KOREAN, VIETNAMESE, CAMBODIAN, AND JAPANESE DELEGATIONS)

Seriously. What's with all the dick-based superstitions and practices? Methinks you doth protest too much. No one is more superstitious than Africans, but they've checked the cock box. Ironically they're the ones with full access to all the weird shit like the rhino horns that you use as an aphrodisiac or penis-lengthening powder. Maybe that's the problem. You see the Serengeti plainsman over there in Africa pulling his tree trunk of a cock in a wheelbarrow and think it has to do with all those animals you don't have on your island. There is no worse day as an organism than when you find out Japanese guys think part of you gives them boners.

Which is why I hate that in America, we are so in love with the wisdom of the Orient. Every liberal friend I have talks about "Eastern medicine." Everything from Asia is great—until you get AIDS. Ginseng root is fine until you come up HIV positive, then it's time to call Pfizer. We keep thinking you know something we don't. You have feng shui, eat with those sticks, sleep on the floor, take your shoes off. But I don't think you're so smart. We invented the fork, then the spoon, and even the spork, and you're still drinking miso soup by picking up the bowl and dumping it in your mouth. Plus we kicked your ass in the war.

(JAPANESE DELEGATION HANG HEADS IN SHAME AND UNSHEATHE HARA-KIRI KNIVES)

Yeah, I went there. A lot of people in my country, mostly in the blue states, would like us to apologize for Hiroshima and Nagasaki. And I'm sure you agree. Well, fuck them and fuck you. Let me explain once and for all why those atomic bombs were necessary. If you had an atomic bomb and a delivery system, you would have happily dropped it in Times Square on New Year's Eve. Secondly, you were fighting like crazed savages to the last man on every ten-square-foot patch of sand that surrounded your home island. If we had invaded that island, every man, woman, and child that could fire a gun or carry a pitchfork would have been waiting for my uncle Ralph and his Browning .50 caliber machine gun. He was part of the island campaign. He didn't talk about his experiences overseas much, but when he did they were gruesome tales of midnight banzai charges with waves of Japanese soldiers, sometimes armed only with swords, coming at him while he and the guy feeding his ammo belt just slaughtered thousands of men. This scenario would have taken place with even more ferocity on the island of Japan. The casualties would have gone well into the hundreds of thousands. And most of them would have been civilians, since the Japanese army had been decimated by that point. Also you nimrods should have surrendered

ten minutes after seeing the mushroom cloud over Hiroshima instead of hanging out four more days and waiting for Nagasaki. Nagasaki is on the Japanese leaders, not us. But you could have avoided your ass kicking in general by not bombing Pearl Harbor in the first place.

And to all my asswipe countrymen who are busy beating up America for this, please pick up a fucking calculator, probably manufactured in Japan after we helped rebuild their country and economy, and do the math. After the bombs, my uncle was part of a peacekeeping unit instead of an invasion force. So when you dickweeds see him in heaven, a simple "I was wrong" and "thank you" will do.

Speaking of the Axis powers, where's Germany? As I've said many times, we should bomb you again.

(MEMBER OF GERMAN DELEGATION SHOUTS "NEIN!")

After going through the Holocaust museum in England, I decided that we didn't do nearly enough damage to your nation. We stopped you from trying to take over the world and wipe an entire people off the face of the earth, but then we were like "Here's a few bucks, put the capital back together. We'll see you later." I think we moved on too quickly. You rounded up Gypsies, Jews, and gays—my favorite Cher song, by the way—put them on trains, and tossed them in ovens. But a mere three years later, during the Berlin airlift, we were dropping off thirteen tons of supplies a day. Instead of dropping pallets of food and medicine, we should have been dropping a little more ordnance.

That said, we're cool, Germany. You drive like champions and I dig that. In fact, as president, I'm stealing your Autobahn idea. You guys drive 150 on the Autobahn because you make a quality product that is safe at that speed. Modern cars have antilock brakes, speed-rated tires, and suspension geometry that doesn't involve leaf springs. Here in the U.S. we do nothing but yell "put on your seat belt" and "slow it down." If you hit the open highway on a road trip, you'll pass a "This Highway Patrolled by Aircraft" sign every

ten feet. And last time I drove to San Francisco I had a cop hit me with a radar gun traveling toward me, pull a *Smokey and the Bandit* U-turn across the wide dirt median, and come up behind me to pull me over. Let me ask you this. What's more dangerous—me doing seventy-nine in an all-wheel-drive Audi S4 with low-profile, high-performance tires mounted on forged eighteen-inch racing rims and bolted on to large cross-vented disk brakes or the cop with his steel rims, straight rear axle, and drum brakes pulling a U-turn on a piece of off-camber dirt spinning the back tires in the weeds as he rejoins the traffic going the opposite direction?

(SILENCE FROM GALLERY)

But I digress. One last thought on Hitler. What is it with dictators and the crazy facial hair? When you see pictures of Castro everyone around him has the beard, all the people that surrounded Saddam Hussein were sporting his cookie-duster, but I watch hours and hours of History Channel and I've never seen any of Hitler's henchmen sporting the shoe-polish-streak mustache. That's how bad his facial hair choice was. Your closest lieutenants, who have seen you order the deaths of millions of people, are like, "I'm still gonna risk pissing the boss off. I don't want that stupid mustache." Conformity was Hitler's thing. The goose step is the most impractical way to move around, yet he'd get thousands of guys to parade in front of him doing it. And his Heil salute was about as creative as Howie Mandel's fist bump. About the only good idea he had going for him was the term "Heil Hitler" and that was just because of the alliteration. If his last name was Stiencooler it never would have worked. He got an entire nation to goose-step, adopt his greeting, and turn a blind eye to genocide, but not one man in his army went with the Chaplin mustache. You know somewhere in some regiment in northern Africa there was a staff sergeant who did sport the Hitler 'stache. And he was probably relentlessly teased by all the other guys in his platoon. "Hey, Dieter, is that a mustache or a crap stripe you got brown-nosing the Führer?" And Dieter was like, "Hey man, I had this in high

school. I was rocking this baby when we were torpedoing the *Lusitania*. Don't make me pull out my yearbook again."

While I'm on a World War II tirade, let's talk, France. I'm a fan of psychology and normally when people think of that they imagine a one-on-one session with a guy wearing a corduroy sport coat who has a beard that looks like someone shaved off their pubes and stuck it to his chin. But I like to take my psychological theories and apply them to whole countries. After all, aren't we all on the same sectional built for 300 million?

(LONG, SELF-SATISFIED SNIFF FROM PRESIDENT CAROLLA)

A great example of basic psychology permeating a culture is you, France. I've always said the more you do for somebody, the more they resent you. Dig this. When the dust settled on the greatest war ever known, Germany was in ruins, Japan had had two atomic bombs dropped on it, and your nation had been liberated. Now, out of those three countries, which one resents us the most—the one we nuked? Nope. They're buying our jeans and singing Elvis songs. The country we carpet-bombed? Nope. They're busy enlarging the cup holders on their cars so they can move more units here in the States. That's right. The country that resents us is the one that should be sending over a new Statue of Liberty every six weeks. Is there any way you would have gifted us the Lady Liberty after World War II? No fucking way. Why? Because we shamed you. We bailed you out and let you know just how weak and inadequate you were. And instead of taking a long look in the mirror, you turned on us, like the ne'er-do-well brother you constantly bail out of jail who still hates you. People always say, "Why do they resent us so much? If it wasn't for us they'd be speaking German right now." That's exactly why you resent us. We shamed you with our superiority.

This, by the way, would explain the Jerry Lewis phenomenon. Nobody thinks Jerry Lewis is funny. Not even those kids with the polio crutches

are handicapped enough to think he's funny. But your country, which does nothing but turn its nose up at our culture, embraces what I would consider the most American of all comedians. I know it probably came up at a "how are we going to piss off the United States?" meeting. "What comedian shall we idolize?" "I think Mitch Hedberg's pretty funny." "Patrice, get the fuck out of the room. Do you think that would piss them off? Now, Jerry Lewis, that's a comedian that would annoy them." "But he's not funny." "Exactly."

Italy. You're cool. You're sort of like Mexico if it studied for the SATs. It's as if someone woke Mexico up, sobered them up, and said, "You gotta go study. We're gonna get you into a state school."

But don't get full of yourself. You've still got a long way to go. I'm a *paisan*, so I can say this. Italians are essentially dumb Jews. You're personable, you love to eat and talk, you've got the importance of family, the nappy hair, and the bigger-than-average schnoz. You just don't have the brainpower Jews have. You have a lot of the same qualities minus twenty-five IQ points. You Italians have an artistic flair, designing automobiles and such. I've always said if you want a sports car, go to an Italian, but find a Jew to help you with the financing.

Now, let's look next door to Greece. Get over yourself. You got out of the gate really well but you haven't done much in a millennium or two. You guys invented civilization and the alphabet, but since then you really seem to have dropped the ball. Your economy almost brought down the rest of Europe, there are constant riots and protests, and no one seems to want to work. What happened? You peaked with Socrates and then were like "just give me a teenage boy and a sauna, I'm going to take the next couple thousand years off and focus on yogurt."

(GREEK DELEGATION IS WOKEN UP BY GREENLAND DELEGATION NEXT TO THEM)

That's all you guys have seemed to have done lately. Greek yogurt is flying off the shelves here in the States. If you were getting your cut, your

economy would be fine. How come your country is falling apart? Did you guys not look at the contract? I think you're getting screwed on your yogurt royalties.

Now, Ireland—please take Bono back. I'm sick of seeing him on American TV preaching about Africa and how it's entirely our fault. Why not ask the starving Africans what THEY'RE doing about their plight. Leave us out of it. I'm so tired of you and Sting blowing hard about American imperialism. How would you like it if we sent Bob Seger to your country to talk about what a bunch of assholes you are?

Before I move on from Europe let me just address the Dutch. I like you guys. You're not troublemakers. But is it the Netherlands or Holland? Nail it down, please.

And either way, why are you called Dutch? Shouldn't it be Netherlanders or the Hollandaise? I suggest you lose the Dutch moniker. There are a lot of Dutch slurs that you need to be aware of. "Going dutch" means splitting a check, which makes you guys sound like the cheapest fucks on the planet. Being "in Dutch" is being in trouble. "Dutch doors" are only half doors. A "Dutch uncle" pretty much means a critical asshole. And when I was doing construction, if you fucked up a mortise and had to sand it down and pretend it didn't happen, that was called "a Dutchman." Worst of all is that back in the day when sailors would fuck a knothole in a piece of a wooden plank, it was called a "Dutch wife." And to all of you who hurl these racially charged slurs against the Dutch, don't think just because you love the Dutch oven it makes it all right. That's like dropping an N-bomb but following it with "It's okay, I have black friends."

I'm just saying, stand up for yourself. Maybe you've just got a little too much Amsterdam in you and wanna lie back and be cool but the rest of the world is laughing at you. You're quietly taking more shit than the Polacks.

(ANGRY POLISH DELEGATION ATTEMPTS TO LEAVE ASSEMBLY HALL THROUGH CLOSET DOOR)

Okay. On to my hemisphere. I'll start in South America with Chile.

All I know about you is food-based. Every piece of fruit in my house has stickers from your country and I love your sea bass. Keep up the good work. But I can't commit to the Cheel-ay pronunciation. But Chili sounds like we're at a cook-off. Like Pakistan and Pahk-ee-stahn. I guess how you pronounce it depends if you're on Fox News or not.

Brazil. You guys have a very confusing culture. You have a giant statue of Jesus that is towering over slums he's doing nothing about, and constant parades with chicks shaking their asses and titties. Which is it? Are you superreligious or debaucherous?

Carnival seems unnecessary. I'd understand if you were a really buttoned-up culture and needed to cut loose once a year, but you see ass cheeks all the time. Chicks wear thongs to a christening down there.

And let me take this moment to compliment you on your ass color. There is no better color for a tush than that Brazilian caramel color. It's just the perfect color for what it's on, like Aston Martin racing green. If you took that Brazilian ass and gave it Tilda Swinton's skin tone we'd all be vomiting. But with Shakira's color—*muy bueno*.

And your nation's name is synonymous with pube maintenance. You take pride in how you look below the belt. Kudos.

But back to the Jesus statue. Can you climb up into that thing? It feels sacrilegious to be a human finger in the Messiah's prostate exam. It just seems weird. The Jews would never make a giant Moses. Palestinians would fire rockets at the crotch anyway and I think the Jews were probably done hauling stones after the pyramids. But as a gesture of goodwill between our nations, I commit now as a gift from America that we will help you complete that Jesus statue by building you the world's largest El Camino dashboard.

Now for Cuba. How is it that you're still just sitting off the shore of Florida mocking us? Fair warning—plans have been drawn up for the invasion. They didn't take long. One Zodiac boat filled with Cub Scouts is all it is gonna take. Then we're going to use the country as a penal colony for all

our worst sex offenders. It will get them off our shores and it's where I'll produce my new hit reality show—*Pedoph-Isle*.

You always had Russia protecting you, like that skinny shit-talking kid at school who had the older brother on the football team. But he dropped out and now we're going to kick your scrawny ass.

Cuba is a great experiment in communism and how it doesn't work. We take an island, put it in the middle of the ocean, and say, "Pick a form of government. Any one you like, just pick one and stick with it for at least fifty years." The cars are all from the fifties, the place is falling apart, and every time the Cuban baseball team goes to play a tournament half the in-field doesn't come back. Isn't this all we need to know about communism? Your island is like a petri dish. The lab results are in and they're irrefutable. You people are climbing into coffee cans and trying to paddle to Florida. When Florida is a superior option you know you're in rough shape. It's crazy, strapping truck tires and milk jugs to pallets and throwing yourself into the Atlantic. It looks like a Red Bull event.

I'll wrap this up with this last directive. Africa. I'm sick of seeing your starving kids on our late-night commercials. It's bumming the shit out of me. And I'm sick of us sending mosquito nets and sacks of grain so you can keep crapping out more kids you can't feed. I have some words of advice that will solve this problem. Specifically four words: cum on the tits.

Thank you.

(SPARSE APPLAUSE FROM BRITISH, AUSTRALIAN, CANADIAN, AND SCANDANA-VIAN DELEGATIONS AS ALL OTHER NATIONS HAVE LEFT HALL IN OUTRAGE)

THE DEFENSE OF MARRIAGE ACT AND OTHER IMPORTANT NEW WEDDING LEGISLATION

When DOMA was overturned in 2013, I was happy. My feeling has always been that gay marriage should be legalized. I was once asked in an interview the top five reasons gays and lesbians should be allowed to marry, and I said the number one reason was they're American citizens who pay their taxes and have the same rights as anyone else. Reasons number two through five were, SO THEY'D SHUT THE FUCK UP ABOUT IT! It feels like we've been arguing about this forever. It's not even about the volume of gay people in the population, but the volume at which they protest. They are that loud and that proud. Asians make up 5 percent of the population but feel like less than one percent. Blacks make up 13 percent but feel like 46 percent. Gays are supposedly 3.5 percent but feel like 96 percent. We get it. Yes, you're here, you're queer. We're used to it. So please shut the fuck up. Unfortunately, I'm sure we'll still be arguing about it years from now. The Supreme Court

may have overturned Prop 8 but eventually some gay activist is going to sue because he's not allowed to get married at the Crystal Cathedral. (For those who don't know, the Crystal Cathedral is a gigantic glass church in Anaheim, not an adult performer. Which is a shame. Crystal Cathedral would make a great porn name.)

Again, I have gay friends and I want them to be able to get married. I'm just sick of hearing about it. I think we should move on to many of the other topics facing our nation that are much more important than whether two guys get to settle down, grow old together, and raise adopted Chinese kids or lapdogs.

Maybe I'm at my saturation point on this issue because I live in L.A. I really noticed this one day when my daughter floated the idea that I marry her idol, Katy Perry. I pictured the C-cup on Katy and thought, "This is the first time we've been on the same page, kid. You're onto something." But then I asked her, "What about Mommy?" Natalia replied that she could stick around, and Lynette *and* Katy Perry could be her mommies. I told her that wouldn't work and that she couldn't have two mommies. She instantly replied, "But Bradley has two mommies." I realized that half the kids at her L.A. charter school had two daddies or two mommies.

Before I move on from gay marriage, let me weigh in on gay slang. I know that we can no longer use the phrase "fag hag." Which is disappointing to me. It was one of my favorites, right behind "sand nigger." But I thought there was still a need for a word to describe the chick who only hangs around with gay guys. The Grace to their Wills, if you will. So I asked my listeners, and they came up with an excellent alternative— "fruit fly." Pretty good, right? They just buzz around the fruit, not really harming anyone but usually annoying the shit out of you.

And while I'm in an area that's going to get GLAAD's dolphin shorts in a bunch, let me also lay out my position on the code words for gay sex positions. I think "pitcher" and "catcher" are played out and "top" and "bottom" are boring. They're not creative at all. During my administration, we will use only "tumbler" and "coaster."

All that said, I do want the government to get more involved in the marriage regulation department. Not so much regarding *who* can get married but *how* they can get married. Here are some of President Carolla's new wedding laws:

NO ELABORATE PROPOSALS: Some guys are fucking this up for the rest of us. No more skywriting proposals, no surprise question pops on the *Today* show. Just take ten minutes and do it right. Get down on one knee and string together a couple choice words that the wife can remember and tell her chick friends. Nothing too long. It should be able to fit on a license-plate frame. We need to get this sorted out for you and your buddies. If you screw it up it will haunt you forever and you will be an object of ridicule by your wife at all family gatherings for the rest of your days. But if you overdo it, then when your wife tells my wife, she gets pissed at me. When she's hanging out with the one-uppers who talk about proposals on private islands, she'll have to angrily say, "Adam threw a ring at me, said 'there!,' and started watching *SportsCenter*." And then I get the cold shoulder and blue balls for a week. Knock it off. One knee, ten words, move on.

THE RING: De Beers has that stupid "two months' salary for an engagement ring" rule. That's fine, but I have some limits to add. If you're a renter, I cap it at $900. If you're living in an apartment, you have no business spending any more than a grand. As long as you have a cleaning deposit, $900 is the max ($1,500 if you're in a condo). I think that's fair. The price on the ring should have a ceiling if your actual ceiling is another guy's floor.

THE DRESS: We've got to put an end to the "$5,000 price tag for a dress you wear one time" bullshit, ladies. From now on the most a bride can spend on her dress is $1,000. For every hundred dollars spent over that grand, she must, *by law*, be able to fit into that dress for one year. Pretty simple math, right? You can go three grand on the dress, but for twenty

years after, you have to fit into it. This would be the only time when a woman didn't starve herself before the wedding. In fact, she'd be bulking up like De Niro before *Raging Bull*.

THE OBJECTIONS: In every wedding ceremony there is the point where the priest asks, "If anyone can think of a reason why these two should not be wed, speak now or forever hold your peace." At this point it's too late. If I know my buddy is marrying Aileen Wuornos's evil older sister, I'm probably going to sit on that info at the ceremony. I wouldn't want to embarrass him in front of the whole family. So henceforward that question has to be asked at the bachelor party. I think after a few shots poured out of a stripper's cleavage, you're going to get the real answer on what your friends and family think of your bride-to-be. Though it will be awkward to have the priest there.

NO DESTINATION OR THEME WEDDINGS: Not only are these exotic location weddings a pain in the ass for your friends and relatives to get to, but they're usually a bad sign for the marriage. If you get married in a bikini, the average length of your marriage is about the same as the bride's pubes. The marriage that lasts longest is the one in the nice suit, but not the tux, because the one in the suit is the second marriage. And none of that theme-wedding, "we both love roller coasters, so we're getting married on the Comet at Six Flags" bullshit. I don't care how much you both love SCUBA, in my America the underwater wedding is going to be torpedoed by the coast guard.

Like the elaborate proposal, this also fucks up your nonmarried friends. When a guy takes the chick he's been dating for four years to the destination wedding, there's gonna be a long flight back from Maui. She's pissed. Remember, she's got all of her supercunty friends telling her, "If you were the one, Steve would have said something by now." Chicks also have that marriage clock in their head. If you take a trip with a woman you've been dating for more than two and a half years, she's going to

spend the whole vacation anticipating a proposal every time you stop at the scenic overlook or checking her pomegranatini glass for a ring. And when it doesn't come, she'll spend the whole flight home with her arms folded, looking like she just smoked a bongload of cat shit. She's disgusted with you and you'll have no idea why. "We swam with dolphins, we saw sea turtles. What's up?" (SILENCE.) So no destination weddings, or my government will not recognize your marriage. And for the aforementioned nonmarried-but-still-dating couple, if you're past that thirty-month mark, there will be no vacations at all. Even if you win a trip on *The Price Is Right*, you have to sell that shit.

THE WEDDING REGISTRY: Weddings cost too much. Back in the day it used to be that the father of the bride would pay for the wedding and you'd get a cow as a dowry and that'd be that. A simple transaction—I'll give you a musket and three geese for your daughter. Now all you get is a bunch of debt and the stink eye from a guy whose precious little girl you're stealing. Then people try to make up for the cost of the wedding with the registry, and ask for a bunch of shit from Williams-Sonoma that they're never going to use. They have to try to earn back the cost of the reception one crystal goblet at a time. (Williams-Sonoma is crazy expensive. They have spices in that place I can't afford, and $500 pressure cookers. Pressure cooker is at the top of the list of things that you only get as a wedding gift.)

So from here on out, all wedding registries have a two-item maximum. First thing on that list—a basket. Everything else, cash. It shouldn't be called a reception. It should be called a "pay off my credit card" party and every just comes with an envelope of cash like that scene in *Goodfellas*. And on that note . . .

NO CASH BARS AT THE RECEPTION: If you can't afford an open bar, you can't afford to be married. It's like my rule about powdered milk. If you can't afford real milk, you shouldn't be allowed to have kids.

ANNULMENTS FOR ALL: A lot of states have laws putting limitations on annulments if you've been married for more than a certain amount of time. I'm lifting all of those laws, especially for anyone who gets married young. If you can't go down to the store and buy a six-pack, it doesn't matter how long you've been married, you should be able to get an annulment. If you've gotten married at nineteen and a half, you shouldn't have to go through a divorce. In fact we'll fast-track ending your shitty relationship before you crap out a kid for us taxpayers to take care of. I don't want you to produce offspring before you realize that the guy who loaded you up with Natural Light and humped you in his Honda behind the high school football stadium is not your soul mate.

7

THE DEPARTMENT OF HEALTH AND HUMAN SERVICES

As president, I'm going to get the government out of health care. I know this is going to piss off the Michael Stipes and Michael Moores of the world, but I just don't think having health care is a right. Health care is a commodity like anything else. I don't look at it any different than housing; you've got to earn it. Somehow we decided health care is something you get cradle to the grave no matter how much, or how little, you've contributed to the system. I know that some people on the bottom need our help, but once people figure out that it's free down there, the bottom all of a sudden starts getting bigger.

I don't know why I seem to be the only one who understands that when the government provides something for free—whether it's food, housing, or health care—there is a human cost. The government may be handing you a free block of cheese but they are taking away your motivation to get a job and buy your own fucking cheese. And what more

powerful motivator is there to get up, get work, and get insurance than the fact that not having it could literally kill you?

This is the inherent flaw in government-mandated health care. It's dependent on young people purchasing insurance they're probably not going to need, in order to fill the coffers for the older people who do. But when I was in my late teens and early twenties, I didn't have two nickels to rub together and if I did I certainly wasn't spending them on health insurance. That was beer money. Why do we expect better from the current generation of twentysomethings? Have they demonstrated an abundance of long-term thinking and self-sacrifice? Fuck no. Unless that health insurance comes with a free copy of *Grand Theft Auto 5*, they're not interested.

And why do we think for a second that having the government involved will make things better when it comes to health care? Now, I'm not entertaining the paranoid "death panel" ideas that ignite some of those on the far end of the right wing. I think the government is incompetent, not evil.

I'd actually be okay with death panels if I thought the government wouldn't fuck them up. The reason we're in such a shitty position when it comes to health care costs is because people are living way too long. I think we have an absurd perspective on death and dying. We want to prolong life forever but never think about the costs. We just hand over our insurance card and think, "Put it on my tab." We don't realize what that's costing the entire system.

Which is why as president, I will be calling for two initiatives:

First, I demand an end to all the antismoking propaganda. I recognize that smoking is bad for you. But as far as overall cost impact on the system, the last fifteen years a person in their eighties or nineties lives cost far more than the six months of chemo a person has before finally dying of lung cancer at fifty-six.

And who at this point doesn't know that smoking is bad? It's been

the broken record playing for the last thirty years. And it's only getting louder, more in-your-face, and more disgusting. I'll be attempting to eat dinner, look up at the TV, and see an antismoking PSA with the chick smoking through the trach hole in her neck. Yuck.

We've even gone past the repeated refrains about secondhand smoke to thirdhand smoke. Now, it is as if I could walk through a cloud of smoke, it will get stuck on my coat, and then when I hang it up at home, the smoke particles are going to jump off in the middle of the night, go upstairs, and rape my kid's lungs.

Being a smoker is worse in this society than being a deadbeat dad. If you ditch your family and take off to Florida, you'll be judged, but not nearly as harshly as you would if you attempted to light up a butt in a Starbucks. The antismoking agenda has gotten to the point of absurdity. I feel like if you had a convict lined up to be executed by firing squad in today's society, they'd be fine with the part where we put him in a blindfold and line him up against a wall, but we wouldn't allow him to have that final cigarette. We'd have to stick a Nicorette patch on him with a bull's-eye on it.

Second, I demand that henceforward all life-support equipment will be coin-operated. I'm not talking about a Beverly Hills parking meter where a quarter gets you eight minutes, but a machine that works long enough to prove you have people who care about you. Why are we all pitching in to keep you around if the people who supposedly love you don't give enough of a shit to cough up a couple bucks to keep you hanging on? And is that a world you want to stick around for anyway? If your family can't bring the mason jar that was earmarked for the Coinstar down to the hospital, then there's no reason for you to bother staying on that ventilator. Just let go. It's part of my campaign—You Better *Hope* They Have *Change*.

But back to the government ineptitude. Why would we trust the government to create an insurance system when that same government wrote a tax code that's harder to understand than Bob Dylan reading

Dr. Seuss? Has this bureaucratic pig fuck ever proven itself to be efficient or competent?

Talk to your doctor, or any doctor, and ask if they're into Obamacare. They all hate it. It reduces their treatment options; it creates a shit ton of extra paperwork, and cuts their compensation. People go through the eight-plus years of medical school and training because it's supposed to pay off in the end. When you inject the government into that system and reduce the payoff, you're not going to get the best and brightest. The smart people are going to say, "Feh; I'll go be a stockbroker instead."

Let's face it—a fair amount of this is due to the lawyers. Mentioning lawyers in front of Dr. Drew is like waving a red beach towel in front of a bull. He goes crazy. Doctors have to carry a massive amount of malpractice insurance now because anyone can sue for anything. I'm not saying someone shouldn't sue if a doctor sews up your gaping chest wound with the forceps still in there, but no one is willing to take responsibility for their own health. If you gave yourself diabetes or some other ailment, a doctor better fix you up or you're going to sue him. Why? Because some lawyer told you that you deserve to be compensated for this INJUSTICE and WRONGDOING and *Hey, free money, right?* But it's more like he wants to get compensated when the doctor or hospital just settles to avoid the hassle and bad publicity. No one is taking into account that you're fucking up the life of the guy who tried to save yours or that of your loved one. It's sad. You hear about the inner city and black-on-black crime . . . well, a lawyer suing a doctor is Jew-on-Jew crime.

And when the government gets involved, so do the lobbyists and special interests and advocates for every age, race, and gender, which makes everything a complete disaster. Everyone is fighting for their little fiefdom and no one is looking at the big picture, so you end up with some Frankenstein system assembled by committee that attempts to serve everyone but does the exact opposite.

PUTTING HOSPITALITY
BACK IN THE HOSPITAL

I'm not saying there should be zero regulation of the medical field. As I get older, and my parents get older, I've had more interactions with the hospital and thus more shit to complain about, especially when it comes to hospitals.

I want to address the decorum. The hospital is a depressing place. You're only there because something has gone horribly awry (with the rare exception of your old lady getting a nice titty lift). So let's do everything we can to minimize the added depression.

My dad was in the hospital for an extended period in 2012. Long story short, he fell and hit his head but didn't really think anything about it. A week or so later he had some trouble with his hand, and when he talked to his doctor, the doctor suggested a CAT scan. Immediately after that test, it was time for emergency brain surgery; there was hemorrhaging and swelling and it needed to be relieved immediately.

When I got to the hospital and was attempting to find my father's room after the surgery, I was greeted by the old volunteer. This is one of the first things my Secretary of Health and Human Services is going to do away with. I'm there to see my elderly father, who is probably on his way off of this mortal coil. To be greeted by the guy who's two steps behind him is a total bummer. I suspect the old volunteers are there to get acclimated to their new environment.

Plus these guys don't necessarily have that much hustle. I'm attempting to get to my father's room before he croaks and you're guiding me there at a two-step-an-hour pace. Move it, Grandpa.

I also had a run-in with an insulting security guard on a different trip to the hospital. He recognized me and said, "Hey, I loved the *Man Show*. What are you up to nowadays?" Before I got a chance to even begin telling him about my Guinness World Record–breaking podcast, the three network pilots, and the two *New York Times* bestsellers, he jumped

in: "Just chillin'? Don't worry, something will come up." Thanks, dick. Everyone does this now. They ask you a question and answer it for you a second later. Why are you even asking if you already know the insulting answer? My guess, as always? Schadenfreude. This dick probably wasn't feeling too great about the life path that led him to manning the security shack at the hospital, so he's going to take the guy he recognizes as a celebrity and try to knock him down a peg.

A day or two later my father took a turn for the worse: he had a heart attack and had to be resuscitated. At a certain point I got the call from my stepmother saying they called the priest to administer the last rites. You don't need a medical degree to know that's bad. So I headed down to the hospital again, with my friend Ray, who has been like a second son to my dad (why he needed a second son when he barely wanted the first one I'm not sure), to say good-bye. We got into his room and found him hooked up to a thousand hoses and ventilators, including one that drained and dripped various disgusting bodily fluids into a clear plastic container.

This is another quick fix my Health and Human Services secretary can make—from now on we will have crocheted body-fluid-container cozies. I really don't need to see the shit leaking out of my decrepit dad into crystal-clear Tupperware.

I held my dad's hand, kissed him on the forehead, freed the family moths that had for years been trapped in his wallet, and made my peace with it. Eventually the bleak prognosis gave way to cautious optimism and then to hope. They began moving my father progressively into less and less important rooms—from the ICU to the recovery unit to a regular room. Eventually he was in a van in the parking lot.

This all took place at a high-end hospital in Pasadena, California. I'm convinced that in a lesser facility he would have died. From the outside this place looks like a luxury resort. Which makes the next part all the more tragic.

After being led to the elevator by Grandpa Walton, I pressed the button for my dad's floor and looked up at the digital readout and this is what I saw.

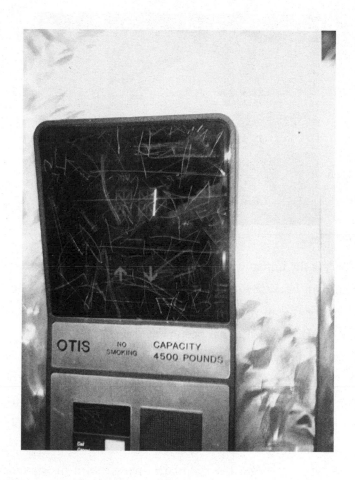

Some shithead gangbanger had taken a drywall screw and carved his gang signs into the smoked Plexiglas cover. This is why L.A. is the most depressing place in the world. Again, this is not County USC hospital in downtown L.A., this was a nice hospital in Pasadena.

Then when I got upstairs I had to use the bathroom. The toilet-paper dispenser, paper-towel dispenser, the toilet seat, and even the underside of toilet seat were all carved up. This cholo assholo took the time to lift

the toilet seat just in case someone from a rival gang wanted to claim the underside of the shitter saddle.

Where is the humanity? Where is the decency? The people are using this bathroom because someone they love is down the hall clinging to life. When they're not wringing their hands they're sanitizing their hands. But fear not, that dispenser has been tagged up too.

When I went to visit my dad a few days later, I was in the same tagged-up elevator with a Mexican gangbanger—maybe the cousin of the guy who scratched it up. He was wearing baggy pants and a tight wife-beater which exposed a shoulder tattoo of a bandito pointing a six-shooter at me. You've got people in extreme stress at hospitals. Why is this guy allowed to further traumatize people with his shoulder tats? What if you walked by a room with a mom inside who was watching her kid, just nailed in a drive-by, cling to life?

This is what you wear to the hospital to visit your beloved relative or homie? Is nowhere sacred? Do we not have a dress code anymore? Can you wrap your junk in foil? Cover your cock and balls in a Crown Royal sack? Is that acceptable attire? Have we fallen this far? This is not the Black Hole in Raider Nation or an airport in Haiti with a chicken

running around. This is a hospital where people go to say good-bye to their elderly loved ones and to read to their seven-year-olds with leukemia.

When I got off the elevator on my dad's floor, I needed a hit off the drinking fountain. (On the drive to the hospital that day I was sipping a Starbucks and had a little coffee mouth going.) As I leaned down into the drinking fountain I took an inhale before I started sipping and smelled something I haven't smelled since my high school baseball-playing days—a large wad of Copenhagen chewing tobacco in the drain.

This was four and half feet from the men's room containing a toilet and garbage can. Yet some dick decided to deposit his chaw here instead.

This is the height of narcissism. We don't recognize the existence of other human beings. The only thought is "I have tobacco in my mouth and I need to get rid of it." In fact, they probably think they are giving you a gift. That tobacco came from His Royal Highness's jowls, and you should be honored to whiff it when you attempt to drink from the fountain. Do you think the animal that committed this atrocity would do it in his own home? Of course not. In my America we will check the security-camera footage and find this asshole. If he was there visiting a

relative who was on life support, we're pulling the plug. Say good-bye to Nana. You blew it, fucko.

It's not just the patients at the hospital that need a little decorum coaching. The nurses and doctors could use a refresher course on bedside manner. They're all a little too casual lately.

I had to get a physical to renew my vintage racing license a year or two ago and that involved a urine specimen. The nurse was very casually handling the cup of my frothy wiz and was making small talk while she dunked test strips and separated it into other containers. I know she does this on a regular basis, but I'm not really used to people playing with my piss.

The fact that she was attractive didn't help. If she had twenty more years and forty more pounds on her, it might be fine, but the fact that she was young and hot made it uncomfortable and semi-erotic for me. I'm positive there are Japanese businessmen that would pay for this service. I wanted to say, "You're too good-looking for this. Send it to the squatty Guatemalan chick in the lab."

It was nice when she was done and dumped it down the sink, thus vindicating my much-questioned practice of pissing in the sink at home. See, honey? I told you it was okay.

Another incident was when I had arthroscopic knee surgery in 2011. I had a torn meniscus that needed to be repaired, so before the surgery I needed a(nother) general physical.

I was sitting on the edge of the table with butcher paper, filling out the health questionnaire with my doctor. She was asking me all the questions about history of heart disease, hepatitis, traumatic brain injury, etc. Then she got to the part about drinking. She asked, "Do you drink?" I replied yes. She asked how often. I stammered for a bit: "Hmm, let's see, it's Tuesday now, so . . . um, every day." That got a look followed by, "How much?" I told her two glasses of wine a night. (Replace "glass" with "Viking helmet.")

Then she moved on to ask, "Do you smoke?" I replied. "No. Well, not really. Only when I drink."

As she started to lecture me about how I should cut back, I noticed I was staring at this:

The picture on her wall was of the world's most famous alcoholic holding a drink and a cigar. Of course I had to comment on it. She confirmed my crazy hypervigilance by saying, "I've had that picture up for eight years and no one has ever said a word about it."

Then I noticed that on the adjoining wall was a similar caricature picture of the Marx Brothers. I said to her, "Why don't you switch them so as you berate people about booze and cigarettes, they're not staring at a guy who smoked like a chimney and has a nice gin blossom on his nose." Her reply to that question was even more confounding than the previous

one. She said, "Well, the Marx Brothers one is on that wall because that's the direction people face when I'm giving the rectal exam," then after a quick pause adding, "They seem to enjoy it."

I assured her that no one enjoys anything while they're getting a digit dropped in them. There has never been a person who was thinking, "Gee, that Harpo sure was funny in *Duck Soup*" while you're cramming your index finger in their ass.

Ugh. I've just recently hit the age where the prostate exam is required. This has provided ample opportunity for the doctor to be super-casual in what is a very sensitive moment. At my first prostate exam the doctor said, "Now it's time to drop the shorts and bend over the table," followed by, "I know you know how this goes." No. No I don't. I'm a straight male and I've done no time in the joint. I do not know how having something shoved up my ass feels. And why the small talk? There is no patter that is going to make this moment any less uncomfortable and traumatic to me. There is nothing you can say to prepare me for this. In fact, if you could just hit me in the back of the skull with a sock full of nickels and wake me up when it's over, that'd be great.

This brings me to dentistry . . .

DENTAL HEALTH IS RUINING MY MENTAL HEALTH

I'd prefer to be knocked out for any and all dentistry. In fact, if you could knock me out for the week leading up to it, that would be awesome. And I will make my Department of Health and Human Services make this a reality. It's necessary.

The evolution of anesthesia in dentistry has gone from "here's a rag soaked in rum, suck on it" to a Novocain shot that hurts worse than the procedure, to "laughing gas which keeps you awake but fucked up enough that we could pull the teeth and molest you a little bit and you'd be cool with it." But the next step is darting people without them

knowing it. The "dread the whole week before the root canal on Friday" is the worst part. I want to make it possible so that while you're out to dinner with the wife, enjoying Red Lobster, you just feel a quick sting in your neck, pass out in your bisque, and wake up with gauze in your mouth and someone informs you that your wisdom teeth are now removed.

I do love me some nitrous, though. Me and Vin Diesel are the two greatest consumers of noz. I was at the dentist and asked for the nitrous and the dick said, "You don't really need it." I replied, "Yeah, but I want it." He then doubled down on the dickitude, saying, "I had an eight-year-old girl in this chair doing the same procedure and she didn't need it." To this I replied, "Good for her. She's a hero. Now hit me." Nitrous is yummy. It makes you feel good, but it can fuck with you if you get caught in the wrong circumstance. I had a root canal once and needed the nitrous. This dentist had the CD player and headphone set up so you could listen to music while he did the procedure. Unfortunately his selection was a little thin. I ended up having to listen to the Manhattan Transfer Christmas album. This was in Burbank, in August. It's beyond weird listening to Christmas music when it's 109 degrees out and you're high as a kite on N_2O.

I also want to force a change in the novelty tooth-polish flavors. Getting your teeth cleaned at the dentist is essentially having an air compressor running a minisander rubbing pumice into your teeth. It sounds like hell and makes my hair stand up on end. Why do you think the fact that wild-mountain-berry flavor toothpaste is going to make it okay? Shouldn't it just be toothpaste-flavored? And don't give me that shit where "a lot of people like that." They just say that because you're holding a sharp electric instrument in their mouth. Unless they want to reenact the scene from *Marathon Man*, they're going to tell you what you want to hear.

We just don't need the novelty flavors. I like piña colada, but I'm at the dentist, not a Jimmy Buffett concert. It's about the context. I also like

brisket and pussy, but not when they're mixed with sand and ground into my teeth.

The thing that drives me most nuts is the fact that when I bring up these simple solutions and fixes to my health care professionals, I'm usually greeted with a blank "never thought of that" stare followed by no action, or worse, "Yeah, we could do that but we don't." A nice dental example of this phenomenon follows.

I was at the dentist for a cleaning and was complaining about the icy-cold water they spray on your bleeding gums and battered teeth after they've gotten done cleaning/raping your mouth. The dentist has taken a very sensitive area, made it more sensitive by poking and prodding at it with sharp metal implements, and then they spray it down with a miniature version of the hose they used to clean up Rambo in *First Blood*. I said to the dentist, "You know what you guys should create? An in-line water heater, something that will warm up the water before you squirt it on my vulnerable teeth." He gave the infuriating answer of "Oh yeah, they have those." Okay. Then why don't YOU have one, asshole? You know the technology exists, you know it would make your patients' experience better, thus increasing your business, but more importantly it would just be the humane thing to do. Why not? Well, since I'm president now, this equipment will forever more be standard in any licensed dentist office.

And since I'm mandating around the mouth, let me throw in this last one for all the female dental hygienists reading this. From now on, when the subject of the BJ comes up in the bedroom, there are no more excuses. You spend your entire day sucking stuff out of strangers' disgusting oral cavities. You can't act grossed out when your man wants a smoothie.

MY ORGAN DONATION NATION

I'm a big proponent of organ donation. I think it's important.

In fact, I think it's so important that in my administration if you have an organ-donation sticker on your license when you get pulled over, you only get a warning. It'll be like the punch card at a Quiznos. The cop will notice you have that little organ-donor dot on your license, punch it out, and let you go. That's your one freebie. I'm not saying you're going free if you get hopped up on prescription meds and plow through a farmers' market, but if you get tagged doing forty-four in a thirty-five, you'll get a pass. In fact, I'll even extend it to the DUI. If you blow a .09 we'll knock it down to .05.

Why is there not more discussion of the need for people to be organ donors? A ton of people get killed in accidents every year and their organs could be used for the kid with the rare cancer. Why not? Why are there more PSAs for proper mercury-thermometer disposal than this? What would save more lives?

And why should you take useful body parts to the grave with you? Maybe it's just because I'm an atheist and I think when you're dead you're dead, but I have no attachment to my internal organs. Go nuts. Harvest away. In fact I'd like to know that some of my body parts are living on. I want to think that my liver continues to get doused in alcohol even though I'm gone and if I can donate my dick that would be cool. It would be like cheating on my wife from the great beyond.

I think that blood donation is important too. And like my organ-donation punch card idea, I have a plan. What blood donation needs is a little bit of my marketing magic. The Red Cross is missing an opportunity. Between the twenty-nine TV shows, three movies in theaters, and

the other fourteen in development, nothing has ever been hotter in pop culture than sexy vampires. The removal of blood has never been sexier. We need to target blood donation to that youth demo. We could make a whole experience out of giving blood, like a cooler Medieval Times. The room could be all dark with red velvet curtains, the technicians can be wearing Dracula capes, the Band-Aids they put on after could be shaped like bloody lip marks, instead of lying on a table we put you in a coffin, etc. The *Twilight* tweens would be lining up around the block.

Then there are the women who say they're donating eggs. I have a problem with this. I'm fine with the gesture that has made it possible for an infertile couple to experience the miracle of childbirth. It's the part where the "donation" nets her fifty grand that bothers me. She hasn't *donated* her eggs, she's *sold* her eggs. Imagine if I sold my Audi on eBay for $30,000, and then announced I "donated" my car. Dudes would never tolerate this. You don't donate your sperm, you sell your sperm. This is like a hooker donating a blowjob for $150. Although, ladies, this *is* your chance to find out exactly what your genes are worth, like a *Kelly Blue Book* for your ovaries. Short, fat, and a GED will get you $185 and a bus ticket back to Fresno. Tall, blond, and a Ph.D. will get you $75,000 and a private jet back to Fresno (it's just a weird coincidence that they're both from Fresno).

THE AMERICANS WITH DISABILITIES ACT

This next section may get a little controversial, but like I said, I'm President Truth Teller. I don't think that half of the people that claim to be disabled actually are. I bet if you took the list of people currently getting disability payments from the government, sent them a letter saying they've been entered to win a million dollars in the Dr Pepper Cadillac Challenge at the Cotton Bowl, and all they had to do was throw a football through a hole in the *P* of a giant Dr Pepper can, 85 percent of them would be on a plane the next day. As president, I'm going to enact this sting operation and save us billions.

What I've been noticing is that it seems like half the people currently in wheelchairs don't need to be in them. When I was a kid and saw someone in a wheelchair, you could tell that was the only way they were getting around. They were missing a limb or two and had their pant legs pinned up. Now you see the obese, or even worse, just slightly overweight woman, get up out of her wheelchair and into the Lark scooter at the Costco and think, "That was a pretty smooth transition. Are you confined to the wheelchair or do you just prefer it?"

All the time, especially here in L.A., I see the guy in the wheelchair pushing himself across the intersection backward with his feet. This makes me mad, sad, and confused. Clearly your legs work, unless you have some obscure disease that renders your knees unable to function in a forward-facing position. So they can push, but if they pull they combust? I don't get it.

The only thing I've seen that is sadder and more confusing than this is when I was heading into the podcast one night and noticed a fat guy riding a bicycle built for two—alone.

But back to wheelchairs. At the turn of the century, being in a wheelchair meant something. If you were unable to walk, that meant you couldn't work at the factory or fit through most doorways. Nowadays the government has mandated I put a handicap ramp up to my bed in case a paraplegic wants to bang my wife. We make everything accessible, especially the workplace. Back in the day, not only would you not be able to work if you were in a wheelchair, but the children playing in the street mocked you by rolling a hoop down the road with a stick. Now you can go to work wherever you want if you are handicapped. Everything we do today is sitting down anyway. If your hands work you can operate a laptop in a cubicle, and even if you're quadriplegic, everything can be voice-activated.

I also feel like I've seen a million handicapped stalls but never seen a handicapped guy taking a shit. Not that I'm into that. I'm sure there are Germans reading this who are turned on by that thought. I always want to use that stall, but feel guilty about it. I know the second I sit down on

that shitter Stephen Hawking is going to wheel himself in there to drop a deuce.

Maybe it's an image problem. It feels like I'm always hearing about people who achieved great things when they've lost limbs or one of their five senses. I've got both eyes and both arms and all I use them for is to masturbate. Every third week on *60 Minutes* they profile someone that has overcome adversity. "He doesn't have the use of any limbs but he pulled himself up Mount Washington with his teeth." Fuck that guy. I'm perfectly able-bodied and it takes everything I've got to get my ass off the couch to grab some Bugles.

The worst is the handicapped guy who's still doing extreme sports. He's got the knobby tires on his chair, which is covered in cool bumper stickers, he's wearing pads and going down the vert ramp at the X Games (probably the same one he went down when he broke his spine in the first place). I guess what I'm saying is *fuck resiliency*.

Before you think I'm too much of an asshole, I'm fine with people who have legitimate disabilities, and providing accommodations for them. I just think that the system is being abused. Our culture has become so narcissistic (and lazy) that half the people I see getting out of cars with handicapped placards are younger and fitter than me.

That's why in my administration I will have a team of guys in unmarked vans patrolling handicapped parking spots, and if they see you take one and you're able-bodied, they will *make* you handicapped with a pool cue.

Maybe there's some confusion about what qualifies someone for handicapped parking. Well, let me make it clear. As far as the administration of Adam Carolla is concerned, here's the simple definition of who gets handicapped parking:

If your cock works, no special spot. That's my Mason-Dick-son line.

Conversely you can be doing one armed push-ups, but if your honker doesn't work then you get to park right up front at the Home Depot.

By the way, I always notice a ton of handicapped spots in front at the Home Depot. For some reason that store seems to have a higher percentage than Kmart or Costco. Why? Are there are ton of quadriplegics putting additions on their houses? Maybe that's how they got handicapped in the first place, falling off a roof trying to install a skylight. I'm just saying we should save two of the eight spots up front for the guy dragging 580 pounds of anchor chain out to his pickup.

One last thought related to disability. We've all seen the blind guy with the long white cane. I understand the need to compact such a thing, but does it need to fold down so small it can fit up your ass? Fishing poles only break down into two pieces. Why does the blind-guy cane need to fold up into a thousand? Won't that make it harder for him to feel around and find when he puts it down on the coffee table?

In general, I miss the old canes. Canes used to be cool. They were made of driftwood and had metallic eagle heads on top or swords hidden in them. Now they're all brushed aluminum and have four feet wrapped in tennis balls. (By the way, tennis balls really have range as far as the pace of the activities they're used for. Nothing is faster and harder on your legs than the sport of tennis, but nothing is moving slower and made to protect your legs more than the tennis ball on the bottom of Grandma's walker.)

As always, I, President Carolla, have a great two-birds-one-stone solution to all of this. All blind-guy canes will now be equipped with metal detectors so they can find some doubloons as their owners walk in the park. And for the regular cane, we will simply attach a nail at the end so Granny can pick up some litter while she walks in the park.

THE TRUTH ABOUT FAT

Nowadays everyone is paranoid about gluten and trans fats. The only time you should be worried about trans fats is if it's your first day doing porn and they say the person you'll be performing the scene with is named Trans Fats.

I had a run-in with one of these assholes when I was doing an interview trying to plug a gig in Denver. From the get-go, I could tell the guy had an agenda because he kept talking about my "right wing" views. Then he hit me about my "controversial" opinion on shaming fat people (more on that in a minute).

He was trying to blame obesity on our "fast-food culture" instead of the fat people themselves. I made the cogent point that I worked at McDonald's and that there was a McDonald's on every corner when he and I were both kids. So why is there a difference now? He said, "Well, the menu was a lot different back then." Yes, it's gotten healthier, dick-weed. They didn't have salad, bottled water, and apple slices on the menu when I was a young politician in the making. If I went into McDonald's when I was eleven and my mom tried to make me order apples, I would've fed them into her asshole like it was a nickel slot machine.

When I argue with people I just hand them a shovel and watch them dig their own grave. So I asked him, "Seems to me like the menu has more healthy options. So what's different today?" He claimed that the food is a lot higher in calories now. I told him that couldn't possibly be true. But like all dumb people going down the bad-argument road, he didn't do a three-point turn, he hit the accelerator.

I told him I'd hang on while he looked up the calorie count for a Big Mac in 1978 vs. today. He said he'd do it after the interview. I said, "No, do it now so I can laugh at you." He fired back, "I'll do it when we're done." I countered, "No. If you do it after I hang up, I won't be able to mock you and your retarded argument falling apart." The guy then said

he didn't have a computer. How fucking convenient. Of course, when I had one of my lackeys look it up later that day, I was vindicated.

This guy wanted to blame our obesity epidemic on the food itself. He's only partially right. Our food today does suck, but it's our will that is really the problem. Big Macs haven't gotten any less healthy for us. It's that we're morally weak, there's a fast-food joint on every corner and they're open 24/7. These places used to close and you'd only go there once in a while. Not too long ago, Taco Bell introduced the "Fourth-Meal." I thought brunch was the fourth meal, but apparently the fourth meal happens between midnight and two A.M., when you're shit-faced.

And of course the sizes are absolutely insane. Every commercial you see now for food is about cheapness and portion size. The voice-over says, "Come down to Hometown Buffet" and they show a guy with a Fred Flintstone–sized rack of ribs and a waiter using a pallet jack to bring the food to the table.

ManDate

Buffets are now illegal for anyone over two hundred pounds that makes less than $35,000 a year. Because when you're poor and somebody says "$7.99 all you can eat" your mission statement is "They're going lose money on this fat hombre." I know, because when I was poor I used to apply basically the same principle to renting porn.

Nothing is about health or quality, it's all about price and quantity. Today you've got 7-Eleven drinks the size of an aquarium. They might as well make one called the Dunk Tank. You just crawl in and use the straw to breathe. I'm not trying to go all Mayor Bloomberg on you, because I'm not big on the government getting involved in this area. But the more fat people there are, the more fat acceptance there is. This is a strain on our health care system, not to mention our bridges. Hell, if you factor in the effect of weight on gas mileage, this is having a major impact on

global warming. Seriously. The bottom line is, fat ain't free. That's why I'm fully behind so-called fat shaming.

This is a term that gets me in trouble, especially with chicks. But I'm not saying we should put fat kids' pictures in the paper or stand them in the town square and take turns pelting them with rocks. I just mean we shouldn't accept obesity as okay. People need to feel the sting of some stares as they waddle down the street. If you visited a person's house and saw them slap their nine-year-old, you'd call Child Protective Services, but if that same nine-year-old were 210 pounds, you'd quietly judge the parents but allow them to feed their kid a breakfast of Slim Jims and Mr. Pibb.

We feel bad shaming the kid but the real shame is going to come in a few years when he can't get a prom date or play sports. So he'll be depressed, won't find a good job, or fit in one airplane seat. Then he'll really feel shame. If you had to make the choice for your kid to be obese or a smoker, you'd want them to be a smoker. Being fat will kill them sooner and will certainly cause more discrimination in their shortened life. They'll lose more jobs and potential relationships from being fat. Especially as a woman. A chunky chick will always lose more opportunities than one who smokes. It's a sad but true fact. This is the ultimate discrimination. I'd argue that every man alive would take a seven or above from any nationality over a fat chick with blond hair and blue eyes. I don't think it's any different when you're a business and you're hiring a receptionist. You want to put your best face forward when a customer comes in the door, and if that face has an extra couple of chins it's not a good thing. Race takes a backseat to fat in the discrimination department. This is the ultimate thing not to be.

Unless you work at the Magic Kingdom. When I took the kids to Disneyland a year ago I could not believe how fat the female employees were. I'm not talking about 15 pounds of "she's got a little extra ass on her, what a pity" fat. I'm talking 120 pounds overweight. The chick running the Jungle Cruise was bigger than the fiberglass hippo she was pointing at.

And they usually came in pairs. It was like a live Tweedledee and Tweedledum, except they were nineteen-year-old Mexican chicks. This is not a good plan. I think we need to team up the skinny ones with the fat ones. Mobile shaming. You don't want to have the two fat chicks deciding on what they're going to get for lunch. You need a skinny one in there to toss around the idea of getting a tossed salad.

I was in a hotel in Boston last year before a gig, bouncing through the channels when I came across some Three Stooges. And because I was in a hotel room I beat off to it. Rules are rules.

Anyway, when I was in my refractory period it occurred to me that Curly is not fat by today's standards. I hadn't seen the Three Stooges since I was twelve and I remembered Curly being "the fat one." But if you put him up against the average female employee at Disneyland, he's a middleweight. I'm not saying he was skinny. He was no Kate Moss, but he may have been a Kate Upton.

The point is I could go to any mall in America and find ten tweens who are fatter than Curly. He was five seven and 192 pounds, with a little bit of a gut on him, but he would not be fat in today's society. Perhaps if he ate some more of those pies instead of getting hit in the face with them, he could get as husky as the teen behind the counter at Hot Topic.

The worst part is that we can easily rectify this with a little discipline. We don't need any new drugs or fad diets. There are three hundred thousand diet books currently in print and ten new ones coming out every day. How much fresh information could you possibly glean? Eat less, move more. That's it. There's no need for a diet book. Everything you need to know about losing weight could be printed on the back of your driver's license or a business card.

Dig this analogy/advice. Your body basically works like a hot-air balloon. It's all about maintaining a consistent altitude through the ratio of weight to fire. If you want to put a bunch of heavy stuff into the gondola (like mashed potatoes and chicken pot pie), you're going to need to stoke the flames extra hard (i.e., exercise). Michael Phelps can eat whatever the

fuck he wants because he spends nine hours a day in a swimming pool. His fire burns so hot and so often that he could butt-chug a garbage barge of tapioca pudding every night before he went to bed and still never gain an ounce. You and I are only willing to commit twenty to thirty minutes a day on the stationary bike, thus we've got to keep track of what's going in the wicker basket. Man, I'm getting heavy here— pardon the pun. You can also choose not to exercise at all but that means a lot of celery and jicama in the basket.

That's why as much as I want shaming to get people to go to the gym, I don't want any shaming when they're there. If they've hauled their fat ass up onto the treadmill, I don't want the skinny bitch training for the marathon next to them making them feel bad that they're slowly walking on a zero incline. This even goes for healthy people, like me. I've been at the gym in the hotel and do my twenty on the treadmill and the chick who is on the one next to me is still chugging away even though she was already sweaty and miserable when I got there. Cut it out, lady. Everything in moderation, okay?

ManDate From now on there is a time limit. Go at it as long as you want beforehand, but as soon as someone gets on the treadmill next to you, you've got twenty-two minutes to wrap it up. You're free to go back to your hotel room and do lunges, but you need to vacate the gym and quit shaming the people around you who don't have your commitment, intestinal fortitude, and eating disorder.

A side note: I'm declaring the inverse of this treadmill rule for the urinal. There is nothing worse than when I'm standing at a urinal and the guy sidles up next to me and finishes first. It makes me feel like I either have a prostate issue or have been drinking too much. It makes

me self-conscious. I want to turn to him and say, "I only piss like twice a week. It's Wednesday isn't it?"

CELEBRITIES AND ALTERNATIVE MEDICINE

We used to trust doctors. We knew they had more education and experience than us. In today's narcissistic culture we treat medicine as a matter of personal opinion. That's what I love about carpentry: I get to be an expert. I can tell you the nailing schedule on shear wall, that if you have exterior hinges they have to be NRP (nonremovable pins), and no one is going to question me. Now everyone has shitty medical information from the Internet, celebrities, and their life coaches. They turn to people who failed out of junior college to tell them they can cure their cancer with purified water and good vibes. Oh, and if they align their chakras. For those of you who don't know, chakras are those things that don't exist that chicks with too much time and too little IQ believe are in their body, even though you can't find them on an MRI. Disturbances in these chakras cause every physical, mental, and even financial ailment known to man. So if you have anything wrong—from a headache to getting laid off—it's time to talk to someone who specializes in fixing your chakras. And guess what? These spiritual healers *always* find a problem. Something is wrong with your root chakra and God forbid something happens to your crown chakra. That's really going to fuck up your third eye. It's like going in for a free brake inspection. They're going to find a problem. Just like Manny Moe and Jack with the brake pads, these shaman sham artists are never going say that you're completely in alignment and clear. Nope, you're gonna need some healing stones and white sage smoke to the tune of eighty dollars an hour. Of course it's all a big fat placebo disguised as the wisdom of the East.

What happened? Doctors used to be doctors. In the Old West the entire area would have one doctor that everyone trusted to fix what ailed

you with a little whiskey and surgery on a kitchen table. It wasn't like some hippie would show up and say, "Hold on. I have a friend in Dodge City whose aunt was cured by an Oriental who burned a cat whisker."

The worst offenders when it comes to this bullshit are celebrities. When they're not pretending to be climatologists, they have a lot of thoughts on "Western medicine" or, as I like to call it, medicine.

The worst of the worst is Jenny McCarthy and her crusade against vaccines. I feel bad that her kid has autism but her quest is a dangerous mix of denial, self-entitlement, and having a megaphone. She can't handle the idea that some random piece of shitty fate struck her. Not *her*! That's for poor people in another part of the world. There must be an answer! A cause. So she hops on the Internet, finds some bullshit, spouts it as fact, and convinces a large segment of mothers—mostly fellow paranoid white ones with too much money and not enough problems—that vaccinations cause autism. Meanwhile a generation of kids will get tuberculosis, measles, meningitis, etc.

Why did anyone listen to her? She won Playmate of the Year, not a Nobel Prize. Could you get any farther away from a lab than the Playboy Mansion? I don't think there's a ton of Bunsen burners in there and it's certainly not sterile. Unless you're researching syphilis, the Grotto is not exactly the lab at Pfizer.

Speaking of, let me do a quick tangent on Jenny McCarthy in *Playboy*. She posed in that again a couple of years ago and everyone was like "She still looks good at forty." Sure. But we were first introduced to her in *Playboy* when she was nineteen. We still have those pictures. We don't need to see her at forty. If she were an astronaut, race-car driver, or Senator McCarthy, that'd be one thing; there'd be a novelty to seeing her at forty. But the whole reason we know she exists is because we saw her naked. Do we need to see her now that she has barnacles? No guy looks at a hot nineteen-year-old and thinks, "Man, I can't wait to see her when she's forty." Did we run out of nude twenty-one-year-olds?

Anyway, Dr. Drew has a $500,000 education, years of training and

internships, and yet people give more credence to the chick with the fake tits from MTV. Why? Because she's peddling easy answers while Drew has an obligation to tell the hard, fact-based truths.

That is why I'm naming Dr. Drew Pinsky my Secretary of Health and Human Services. He's a real doctor. I've always described him as an "airplane doctor." Imagine you're in coach, halfway through a flight from L.A. to New York. You start feeling some chest pains and get the stewardess. You're having a heart attack. She starts looking to see if there is a doctor on the flight and heads up to first class. She could come back with Dr. Laura, Dr. Phil, or Dr. Drew. Trust me, the one you want her to have on her arm is Dr. Drew. He could actually save your life. Drew gets incredibly annoyed when people lump him in with all the TV doctors. He's not a celebrity. He is a medical professional.

A little sidebar directed to Dr. Oz: We get it, you're a doctor. The word "doctor" is right in your name. You don't need to wear scrubs everywhere. Every time I see you on TV you're wearing those blue scrubs. Are you about to do emergency surgery or talk to housewives about their colon health? Joe Namath doesn't have to wear his Jets uniform everywhere. We know it's Broadway Joe.

A subsidebar to my scrub sidebar—this is something I will have Drew address as HHS secretary. What was the plan with scrub sleeves? It seems like the guys designing them couldn't make up their minds. One wanted to go all the way to the wrist and one wanted to go sleeveless and they settled on an unsatisfying one-third of the way down the arm that accomplishes nothing but accentuating how skinny the doctors' arms are and how fat the nurses' arms are.

To the pediatric doctors with SpongeBob or panda scrubs, God bless you and your work, but I've got to think that your fashion choices are freaking kids out. They're injured and scared and anesthetized. They don't need to see some blurry shape covered in pandas coming at them with a rib spreader.

And why that color choice for scrubs? We don't want to see doctors

covered in blood. It's unsettling. Nothing makes blood pop more than light blue scrubs. It's like at the end of a boxing match, if the fighter is wearing white trunks, it looks like he's having a heavy flow day. No one wants to see that. From now on scrubs are to be red for the same reason my underpants are black.

Okay, back to Health and Human Services.

I have always wondered about the percentage of young males who died of alcohol poisoning that came into the morgue with a cock drawn on their forehead in Sharpie. Of the couple thousand sixteen-to-thirty-year-old dudes who choked on their own vomit after a night of binge drinking, how many of them had frat-house buddies who covered them in dick drawings thinking they had just passed out? And what's the protocol in that situation? Isn't the right thing to do as the coroner to bust out the Windex and clean that shit off? I imagine the poor parents of the twenty-year-old sophomore at CSUN having to come identify the body. "Yes, that's Trevor. He didn't have the dick and balls on his forehead last time he Skyped with us, but that's him."

Drew does fall into that Doctors without Decorum category. The best example of this is something I've been beating him up for years about. On *Celebrity Rehab* you'll always see what I like to call "The Van of Shame." The group will be going out to an animal rescue as part of their rehab and will all pile into the white van with the giant "Pasadena Recovery Center" logo on the side. I thought part of the recovery from being alcoholic was the anonymous part. Why do you need to humiliate the people in that van by advertising that they are addicts? I've told Drew either just keep it blank, or write AIRPORT SHUTTLE or FOGHAT on the side.

Dr. Drew Pinsky will be a great Health and Human Services secretary because we are completely simpatico on the two greatest health and public safety concerns facing the country—unwanted kids and mental health.

Let's start with the mental health part. I sat next to Drew for ten

years on *Loveline* trying to cure the kiddies. In that time I picked up a lot from him. One thing I gained is a keen awareness of undiagnosed and untreated mental health problems and how it has an exponential effect on our society. The damage spreads faster than herpes in Paris Hilton's hot tub.

It's the guys with undiagnosed or untreated schizophrenia, addiction, PTSD, and bipolar disorder that are defecating in the parks, not paying taxes, filling the emergency rooms, and getting shot by cops. But we're narcissistic; we can't imagine the world through other people's eyes. We have much more awareness and empathy for Sarah McLachlan and her abandoned dogs than we do for the guys sleeping under the freeway overpass. We imagine that guy's life from our viewpoint and treat it like there was a choice. We can't imagine being a dog, so we say, "It's not his fault he's abandoned." But we look at the homeless guy like "He's sleeping in a refrigerator box, what an idiot. He should have Just Said No like Nancy Reagan told us to." We need to realize that viewing the mentally ill through the filter of our mentally healthy minds is not helping them.

Politicians won't touch this. It's not glamorous, they can't hang their hat on it, but mentally ill people are costing us money. There is a tent city in downtown L.A. full of these guys. Let's start with that before working on the light rail to Sacramento, okay?

On this note, when it comes to my federal budget, I'm going to peel off a little extra for L.A., for all of our extra nut jobs. I think showbiz attracts them, plus our hobos stick around. They're crazy, but not so crazy that they'll go somewhere that has a brutal winter. Maine doesn't have the issues with psychotic homeless guys that L.A. does, so I'm going to earmark a couple extra million for SoCal.

I'm also going to create an awareness campaign. No offense to the good people involved with the breast-cancer charities, but I think we're all completely aware of breast cancer. I would just like to take one month off breast-cancer awareness and put it on mental health awareness. Instead of the guy in the NFL wearing pink cleats, I'm going to put him

in a Napoleon outfit, and when he breaks out into the open field have some guys in white jumpsuits chase him with butterfly nets. It'll be great watching him trying to hold the hat on as he's running. And we'd replace the ball with a jar of change meant for UNICEF that was stolen from the counter of a 7-Eleven.

Why not? We have PSAs for a hundred other things that we don't even need to be aware of. I saw one the other day imploring everyone to "Be Track Smart." It features a group of teenage girls in a car. Of course there had to be one of every race, as if the car wouldn't run if it didn't have a white chick, an Asian chick, a Hispanic chick, and a black chick.

They are all headed to some multiracial cheerleading camp or something and come up on a railroad crossing. The gates go down, the lights and bells are flashing and dinging, and the white girl behind the wheel says, "I bet we can make it. I've got this," then tries to zigzag through the barriers and of course doesn't. The ad ends with the girls all screaming as they get cleaned out by a speeding freight train.

No kid is ever going to see this, and if they do they're just going to laugh at it. I bet this actually encourages more stupid teenagers to attempt beating the train across the tracks.

And even if this ad is 100 percent effective, it saves, what, ten lives a year? And costs how much? At least $100,000 just to make it, never mind the distribution costs of getting it out there. In the time you read that last sentence, our lack of awareness and resources for chronic mental illness cost us over a million in public defenders, cops, and prison guards to deal with the unmedicated whack jobs inhabiting our streets who end up in our jails.

The second major health initiative I will enact is to prevent unwanted pregnancies. My feelings on this topic are well known to anyone who has listened to me for ten minutes. I think unwanted kids are the problem that underlies every other problem in this country. But what do we do about it? I have come up with a genius idea. As detailed earlier, I can't stand the bullshit Click It or Ticket campaign because every

car manufactured after 1968 was required to have seat belts and every car since 1975 has had the warning light and chime when the belt isn't buckled.

We need to apply this technology to the boudoir. From now on any bed manufactured in my United States, or imported into my United States, will be equipped with a giant orange light-up, beeping, buzzing placard in the headboard. It will look like this:

And it will go off every time you attempt to mount your old lady without a condom. Problem solved.

8

THE DEPARTMENT OF AGRICULTURE

I don't give a shit about farming. I know Willie Nelson talks about how important it is, but I don't look at a head of lettuce and think, "How did that get there?" Somewhere along the line we decided all farmers were noble and that the government or big corporations were out to get them. John Mellencamp is constantly singing about the heartland and blood on the plow, meanwhile he's in New York and the only plowing he's doing is a model's vagina. And we all know the only crop Willie Nelson is interested in. (By the way, can we just pass the hat and get that guy a new guitar? It's the only thing on the planet that looks more beaten and haggard than him. Maybe that's why he keeps it.) These guys just glommed onto a topic that gave them some dirt road cred and are riding it for all it's worth. I'm not afraid to stand up and say, "Screw Old McDonald and his fucking farm."

Plus, I'd make a terrible farmer. I'd just be looking around at all the open space and thinking, "Can't we just put some condos here and make some money?" And you know my stance on waste. The idea that every fifth sugar beet you pull out of the ground has a fungus on it and you have to throw it out would drive me insane. I get that we need agriculture, but I just don't have a lot of strong opinions about it, with the exception of the following ten pages.

VEGETABLES AND VEGETARIANS

ZUCCHINI: I'm sick of zucchini. There, I've said it. I don't care what kind of backlash I get on Twitter. This is an important topic and we need to start a dialogue. I don't need it anymore. And don't give me that "what about when it's deep-fried?" shit. You can deep-fry a golf ball and it would be fine. If you cut off my son's finger, rolled it in bread crumbs, and deep-fried it, I'd eat it. I'd probably need to dip it in ranch dressing first, but still. "Well, what about zucchini bread?" Fuck off. You can put anything in cake batter, toss in a bunch of sugar and chocolate chips, and it'd be good. It's like wrapping everything in bacon. It's a culinary apology.

That's just it. Zucchini can't stand on its own. That's how I judge it. Grating it into something that's already fantastic doesn't count. Like sometimes you'll get zucchini pieces in lasagna. That lasagna would be fine without it. Zucchini brings nothing to the party. It has no flavor. Cucumbers mock zucchini in the flavor department. There are plenty of foods—like the lonely beet—that don't get their due. But zucchini is just using up space. I hereby ban the use of zucchini for the duration of my term. And should I be reelected, I don't even want to have to discuss this. It is over for you, zucchini.

Here's how you know it's worthless. No dietitian has ever said, "You need more zucchini." No vitamin commercial ever claims, "It has more

vitamin B than zucchini." What the fuck is a zucchini anyway? I think it's kind of coasting on a cool name. It's a combination of "Zeus" and "bikini." It's just a green skin that holds flavorless moisture. It has all the taste and nutritional value of a water balloon.

TOMATOES: I enjoy tomatoes like any decent Italian. I like a Roma tomato and I especially like the beefsteak tomato. That sounds awesome. Beef? Sounds good. Steak? Yes, please. Tomato? Definitely.

But the cherry tomato is just a tough skin full of puss. The fact that I'm supposed to eat the entire vegetable is the worst part. This would be like a lobster that's all shell. It's like eating a paintball. You bite into it and it explodes in your mouth in a very homoerotic way. Plus the name is misleading. I like cherries and I like tomatoes but this is the worst of both.

I know I called it a vegetable and right now there are several know-it-alls who are saying, "Technically a tomato is a fruit." Well, it's a fruit and you're an asshole. I'm the fucking president and if I say it's a vegetable it's a vegetable.

And while I'm on tomatoes, let me say this about tomato soup. Perhaps Campbell's has ruined it for me, but this just tastes like ketchup that has been sweetened and heated. Tomato soup is the reggae of soups.

Here's why. People always qualify reggae when I say it's a shitty genre. "Well, what about when you're sitting on the beach drinking a Mojito and getting blown by the Doublemint Twins? Reggae is great then." Of course. But the sound of your mother being sodomized would be enjoyable while you're relaxing on a beach drinking a rum-based cocktail out of a pineapple.

It's the same with tomato soup. Later today, with a friend or co-worker, bring up how much tomato soup sucks and set a countdown for how long it takes them to get into the location. It always ends up with,

"Yeah, but on a rainy day, when you're home from school and your mom would make you a grilled cheese . . ." That's how you know tomato soup sucks. They don't do that with minestrone or beef and barley. It's never, "What if we were at a raging bachelor party and a topless chick comes out with some beef and barley soup?" The quality of a soup should not depend on the situation.

Maybe we should commandeer the bread bowls from clam chowder and give them to tomato soup. Clam chowder is the one soup that doesn't need the bread bowl. It stands alone. It's not like you get the crock of clam chowder and toss it on the floor saying, "What the hell is this crap? Why is this not being contained by sourdough?!" Chowder is atop the soup pyramid. It's almost a stew, which is the highest compliment you can give a soup.

CELERY AND CARROTS: These are just something they put on the side of buffalo wings to make fat guys feel okay about eating them. You tell me if there's a bigger contrast than that. Wings are nothing but grease, fat, and bones dipped in ranch or blue (pardon me, *bleu*) cheese dressing. There's nothing worse you could put in your body, but it always comes with a couple of celery and carrot sticks. Has anyone ever had a plate of wings delivered and gone for the celery first? Never. In. The. History. Of. Man.

PLANTAINS: These divide our nation. They're tearing us apart. We've got to get rid of them. You can take all of humanity and split it into two categories—people who love plantains and people who hate them. If you go out for Cuban food with a friend, you either have to eat them for him or fend him off from taking yours. I'm convinced this rift has been the cause of innumerable divorces.

Plus they're Cuban. This is essentially a communist banana. Not in *my* America.

VEGETARIANS: Last year I was at a shitty house in Covina shooting my Spike TV pilot, which is really the only reason anyone should be in Covina. We were breaking for lunch and someone had run to the Quiznos to grab food for the crew. He got the usual suspects—roast beef and turkey club. But among them was the box of veggie sandwiches. A whole box of vegetarian subs.

A veggie sub is somehow worse than just vegetables thrown on the floor. It's some wilted lettuce and a bell pepper in stale bread with some mayonnaise slathered on it. But here's the point—even though way less than 2 percent of the crew were vegetarians, 33 percent of the sandwiches were. And of course what happens? The turkey and the roast beef get devoured immediately and we're left with a dozen veggie subs.

If you're vegetarian you should have to bring your own shit to work. We're going on a sandwich run; we're getting meat and bread. That's what a sandwich is: meat SANDWICHED in between two pieces of bread. We could possibly consider a grilled cheese in the mix, if you've been good. But we're not going to get an extra box of crap just because your skinny vegan ass hates food and your stepdad, I assume, molested you and then enjoyed a nice T-bone steak, thus your aversion.

It got worse a couple days later on the same set when I found out the lunch was vegetarian chili. I asked where the regular chili was for the regular people. There was none. Just the five-gallon vat of vegetarian slop.

This was an attack. I don't eat nearly enough chili. I'm putting it up there with fish and chips, Bugles, and rice pudding in the Mount Rushmore of foods I love but never eat. (Note to self: Invent Bugles stuffed with chili.) I average a teaspoon of chili a year. So to have that intoxicating smell and mouthwatering visual put in front of me only to be robbed of the meaty climax was a tragedy.

There's no such thing as vegetarian chili. Chili needs parts of something that formerly had hooves on it. Vegetarian chili is like smokeless

cigarettes, nonalcoholic beer, and decaf. You've removed the best part, the essence of the thing. I want my shit to have shit in it. If I get a hooker I want her to come with a vagina.

Of course I couldn't let this travesty go unnoted. As the saying goes, "All that is necessary for the triumph of evil is for good men to do nothing." I ranted and raved at the crew until one guy from the carpentry crew (yes, a carpenter, one of my own) admitted he was a vegetarian. He only added to my rage by saying there was another vegetarian guy on the staff but he wasn't there that day. I got the assistant director to tally the crew. There were thirty-plus crew members and among them one vegetarian.

And I don't even consider this traitor a vegetarian. I don't think vegetarians even exist. There are omnivores like me, and narcissists who need you to know they don't eat meat. They're not vegetarians because they love cows and pigs, it's because they love attention.

I ran into one of these "vegetarians" at Carney's in L.A. This is a hot-dog-and-burger joint shaped like a train car. Once a month I take my son there. He calls it "the hot-dog train," which I tell him not to do because it sounds pretty gay. They do a good hot dog and a pretty good burger. That's what they do—burgers and dogs. Of course, when I took the kids there, I got stuck in line behind the guy who decided he needed to order the veggie burger. The chick behind the counter was confused. It was probably the first veggie burger that had ever been ordered there. This gummed up the whole works. That place is essentially a hot-dog assembly line. What the fuck are you doing there if you want a veggie burger? Get that shit from Whole Foods and cook it at home in a shroud of shame. But hey, you got written about in a book. I noticed you. Mission accomplished.

In my administration we will start tagging these vegetarians and tracking them. That way when they show up to the jobsite, they get handed a green beanie. Then, if they get out of line and start making lunch

demands, they're going to be put on an island where eventually they would start eating meat—each other's flesh!

These are the same hypochondriacs who blather about toxins. They have to work it into every conversation. You can say to them, "I need a ride to the airport," and they'll follow it with, "Well, I'm on day four of a cleanse to get the toxins out of my body." I didn't ask you to take me to Arby's. This is a topic that drives Dr. Drew nuts. We'd always take calls from these assholes on *Loveline* who would say, "You know your body is basically a sponge that absorbs toxins, right? We live in a toxic environment. Do you ever wake up in the morning and feel tired? That's your body storing toxins. Ever get tired around three or four in the afternoon and can't focus? Toxins." Drew would always challenge them. He'd say, "Tell me what the molecule is. What is the chemical formula for this toxin that you're speaking of?" Of course they wouldn't have an answer. What they would have is a stupid metaphor they don't actually understand like, "You know how your car has a radiator. It's filled with gunk and residue and you need to clean it out. It's just like that with your body." Thank you, Sanjay Gupta. What the fuck are you talking about? You got put on academic probation at junior college. You're just spouting a bunch of bullshit you heard from another stoner at a drum circle.

Before I move on from vegetables to other areas covered by the USDA, I ought to name a Secretary of Agriculture. I'm going with Terry Schiavo. Not just because she was the world's most famous vegetable but because she's no longer with us and I'm committed to reducing the size of government.

MEAT AND CHEESE

There was a lot of hand-wringing and paranoia a year or two ago when they found some horsemeat being sold in Europe as beef. At the time I thought, "Who cares?" Why do we prioritize some animals over others as far as what is fit for us to consume? It's all just protein. No matter what it is, you're going to shit it out in fifteen hours anyway.

What's the different between a cow and a horse? They've both got four legs, hooves, and eat grass. If you showed someone from a different planet a picture of a cow and a Clydesdale and asked, "Which would you rather eat?" I bet they'd go with the Clydesdale. It looks like it has more lean meat and it comes with its own beer.

Was there some agreement reached between man and horse back in the Stone Age? The horses were like, "We'll let you ride us, but only if you promise not to eat us. Agree?" And we came back with, "Yes, but occasionally some guy in Florida is going to want to fuck you." "Okay, deal."

On to cheese. I think we need to have a bleu ribbon panel convened to get us all on the same cheese page. We need clarity. I'll tell you the triggering incident for this.

I was waiting for my buddy Kevin at a diner. We were going to work on a script together. I beat him there by a little bit, so I ordered an omelet with peppers, turkey sausage, and Jack cheese. It came out and upon first bite I knew something was off. It was pepper jack. Pepper jack is not a real cheese. It's the synthesized, pepper-infused knockoff of real Jack cheese. I was blindsided by this, because you expect the rubbery synthesized prepackaged slice of American or Swiss, which is why I specifically ordered Jack with my omelet. I don't want that fake shit. That crap doesn't come from a cow, it comes from canola oil and a laboratory.

This stuff is always way too salty, ruins the taste, and doesn't act

like real cheese. It doesn't melt properly. For example, you can't put real cheese into hot dogs or stuffed-crust pizza. Only fake cheese can be injected into those pieces of retard chow.

After Kevin arrived and I spouted at him for ten minutes, I went up to the counter to get my cheese situation sorted out. There were six people in line and, I shit you not, while I was behind them someone ordered a pepper jack pizza. As far as my Justice Department is concerned, this is a felony offense. Eventually I got to the front and talked to the chick who had initially taken my order. I told her what had happened and asked politely if I could have it remade with regular Jack cheese. She said this fake pepper jack was the only Jack cheese they carry. How about that information up front, bitch? When I order Jack cheese you should probably warn me that the only variety you have is the one that was made in a lab and tastes like a Mexican wiped his ass with it.

Dejected, I told her, "You should probably tell people that." And she had the gall to say, "I'm pretty sure I told you."

This incident points to a bigger issue beyond cheese. Whatever happened to "I'm sorry, sir, we'll fix that right away, our apologies." This is the Nike "It's Your World" generation at work. She even followed it up when I contradicted her, with, "Well, I heard it somewhere." I then had to warn the other people in line that I was going to be a dick and possibly reach across the counter and beat her with a skillet. I was furious. Don't push this back on me, lady. This is your horrible decision; don't pretend that I didn't ask correctly.

Don't get me wrong; there is a time and a place for American cheese. Just not an omelet. The grilled cheese is the one place where I like American cheese more than cheddar or Jack. American cheese melted on some toasted buttery white bread is great. But American cheese melted in a quesadilla is an abortion. You must go with cheddar or Jack (NOT pepper jack) in the quesadilla. Why? Both are just slices of carbs made from flour encasing some melted cheese. Why so great a chasm?

ManDate

While we're talking quesadillas I have a quick mandate for tortilla manufacturers. One out of every four must have a picture of Jesus on it. It'll just be fun to fuck with the Latinos.

Before we move on from Mexicans and cheese, let's talk nachos. It is hereby federal law that the pump squirt of Velveeta goo you get on nachos at a ballpark or the movies is banned. It is not cheese. It feels like Dow makes it. If it were green instead of orange and sold by Mattel instead of Kraft, there'd be a warning sticker on the container it came in saying, "Do Not Ingest and Do Not Expose to Open Flame."

We need to address nachos in general. Nachos have an incredibly short window in which you can enjoy them. Is there anything that starts better and ends worse? Pizza, when you let it sit around for a while, goes from a nine to a seven. Nachos go from a ten to a negative twelve. They go from the world's greatest food to a soggy pile of hippo flop before you even know it. At some point the chips are like "I can't take the weight of this guacamole another second. Oh shit, here comes some sour cream! Fuck it, I'm going back to being a tortilla. I can't stay solid anymore." There's no such thing as a nacho doggy bag.

We have overshot the mark with the nachos. We started piling on too much stuff. For years it was, "Hey, I've got an idea. Let's take some tortilla chips and melt cheese on them and maybe a couple jalapeños on the side." But somewhere along the line it became, "How about we add a snow-shovel worth of fake guacamole, a chub pack of ground beef, and top it off with a bucket of sour cream." At a certain point this perfect dish went from nachos to a nacho sundae.

But this isn't an issue if you eat your nachos right away. That comes with a completely different problem. Nacho cheese ends cold and congealed, but starts magma hot. If you eat them too soon you burn the roof of your mouth.

What did God have in mind with the roof of the mouth? Feet are

tough. I could go out and walk my dog barefoot because the skin on my feet is tough. We're designed that way. Our feet and our hands are tougher because they make contact with hot, cold, and sharp things all the time. So why is it that the roof of your mouth is such a pussy? A cup of Top Ramen that was in the microwave eight seconds too long will fuck you up for a week. Why is the roof of your mouth as soft as a baby's bottom? Why did God make that the most sensitive part of our body when it takes the most punishment? It should be like the shell of a horse-shoe crab. I should be able to wash down a fistful of the world's sharpest object—dry Cap'n Crunch—with a pot of hot coffee, while laughing the whole time.

My last straw with the fake cheese is the little packets of Parmesan at pizza places. The sixteen-inch-diameter disc covered in mozzarella isn't enough cheese for you? You have to sprinkle on a weird packet of white dried-out sawdust passing itself off as Parmesan?

As a proud Italian American, I find this offensive. Parmesan is great and doesn't need its reputation sullied by this impostor. I love Parmesan. I've often fantasized about opening a theme restaurant called More Parmesan. Every time you go out to the Italian joint the waiter stops by and asks if you'd like Parmesan. He either then sprinkles it on with a spoon, or even better, grinds it fresh onto your plate. But eventually he slows down and asks if that is enough. You feel weird and don't want to be fat, so you say yes. But three bites in, you need more. At More Parmesan the waiters will constantly be coming by—in fact they may never leave the tableside; they'll just sit there and grind Parmesan on your pasta. Hell, they'll put it in your martini unless you tell them not to.

I'll wrap up with this food-related observation and rallying cry. I was thinking about the decline of this country and how everyone just spits their gum everywhere and blows snot rockets on the sidewalk or leaves pubes on top of the urinal, and then it occurred to me what the issue was. You know what we're missing? Stew and casserole. If you had a graph charting stew and casserole consumption and America's greatness,

the line of decline for both would be the same. (By the way, *Stew and Casserole* would also make a great eighties cop show. Thurston "Stew" Stewart plays by the rules and wears a bow tie, but his partner, John "Casserole" Cassorelli, is a loose cannon in a leather jacket.) I say we get back to eating some hearty stews and casseroles. About the time we started eating wraps is when things started to take a shit in this country. And then when smoothies came in it was all over. All I know is this—the heroes who stormed the beaches of Normandy didn't have a peach-guava smoothie in their belly. So Mamas, let the word go forth from this time and place—get in that kitchen and start rattling them pots and pans. Let's make this country great again.

THE SECRET SERVICE

I don't know what the budget is for the Secret Service but I think I can significantly cut down the cost. As President Carolla, I won't need a bunch of guys in sunglasses and black suits. I just need some crows. A flock of attack crows would be the ultimate in security.

These are the meanest, smartest animals on the planet. Pigeons are ten times dumber than crows, and we can train pigeons. We are clearly not utilizing a valuable resource here. I once heard that crows are second in weight-to-brain-size ratio behind humans, and are number one if those humans are from Florida.

Those K-9 unit German shepherds are thirty-grand worth of training and breeding down the drain when the meth head in his underpants waving a machete around at a 7–Eleven slashes the dog just before the police finally Taser the idiot. Not the case with crows. They're cheap and abundant. They could live on the White House roof and all we'd have to

do is put out a can of corn once a week. Then, whenever the motorcade left, they'd follow along. And if anybody got too close to me they would swoop down in a sea of black wings and razor-sharp beaks and talons. Death from above.

I don't care who you are or how crazy you are, when an angry gang of crows comes at your head, all you can do is run and scream like a girl.

They can fly forty miles an hour, they're black, and they're stealthy. Plus a group of crows is called a "murder." How badass is that? This is my new security detail. If John F. Kennedy had had my attack crows on that fateful day in 1963, he'd still be alive today. (Actually, he would probably have been claimed by syphilis in the seventies, but you get my point.)

9

THE DEPARTMENT OF THE INTERIOR AND THE NATIONAL PARKS SERVICE

A good president is an environmentalist, sportsman, and historian because he has the solemn and sacred duty to be a steward to our majestic national parks and historical sites. He must protect the land and the noble creatures that inhabit it and preserve the birthright our forefathers bequeathed to future generations.

With this in mind, we're fucked. Everything I know about our park system and historic landmarks I learned from the *National Treasure* movies. I don't have stream water running through my veins. It wasn't like the Carollas were packing up the family truckster to head out and see Old Faithful. I was well into my thirties before I owned a sleeping bag. (By the way, I've always thought "sleeping bag" was up there with "toaster oven" for least creative name. "What is this?" "It's a bag that you sleep in." "What shall we call it?" "Um . . . a sleeping bag?" "Cool, let's hit the Quiznos." I'm glad these guys didn't name the coffin or the condom.)

THE "GREAT" OUTDOORS

I've never been much of a camping guy. To me the only point of camping is to make your kids hate you a little less. On the surface it looks like family fun time around a fire eating s'mores and getting eaten by mosquitoes, but really it's just a preemptive strike on the conversation in the future where your kid is at the therapist complaining about how you never bonded with him. My plan is to throw Sonny and Natalia in the car, drive up Mount Pinos, push them out, toss a tent at them, and say, "There! Check it off your list."

I hate camping for a couple of reasons. Every time you go camping you get the guy whose tent is a few spots away who wants to bond. He looks like Liz Taylor's construction-worker boyfriend, he's carrying three cans of Miller High Life by the six-pack ring and wants to know if he can pull up a log for a nice heart-to-heart. And it's not like you can tell him you've got somewhere to be. "Uh, I've got to go sit around on a different log over there. Sorry."

Camping fucks with my sleep too. It gets dark at 6:30 so at 7:10 it's like, "I'm gonna turn in nine hours earlier than I usually do." Plus there's no *SportsCenter* to watch and no place to beat off, so I might as well just go to bed. Or, in this case, ground.

As if you could sleep anyway. You spend the whole night hearing things. And when you're in the woods everything sounds like a bear. It never sounds like a rich guy with a pillowcase full of money and the *Deal or No Deal* girls. It's always something that is going to eat your food and then you. (By the way, how bad a role model is Yogi Bear? I can't believe we showed this to kids. He goes around stealing people's hard-earned pic-a-nic baskets with his superdepressed gay partner, the whole time wearing nothing but a hat and tie.)

Bears are pretty aimless. They're the opposite of monorails. They wander around just looking to get into shit. Every summer you see on the news some footage of a bear in a suburban swimming pool. It just

wandered down from the hills, thought it found a very clean pond, and took a dip. They have no plan. Bears need Siri. They just leave the cave and decide on the way if they're going to a stream to swat at salmon, down the trail to maul a hiker, or into town to hop in a Dumpster or break into a parked car. This is where they get into trouble. I think they need a bear symposium entitled "Not Getting Shot for Wandering." I could moderate. I'd start with a warning about how when you get cornered by the Animal Control guys, don't panic and climb a tree. You're just going to get darted with a tranquilizer. And then when you fall out of the tree, you think you'll drop safely into the trampoline net the firemen are holding, but you're just going to bounce out and land ten feet away on your head. Ultimately the lesson of the symposium will be "You want to not get shot? If you're walking around and you feel pavement under your claws, turn around. Here's an easy way to remember—if you feel asphalt, get your ass off."

I've always been dumbfounded by the advice park rangers, nature shows, or just stupid guys who think they're park rangers give out regarding bear attacks. I've heard two recommendations—both idiotic. The first is to make yourself appear bigger to scare the bear off. I'm not sure how this works. There's no bigger version of myself. I'm not a blowfish. I don't have a rip cord that when pulled turns me into Brock Lesnar. Should I tell the bear, "Hang on, I'm gonna pick my hair out"? Plus the bear is two thousand pounds. The bear ain't thinking, "Shit. He just ballooned up from a buck eighty-five to one ninety-two. I'm outta here." The bear still knows it's got a fifteen-hundred-pound weight advantage on you. And ultimately doesn't that just make you look like a bigger meal? This would be like if you were at a steak house and the waitress brought you the twenty-four-ounce prime rib instead of the eighteen and you ran out screaming.

The other stupid piece of bear advice is to play dead. That's a lot of range in bear-attack prevention technique. You can shout and flap your arms and try to scare it away, or you can collapse and go into the fetal position. Either way.

That's the second thing I would address at the bear symposium. If you come across what appears to be a corpse, sniff it, nudge it with your nose, and then have sex with it. You'll find out pretty quickly whether it's an actual corpse or someone just playing dead. The poor bastard would come home and his wife would ask him, "How was the camping trip?" "It was wonderful. I definitely didn't get raped by a bear. Now just drop it."

Again, I'm not sure how the playing-dead plan is supposed to work. I can't hold still if an ant is crawling on me, forget fifteen hundred pounds of Kodiak bear.

Speaking of ants. Usually you'll see a bunch of ants in a line, but every now and again you'll spot the lone ant. Just one ant going solo, wandering around your bathroom sink. It doesn't make sense. There's no food in there. It's not like someone's having a picnic in the can. I think it's something to do with cell-phone towers. The electromagnetism is throwing the ants off and they're just wandering alone in circles. Ants are aimless now. They used to march in nice tight formations and lines like Revolutionary War soldiers. When I was a kid ants knew what they were doing. According to cartoons, they were so organized they could make off with a whole basket of fried chicken.

People always say that a lone ant is a scout. He's the Flint McCullough of ants. I think it's just a weird hobo ant. You don't see a homeless guy wandering around and announce, "He's a scout, get him!"

Another outdoor activity I have no interest in is ice fishing. This is the frozen, more drunken version of golf. Golf was invented so guys could get away from their wives for a couple hours and down a few beers. (Which is why I've never understood the guy who wants to get his wife into golf. The whole point is to leave her at home while you hit the links and have a couple drinks.) Any kind of fishing, but especially ice fishing, is the same. You want to get away from the wife for the day and get hammered, but if you did it in the backyard she wouldn't buy it. So you create an activity that involves pulling a Sears gardening shed with no

bottom over Lake Minnetonka, drinking, and marinating in your own farts under the guise of trying to pull a trout from a hole in the ice the size of a toilet seat. That is, unless you have one of those supercabins with the carpeting, heat, full kitchen, and fifty-four-inch plasma. At that point you're not even ice fishing. You might as well just have a guy show up at your house while you're in a La-Z-Boy watching football and hand you a prespeared sturgeon.

Since I don't give a shit about the outdoors, I'll be naming as my Secretary of the Interior someone who has great respect for the land and waterways of our nation—Jimmy Kimmel's fly-fishing partner Huey Lewis. I've always joked that "fly-fishing with Huey Lewis" sounds like a threat my agent would make. "If you don't take this deal, your next gig will be fly-fishing with Huey Lewis." But the truth is Huey is an avid outdoorsman and he could probably come up with a nice jingle and some PSAs to get people to visit our national parks. "Hi, I'm Huey Lewis. Burned out from workin' for a livin? It's hip to breathe clean air at our national parks."

THE FAKE OUTDOORS

I'm not even a big fan of theme parks, never mind national parks. Just like with the family camping trip, you're going to get a lot of shit talked about you to a therapist someday if you don't take your kids to Disneyland. There are three types of people at Disneyland—superhappy kids, their miserable parents, and lost souls trying to recapture a stolen childhood. This is the guy you see at Disney with the denim vest covered in buttons depicting every ride and attraction. He collects and trades them with other lost souls/molestation victims on the Internet. The number of buttons and pins on that vest is directly proportional to the number of cigarettes stepdad put out on him. The adult relationship with Disneyland should be "once every couple of years for the kids," not "This is my home. The Magic Kingdom is where I belong. It's my safe place." If

you've gone there more than ten times in your life, and more than one time in any year of that life, something went horribly wrong and there is no amount of pixie dust that can fill that hole in your soul.

I've taken the kids down to Disneyland a couple of times. That park is exquisitely crowded. There's no cap on the number of people they let in. Last time I was there I saw a three-hour line for the *Cars* ride. You seriously couldn't see the end of it. When was the last time you stood in line for three hours? There could be a line to titty-fuck Sofia Vergara and it would only be two hours. At that pace one afternoon at Disney will get you on three rides. So I finally wised up on my last trip and coughed up for the valet. Many people don't know about this, but you can pay extra for a park employee to take you to the front of the line. Sounds great, right? Well, when I say "extra," I mean $350 an hour. With a six-hour minimum. But if you have the money and the option is having your kids cry the whole trip home because the lines stretched into the next state and all they did was the Matterhorn and Splash Mountain, it makes sense.

But here's the problem. As we were being escorted around by the valet, lunchtime hit. Lynette said, "Let's take a break, the kids want to eat." I was instantly doing the math in my head on how much of the $350 an hour I was paying was going to be consumed by the time consuming overpriced hot dogs. So I said, "Okay, ten minutes." Lynette said, "No, we need to relax." I was thinking, "How about we relax when we don't have a nineteen-year-old former host at Chili's with a GED who I'm paying more than Phil Spector's attorney." The valet, wife, and kids all headed to the snack shack while I grabbed a table. When they came back I saw the valet with a bottle of water, which, of course, I later found out I had paid for.

Then at the end of the day the tipping part came up. I asked Lynette, "Do we tip her?" Lynette replied, "I don't know. Maybe give her twenty-five bucks? Or fifteen percent like a meal?" I was okay with the twenty-five dollars but 15 percent would be $300 on the two grand for the day.

So I just came out and asked her if they accepted tips. She told me that they weren't allowed to before but recently that changed, so yes, she'd be happy to take more of my money.

As much as it hurt my wallet and made me resent my kids (after all, there is no way my parents could have/would have done this), it was a satisfying lesson in capitalism and how the government doesn't work. Disney is a business. They recognize that me paying more is good for business, so they make it worth my while. When it comes to the government, the guy paying a ton more in taxes doesn't get to the front of the line on shit. We get no return on that investment. This would be like Disney letting in a bunch of people for six bucks, some for two grand, and many for free, and not only letting everyone fight it out in line, but letting the people who paid nothing vote to see who covers the cost of maintenance on Space Mountain.

GRIFFITH PARK AND THE L.A. ZOO

When I don't have the time or inclination to take the kids camping or to Disney, our local park is Griffith Park. It's got the L.A. Zoo, pony rides, a miniature train, etc.

I recently took Sonny to the L.A. Zoo. Let me say this—the people at the L.A. Zoo are much scarier than any of the animals. Lots of tattoos. Plus some of those people outweigh one of those lowland gorillas. That might have to do with the fact that one of the first things you see when you get into the zoo is the Churro Hut. Yes, a stand solely dedicated to the sale and distribution of churros. For those of you in the Midwest and Northeast, a churro is a Mexican donut. It's a deep-fried stick of dough that they were too lazy to shape into a circle. But at the L.A. Zoo they're not just any churros—they're stuffed churros. As if the dough javelin wasn't bad enough, these are filled with jelly, chocolate, and cream. Do you know how homoerotic it is to see a male devouring a nine-inch, flesh-colored baton stuffed with cream?

Another thing that pissed me off about the L.A. Zoo is that they have benches named after dead people. As a fund-raiser people get to put a little plaque on the bench in memory of their long-lost zoo-loving relative. This is a total bummer. After a hard day hiking around the giraffe-a-torium, I need to take a breather on that bench and I don't want my balls resting on dearly departed Nana.

But the thing that drove me insane about the zoo was at Sonny's favorite, the reptile house. Here's why. All the snakes and lizards and turtles and shit are in a simulation of their "natural habitat." First off, how natural can it possibly be? Three times a day some fat lesbian in cargo shorts comes in and feeds them crickets while a fat gangbanger staring at them feeds himself a churro. Yep, just like in nature. (By the way, it must suck to be a cricket. You're the go-to food for every asshole who has a pet lizard. They must be thinking, "Why not cockroaches? There's plenty of them and they're disgusting. We're just trying to rub our legs together and make some night music. We're cool.") So anyway, I've got my face pressed against the glass trying to see some African tree snake in its "natural habitat." But because it's green and everything around it is green, I can't spot it. All I see is the green leaving my wallet for the fucking zoo ticket. Secretary Huey Lewis will now enforce that all zoos cut this "natural habitat" shit. I want the whole thing angled forward so they slide toward me. I want the animals suspended from a fishing line in front of a stark white sheet. I know that's not how nature intended it but I want my money's worth.

Another thing I see at the park that drives me nuts is Recumbent Bike Guy. If you go there on the weekend you'll see groups of cyclists, in packs of twenty, but this cat always rolls alone. Think Lorenzo Lamas in *Renegade*, minus the part where he gets laid. It's always the same guy, late forties, early fifties, no friends, who is never part of the group of Sunday cyclists three hundred yards in front of him. He's a lone wolf. And he's just as anti–sitting upright as he is antisocial. This guy is motivated enough to pedal around Griffith Park four times, but not motivated

enough to sit up. He doesn't talk much, but when he does he'll tell you the recumbent bike design is 42 percent more efficient. But if that's true, how come you never see a guy in a yellow jersey coming down the Champs-Élysées on a Barcalounger?

The only bigger loner you see at the park is Metal Detector Guy. There's never a gaggle of them. Just one guy in jean shorts with a T-shirt tucked in, wearing giant headphones and waving a metal wand around looking for loose change. What are you expecting to find? It's one thing if you are walking around a Civil War battlefield looking for artifacts. At Griffith Park the only metal you're going to find is a used cock ring from the previous evening's after-dark activities. Have you ever lost anything more valuable than ChapStick at the beach or the park? It's not like you're in the car on the way home going, "Where's that sterling-silver dinner tray I brought?" This isn't about treasure; it's about tuning out the world. I'm convinced those metal detectors don't even have batteries. It's just a spray-painted mop handle with some headphones attached. He just doesn't want to talk to his wife.

You can find some scary dudes at the park. I took Sonny and Natalia to the pony rides there and looked down the line of felons in front of me waiting with their kids. As president, I'll raise the price for things like this to ten bucks to thin the herd a bit. I can do without the twenty-one-year-old father of three that has FUCK tattooed on one eyelid and LAPD on the other. It's even worse when the scary dude is the one working there and supervising your children. Whether it's at the park or just a carnival that's rolled into town, the people responsible for our children's safety are some of the sketchiest characters out there. You know the type—wears a jumpsuit with no T-shirt, unzipped to his navel, smoking a Winston, has a weird mustache, and is a little short on the dental work. I'm sure that whenever they pull into town, most carnies have to head to City Hall and register as a sex offender. That paperwork is probably the worst part of their gig.

And the rides they're manning are dangerous. The Zipper is scarier

than any ride at Six Flags because there is a real element of danger. It was put together that morning by a guy who was smoking and sipping off a flask while he was doing it. And the House of Mirrors is a disaster. It's a fun house where the fun is head trauma from running into a sheet of glass. Kids just dash into this maze and plow right into the glass like a dog running into a closed sliding door trying to chase a squirrel in the yard. I saw my kids running around the house of mirrors at the Feast of San Gennaro a few years back and they both hit their heads. I said to the guy taking the tickets, "What is that? Is it Plexiglas?" He said, "No. Just glass." Does anybody think this is a good idea to have disoriented four-year-olds banging their foreheads into panes of glass? In a world full of lawyers, how does this exist? It's okay; I'm sure the carnies running these death-traps have complete and up-to-date first-aid and paramedic training.

A last quick thought on carnivals. In terms of hotness, is there a bigger gap between the chick in a booth at a carnival and the chick on a float at Carnival?

Back to the pony rides. My son is a puss. I put him on one of those ponies at the park and he had a look on his face like a black actor from a 1950s mummy movie. My daughter, on the other hand, is the daredevil. She wanted to ride the one named Hurricane. Sonny was waiting for the one named Quaalude.

One of the other things I don't like about taking my kids to the pony rides—other than spending time with them in general—is that horses piss wherever and whenever they want. At least dogs will give you a little heads-up. As I'm taking in a nice moment watching my kid ride a horse, the thing just lets go like one of those planes dumping water on a forest fire.

And they poop everywhere too. I was walking on a trail the other day with my dog, and as I bent over to pick up her poo I stepped in a big pile of horseshit. I realized the only crap we're not required to pick up is the horse dook. How come it's no problemo if you let a metric ton of horse dung go on a trail but if I let my yellow Lab take a dump

you'll give me the stink eye if I don't pick it up? Horse owners should be required to scoop that up. It's the biggest of all shits, outside of a zoo or safari scenario. But there aren't a lot of bull elephants and hippos in my neighborhood.

Plus horse owners get to ride their pets. If I'm walking my dog, I'm already working hard enough. If I could ride her—I haven't been able to since I cut back on the drinking and her hip went bad—it'd be a different story.

All horses should have to strap on the shitbag. What's wrong with the sack they put on horses like they do with the carriage rides in Central Park? The horses don't care. No animal is more used to having stuff strapped to them than a horse. I don't think this is too much to ask.

ENOUGH WITH THIS HORSESHIT, ON TO A BIGGER POINT

Speaking of shitbags, this ultimately leads me to a bigger point. As president, I'm going to use our parks as an example to other shitbag countries about how to be great. How to get their acts together. I'm going to convene a delegation from all the third-world nations—from the Middle East to Mexico and Africa to Afghanistan—and bring them to Griffith Park. I'll say, "Now over here we have some horses. These horses don't go anywhere. We put our kids on them, we pay a former convict to walk them in a circle. Unlike your horses, these don't pull a cart or take us to the bottom of a mine shaft. This is just entertainment for us. And by the way, that horse ate better today than you have this month."

Then I'll take them to the miniature train. "Like the horses, we just send this in a circle for the fuck of it. Unlike your trains, we don't have people riding on top clinging for dear life hoping not to get scraped off on an overpass so they can get to the next village for a sack of grain the UN dropped off."

Griffith Park has a giant fountain which would be my pièce de résistance in the third-world shitbag shaming. "Here's what we do with our clean potable water. That's right. We have so much that we shoot it into the sky until it evaporates just for the fuck of it. And then if we get bored enough watching that, just for good luck we'll take some money out of our pockets and throw it in there. We have that much extra water and extra wealth. But anyway, that wraps up our tour. Good luck with your well."

10

THE DEPARTMENT
OF EDUCATION

Every president declares that he is going to be "The Education President." The one who fixes our completely broken educational system. Well, I am the man for that job. Longtime fans of mine know my educational history—after being named valedictorian at Harvard Westlake Prep School in L.A., I did my undergraduate studies at Brown then my Ph.D. thesis on gas chromatography at Caltech. Or . . . my hippie mom applied the "drop out" part of "turn on, tune in, drop out" to parenting, sent me to a free-range commune school where I learned nothing, and then had that nothing reinforced in the series of warehouses known as the L.A. Unified School District.

I hated school. I used to hope for an earthquake every morning instead of going in. Education has meant nothing to me. I'm a self-made millionaire and it had nothing to do with the prestigious preschool my parents fought to get me into or having one really great teacher who

believed in me. It all came from a little something called grit. That "dust yourself off and try again," "power through the pain" attitude that we seem so desperate in our current system to do away with. So as president, my plan is to help American kids buck up, get tough, and show a little respect.

BULLYING AND SELF-ESTEEM

That's why as president, my first directive to my Secretary of Education will be to cease all of the antibullying bullshit. This administration is staunchly pro-bullying. We're spending so much time and energy protecting kids from having hurt feelings we don't recognize that we're hurting their future.

First off, the definition of bullying has changed. Everything is bullying now. My boy came home one day and told me he was bullied at school. I gave him a once-over and said, "I don't see any bruises. What happened?" He said, "I was telling a story and Declan put both fingers in his ears." That's bullying now. By that definition, I've been bullying my parents for years. The word doesn't mean anything anymore. It's the boy who cried he was bullied by the wolf. Sonny is going to come home someday and say he was bullied and I'm not going to even look up from TMZ. It's like the words "hate" and "discrimination." They get tossed out so frequently that we're numb to them.

Last year in Texas the father of a kid on a football team that got beaten ninety-one to zero filed a formal complaint about bullying because the coach of the winning team didn't tell his players to lay off. If that is a form of bullying, our country is in big trouble. This would be like telling Dale Earnhardt Jr. not to lap another driver.

First off, this was in a suburb of Fort Worth. I think in Texas they don't even know what bullying is. I bet they thought an actual bull got on the field. The principal was like, "Rob, what's going on? Parents are complaining about bullying. Did a cow get on the field? I knew this

would happen someday." Clearly this dad had just moved there from Portland.

More importantly, it's football. The entire sport is based on the concept of bullying the other team. A guy lines up across from you and then you bull-rush him. The word "bull" is right in there. That is the whole point. You can beat a team before the first kickoff if you intimidate them. If you get in their head they'll start making mistakes. It's part of the sport.

And as for the guys who lost ninety-one to zip, not only will they get over it, it will be a great story. They'll be telling that one in bars for years. Every time they crack a beer, that's going to be the story they tell.

Please, let's stop working so hard to make sure our kids are pussies. What kind of a father files a bullying complaint because his kid's football team got their asses righteously handed to them? What message does that send? This cycle is just going to repeat and expand and eventually our country will no longer defend itself when attacked. Do you think the generation that's being told that every name they're called is an assault would have stood up to Hitler? Do you think my kids' generation would have won the Cold War? They would have said the Russians were mean but they were going to ignore them or report them to the UN. I wanted to teach Sonny some boxing to defend himself in the case of real bullying and he told me he didn't want to because if he hit the kid back, he'd get in trouble.

When it's not pussy parents, the ACLU gets involved. In 2012, the ACLU sued a school board in Rhode Island over "gender-based" events for kids. That's right, no more Daddy-Daughter dances in Rhode Island because it might hurt the feelings of the kid whose dad skipped town. We're now penalizing all the other children to protect one kid from the feeling of envy. I'm sorry Pops jumped ship and moved to Florida but you should be pissed at him about that, not all the other kids with intact families.

This is an even more disturbing trend. The definition of bullying has expanded to include simply having something someone else doesn't. By that rationale *Dallas* should get pulled off the air because it shows people

in private jets having a great lifestyle. I'm sorry but I think envy is a good thing. We should all look at the people who have more than us—whether it's a bigger house, a better body, or a nicer car—and think, "What am I doing that is preventing me from having that? How can I improve?" That's the real learning that should be happening in schools.

The news girl on my podcast, Alison Rosen, brought up a story a year ago where the principal at a high school in Massachusetts canceled "Honors Night" because it might hurt the self-esteem of the kids who didn't receive an honor. I would like to honor that principal with my foot up his ass. All we have is competition; this is what makes us get better. What if there was no competition in the cell-phone business, what if the government just took it over in 1987? We'd all be walking around holding beige bricks with long antennas. That's how progress happens. Samsung and Motorola battle it out and we benefit. Things get smaller, faster, more efficient. Competition breeds competence.

This is going to make failures out of our kids. There is competition in the world. Kids need to fail, they need to know that they're not doing well, but that if they work hard they can recover. Right now we're heaping praise on everyone for just walking through the door and minimizing the accomplishments of kids who do bust their asses. Our kids are going to look back on us and be pissed we didn't give them the skills to go out in the real world and thrive. I know they talk about the three *R*s in school but we need to add a fourth and most important one—Resiliency—the ability to know that you're not perfect but that you can get better if you look within, internalize the struggle, and work harder, instead of bringing everyone else down.

This is the real bullying that's going on in schools. It's the parents, the school boards, and the ACLU telling kids they can't handle shit, lowering the bar and softening them up. When you work with your hands repeatedly you build up calluses that protect you from splinters, sparks, and shards. There needs to be an emotional callus built up in high school before you go out and face the real world.

That's why I'm naming as Secretary of Education R. Lee Ermey. We need a drill sergeant to get in there and toughen up all these kids. Someone who's not afraid to get in your son's face and shout, "YOUR LAST EASY DAY WAS YESTERDAY, YOU WORTHLESS MAGGOT! YOU MAKE ME WANT TO PUKE! YOU'LL KNOW WHAT BULLYING IS WHEN I RIP YOUR HEAD OFF AND SHIT DOWN YOUR NECK HOLE!"

I'm not saying there's no violence in schools. It's a fucking pathetic state of affairs that we now need cameras on every school bus (but still no seat belts). A month doesn't go by without some black-and-white footage of two kids kicking the shit out of another kid on a bus, or worse, a parent coming on to the bus and smacking around the girl who called her kid fat on Facebook. We've created such a shitty society that those kids would be a hell of a lot better off if that bus just drove through a guardrail and into a reservoir. Imagine trying to explain this phenomenon to someone from the fifties. It would be confusing to them, and not just because the black kids are sitting up front.

Every now and again you see the bus driver getting involved. But other times you see them helplessly witnessing it because we've built a system where they're afraid to break up the fight because the parents of the delinquents will sue them. Well, as president, I'm going to enact the Bus Driver Protection Act. Any driver can break up a fight on a bus and smack those little shits around himself. In fact I'm going to arm them with Mace and a cattle prod. As long as we're raising a bunch of animals, then our bus drivers are going to have to be zookeepers. This is the sad new reality. We have to accept it.

It's the least we can do for these people. Bus driver is a gig with zero upside and a ton of downside. There's not even tipping. The parents don't give you a bottle of scotch around Christmastime. This person gets your kid to and from school safely every day, yet the guy at the Starbucks gets

more tips. Being a bus driver is as bad as being a mover as far as appreciation. They can move ten thousand square feet of home, but one dent in one leg on one end table and the chick who hired you will say it's a disaster and try to get her money back. There's no good day as a mover or bus driver. Bus driver is the most "something went wrong" job. No one sets out to be a school bus driver. The story of how one becomes a bus driver always begins, "I got out of rehab, finished my community service, and now . . ."

PARENT INVOLVEMENT

I guaran-fucking-tee that the problem with all those li'l criminals on the bus is absent fathers. In certain communities there is a pervasive lack of fathers and thus a pervasive lack of discipline. If kids don't have a father to grow up being afraid of, they don't fear any authority figures like teachers or cops and thus treat the world like a RadioShack during a riot.

This is going to be the undoing of our society and I'm the only one with the balls to say something about it. I was incensed during the 2013 State of the Union when President Obama said his administration would do more to "encourage fatherhood," adding "because what makes you a man isn't having the ability to conceive a child but having the courage to raise one."

The courage?! It's not storming the beaches of Normandy. It's hanging and paying some rent while Mama raises the kid. It's not courage, it's a fucking obligation. That would be like saying, "What makes you a man isn't eating at IHOP, it's having the courage to pay the bill."

We've lowered the bar *that* much? If raising your kid is now a bridge too far, it's time to just light off all the nukes we have, let the winter go on for a couple thousand years, and start fresh. Because if you don't raise your kids, the government is going to, and guess what? They fuck up everything they touch. And not only that, but they're going to raise

them with *my* money. If you're going to have a kid I'm going to pay for, I should get to fuck your wife.

Why is sticking around and raising your kid such a tall order in some communities? Why does the president have to take time in the State of the Union to tell black guys that fatherhood extends beyond the moment of orgasm? There was a story about a thirty-three-year-old guy in Tennessee named Orlando Shaw who had twenty-two kids by fourteen women and refused to pay child support.

ManDate

My Justice Department will put a Denver boot on this guy's junk and that of anyone like him. He should never be able to have sex again. It will be like one of those collars that you put around a dog's neck when they have stitches. Just a big cone around this guy's dong so he could never again penetrate any of his gaggle of bitches. But that's only the first step. Then I would like to parade him around the country as an example of the world's worst father and possibly world's worst human being.

Think I'm being hyperbolic? Let's do the math on this. A little side-by-side with Charles Manson. How many kids does Manson have? Zero. How many people are dead as a result of him? Nine. Now let's look at Orlando Shaw. How many kids? Twenty-two. How many people are dead as a result? Well, statistically the twenty-two kids that he crapped out that are going to grow up in poverty without a father will be in gangs or pregnant or both by the time they're seventeen. Even if half of them escape their fate, you've still got a higher death toll when the dust settles, especially when you factor in that a percentage of the kids will go down the same broken, fatherless road. And look at the cost to society, between the food stamps, social workers, cops, graffiti cleanup, Child Protective Services, etc. Think about the potential price tag vs. what it cost to house Manson and put on a show parole hearing every couple of years. This guy could do far more damage than Chuck ever did.

As I've often said, this is the biggest problem we have in our society—unwanted kids. If we solve this problem we solve all the other problems. So we have to start judging. As I said before, we judge smokers more harshly than we judge deadbeat dads in our current society. Seriously, how many antismoking PSAs have you seen this week vs. ones saying raise your kids, or don't have kids if you can't afford them? And what's hurting our society more? People need to see that asshole and call him an asshole so maybe other people thinking about being assholes wouldn't become assholes. We stopped judging people a long time ago because the idiots on the left told us everyone is the same and that we couldn't do that. We need to bring back judging. So let's start with this dick. Here's your grade. As far as life goes, you get an F. But then again, what would you expect from a guy named after a city in Florida.

Until you get the family unit back together, we have no hope and we'll never dig ourselves out of this hole. No matter how great the school is, how excellent the teachers are, how many computers, field trips, or other window dressing there is, until you have intact families that give a shit, we're doomed. If you have chalk, pencils, and a roof that doesn't leak, you've got a school. Back in the day people would do stuff by candlelight on the prairie and are a fuckload smarter than kids now despite all the iPads and online homework. Why? Because if they didn't read their assignment, their parents would take the ruler they were supposed to be using for that assignment and smack them with it. We don't need to keep throwing money at the problem, we need to throw parents at the problem.

That said, the focus is on the wrong parents. It's the previously mentioned deadbeat dads and absentee moms that you need to get involved. Me and Lynette are fine. Lynette is at the kids' goddamn school volunteering four days a week. And they schedule all these events at noon on Tuesday. How about the fact that I work? Every week there is some unimpressive event that I have to attend or my wife will think I'm

a monster. It's a total mixed message. The only way to be a good dad is to show up at all these events, but the only way you can do it is to be an unemployed loser. How about Daddy goes out and works while Mommy attends the events the kids aren't going to fucking remember anyway? I'm sorry but I've got to go and earn money to feed everyone and put a roof over their head and get life insurance for when I die of hypertension from working every weekend to provide said food and roof. I'd like to invite all those "hero" teachers to come by my house on Saturday to sit on miniature chairs, drink punch, and eat shitty square pizza and see how many of them show up. Where are you, teachers? Don't you care about the children? That's why this shit is always in the afternoon. It has to happen when they're on the clock. These events can never happen at five on Friday because these so-called heroes punch out at three. Unless it's the summer, in which case they're not working at all.

This has caused major strain in my marriage. The wife was pissed when I didn't give a shit about my kid's graduation from kindergarten to first grade. When I was a kid it was sixth-grade graduation, then ninth, then high school graduation, then you were eighteen and your parents kicked you out. Sprinkled throughout were some baseball games and maybe a parent-teacher conference and that was it. Now there is a school event every 2.5 days.

I would love to see my kids' calendar of events for one month and compare it to the entire calendar of my childhood. There wasn't one event that caused my father to cross the threshold of North Hollywood High. Once a year there was an open house, but my parents had a Don't Ask, Don't Tell policy. They didn't want the dirty looks from the teacher. They also didn't want to leave the house. That was a lose, lose, lose. So they just skipped it. They had the same approach to parenting as passing a motorcycle accident. They didn't get out of the car and kick the guy, but they didn't perform CPR either, they just turned up the stereo and kept driving.

Here are a couple examples of important events I had to attend and how horribly awry they went for me.

Natalia had a singing recital. So I hustled down to the school in between meetings and podcasts and other shit that pays for that school. I pulled up and could only find a spot in twenty-minute parking. I thought I'd dash in, make an appearance, slide out as soon as she saw me, and be back in the car before the twenty was expired.

I rushed to Natalia's class but there was no one there. Confused, I found someone who said the recital was in 3B. So I hustled over there. I had my hand on the doorknob when Sonny's teacher turned the corner, saw me, and said, "Are you looking for Natalia? She's in 3F." So I headed toward my third attempt at seeing my daughter. Knowing I was late, I flung open the door to 3F. Ten teachers who were eating lunch whipped their heads around to awkwardly stare at me. If there had been a record playing it would have scratched. I apologized and slunk back into the hallway. I thought, "Fuck it, I'm in twenty-minute parking, I've spent the last eight trying to find this fucking room, I'm going to outtie to my Audi. I later found out Natalia *was* in 3B, the room I was attempting to enter when I was headed off at the pass by Sonny's teacher.

When I got home later I was greeted with a hearty stink eye from Lynette. She told me that Natalia was disappointed I didn't show up. I explained what happened and Lynette did something that drives me crazy. She did a second lap of "Well, Natalia is disappointed." What should I have done different? When Sonny's teacher, someone who spends the majority of her time in that building, someone we know and trust, said that the event was in 3F, should I have said, "Fuck you, you lying cunt," and then snapped her neck and kicked down the door?

This mandatory parent-attended event shit really goes into overdrive around Christmas (or whatever we're calling it now because we're too PC). I feel like I lived at that school starting a week before Halloween until Valentine's Day.

When Natalia had her Thanksgiving party I got stuck parking in the same twenty-minute-only spot. And since parking tickets are the only thing L.A. does well, I ran in, supported her for nineteen and a half minutes, and then beat it like I robbed a bank and had a wheelman waiting for me.

Then there was the first-grade Christmas pageant. I hung out for over an hour on that one because Natalia's class went last. I showed up at eight A.M. and waited for an hour outside the auditorium in the cold. When her class finally got up there, they performed "The Dreidel Song." It's fucking Christmas. I want a song about chestnuts and figgy pudding, not Jew dice. (Another time I did the same mad dash to the school for a different Natalia talent show. It was supposed to start at 8:15. I walked in at 8:17 to find that Natalia's class went first and I had missed it.) When I thought they were done I turned to walk out and Lynette stopped me. I was informed that we had to go to Natalia's class and watch the kids eat muffins, otherwise I was a bad parent.

I hate the part where it's required. It's like going to the funeral of a coworker you didn't like. You have to show up so the other people don't think you're an asshole. I don't want Lynette pissed off and I don't want the teachers blaming every time the kids do something wrong on me, the absentee dad who didn't show up for their Arbor Day tree-planting pageant.

Plus every second of these events is being documented anyway. Everyone has the cell-phone camera out. So why do I have to be there? I'll catch it on YouTube.

Then there was the walkathon to promote physical fitness. This one took place at nine thirty A.M. on a Friday and consisted of watching six-year-olds just walking on grass in a big circle. It was a fund-raiser because at a certain point I asked Lynette, "What's the end game here?" She said, "They're trying to raise a hundred dollars for each kid." I said, "Why can't we give them a hundred dollars and just get out of here?"

This event was not only a waste of my time but a waste of my kids'

time too. At least the pageants and plays are fun for them. In the middle of this field where the kids were walking in a circle was a coach shouting, "No running. Safety first." These aren't morbidly obese women in their seventies who just had a hip replacement. To a six-year-old, being told not to run is a punishment. It peaked when the guy shouted, "Thirty seconds left!" followed immediately by another blast of "No running." You can't tell a first grader they have thirty seconds left in a contest to see who can cover the most ground and expect them to not start running

I was also annoyed that there were plenty of parents holding up signs encouraging their kids. This was a fund-raiser and they were actively telling them to slow down. Why the encouraging signs? I'm surprised one of the other parents didn't file a bullying complaint.

The worst school event was the time I went to Sonny's second-grade play about the Constitution. The whole thing happened in that monotone kids do when they're reciting things they don't give a shit about but have been forced to memorize. It's an awesome way to learn, holding something in your brain just long enough to regurgitate it in front of your parents and then never recall it again. I actually gave him a quiz on the way home and he didn't remember shit. All the parents were there and were forced to sit on those minichairs where your knees are so high you can practically blow yourself. As if that didn't suck enough, the teacher then called on us and said, "Okay, parents. Now it's your turn. We need to see what you know about the Constitution." I was thinking, "I came here to see my kid make an ass of himself, not to do so myself." I turned to Lynette because between the two of us we have half a GED. We were both wearing a fearful "oh shit" look because Sonny was onstage with a hopeful "don't embarrass me" look. There should be something in the Constitution about pop quizzes on the Constitution.

So the parent quiz began and hands were flying up left and right while Lynette and I sat there like stooges. Finally my opportunity came. I don't know anything about the Constitution, but I do know math. The teacher asked, "There were twelve states but they only needed two-thirds

to ratify. How many states did they need?" My hand flew up and I said a confident "Eight." The teacher replied in a snippy tone, "Nope, It's nine." My son snapped a pencil and his eyes welled up while my wife was looking at me like, "What have you done?!" Meanwhile I was thrus through a humiliation vortex back to Colfax Elementary. A shame-filled eight-year-old Adam Carolla sitting in a miniature chair not learning to read. Back in 2013, a parent in front of me who—despite having a shitload of tattoos—was getting every question right, had my back, jumped in, and said, "No, it *is* eight." The teacher laughed it off and said, "Moving on." I was so confused at that point she could have told me my name was Alan and I would have bought it. So I did what I never do: decided not to be a dick. She had worked on this play, and was trying to teach my kid. I let it go. But then as we were leaving she said to me, "You, young man, need to work on your fractions." I was about to grab a miniature chair and use it to divide her skull into two halves. Then she got sing-songy, "Three plus three, plus . . . oh, you *were* right."

Was there a lesson learned? Yes, and it wasn't about the Founding Fathers, or fractions, it was about functions and to never attend another one at that school again.

An infuriating epilogue to this tale: I told this story on the *Kevin and Bean* morning show as part of my recurring "This Week in Rage" segment. Well, a concerned parent—and by that I mean miserable cunt—decided that Sonny's teacher needed to hear the segment. She actually downloaded it and gave it to the teacher. By the way, I just assume this is a she, but far too many dudes are now getting into this "I just thought you should know" schadenfreude shit. What's your motivation? Are you really concerned about the teacher's well-being or the sensitivities of the second graders who weren't listening to the show? No, you just needed to cause trouble. Sonny's teacher would have been fine not hearing that segment. It was a fucking bit on a fucking morning radio show. It's not like I wrote a manifesto in blood threatening her life and nailed it to the schoolhouse door. I also complained about frozen yogurt that morning,

are you going to head to Pinkberry headquarters and warn the CEO of the ranting madman who's out to get him? When did everyone become a humorless twat?

Well, congratulations, bitch, trouble you did indeed cause. Mission accomplished. A few days after the segment I received a handwritten note from Sonny's teacher. I could practically see the tearstains on the stationery. She said she prided herself on being an educator, and while she could never forget my hurtful words, she would not let it affect the way she taught my children, who, despite our conflict, were still the priority.

Of course Lynette ate this up with a fork and spoon and then wanted to stab me with that fork. She took me to task for ruining my kids' education because I can't keep my mouth shut. A halfhearted e-mail later, this all went away and we moved on with our lives, which only goes to prove that this was a molehill of nothing turned into a mountain of shit.

That being said, if anybody reading this book knows the miserable cunt who dropped a dime on me, please present her this page and say, "I just thought you should know."

As a side note, I have to say that I hate when the Wyclef Jeans and Rob Reiners of the world talk about the arts and music education as if it's a cure-all. They always preach about how kids who play instruments and engage in the arts have higher test scores and are more likely to go on to college. Of course, but it's not like playing the flute makes you smarter. It's the parents who bought the damn flute. If you have the time to make your kid practice the bassoon, and can afford a bassoon, that's the reason your kid is going to be fine. You're a parent who has time, money, and cares.

And while I'm talking about arts education, enough with the idea that this turns on kids' imaginations. All you have at age seven is imagination. We don't need them to have any more. When a kid is going to be creative they're going to be creative. Musicians cannot be stopped. There isn't one famous drummer whose parents wouldn't say they started

banging on pots and pans when they were toddlers. It's in there or it's not. You can't just give a kid an easel and think it's going to turn on the artistic part of his brain. So let's remove the focus on creating more oboe players and turn our attention to creating some more builders. This is all part of my campaign "Fuck the Music, Save Shop Class." What does America need more of—guys who can build houses or chicks who can design dresses?

THE TEACHERS OF TODAY

I also had a run-in with Natalia's teacher at one of my mandatory/ completely unnecessary parent-teacher conferences. This one was particularly infuriating.

First, I walked into my daughter's classroom and was wandering around looking at her shitty finger painting when some little boy poked me on the hip with his index finger and said, "You're not supposed to be here." Can you imagine doing that in first grade? This is a more-than-six-foot, over-forty male in your classroom, and you're attempting to settle his hash? You should be respecting him, not playing bouncer. I'm ordering my Education Department to commission a study on these types of kids, because I'm sure there are at least three in every class. I want to tag and track them through their life and find out if they're truly douchebags in the making. I have a suspicion all the adult assholes we deal with every day were this kid at one point.

But back to Natalia's teacher. I noticed several things about her that day. First and foremost was her attire. She had a nose stud and go-go boots. I'm not trying to sound like Grandpa Carolla and this is no comment on her as a teacher but she just didn't feel like a teacher. When I was growing up I had Mrs. Parker, who looked like someone from a Marx Brothers movie. She dressed like the dowager who would see some of Groucho's shenanigans and say, "Well, I never." I know it's the culture now and there are probably very few teachers without some odd piercing

or tattoo. But where do you draw the line? At some point the nose ring is going to give way to the guy who has the ball bearings put under his forehead to look like a Klingon and he's going to sue when the school board asks him to remove them.

The other thing I noticed was that on her desk she had a huge Starbucks Frappuccino with the whipped-cream dome. Again, this seemed unprofessional. If I were six and forced to stare at a pile of whipped cream, there's no way I could focus on my ABCs and 123s. Then I noticed her first name written on the cup. I subtly rotated the cup away from the kids because if they found out her name is Stephanie, it would be all over. She'd lose their respect. They wouldn't fear her anymore. For me, it was Mr. Spathe or Mr. Gregory. Not Nick or Ed. I didn't know any first names because they were supposed to be authority figures.

This position of authority has gone away because every teacher wants to be the cool teacher, not the hard-ass who actually forces kids to learn. That's how it was when I was a kid. Plus, my nondisciplinarian "cool" teachers were into the Doobie Brothers, not Katy Perry.

That's something you don't really realize until you're an adult. Looking back at the people I feared or looked up to when I was a kid, it occurs to me that they were all idiots. No one ever tells you that. When you are an adult dealing with other adults, you see just how stupid they can be. But when you're a kid you think your teacher is a good teacher just because they're taller than you.

To me, teachers are like cops, some are good and went into that profession for noble reasons, but most went into it because they didn't know what else to do with their life. Some were teenage girls who enjoyed being babysitters and thought they'd make a living out of it. It's always a little bit of a roll of the dice, just like anything. There are good lawyers and shitty ones, good dentists and shitty ones, good authors and shitty ones.

One day Lynette wanted to have a talk about Natalia with her teacher at the time (a.k.a. Miss Nose Stud). The teacher said that Natalia was "just

not responding to her." I wasn't even sure what that meant. And Natalia was in first grade. I only remember my first-grade teacher, Mrs. Doris, because we ran into her once at a grocery store and she took my mother aside to tell her I was behind in my reading. I have no idea if I "responded" to her. I said this to Lynette and asked, "And what's the option? Can you get a new teacher? If not, then what are we talking about? Natalia has a tutor and a mother who gives a shit and reads with her every night. She's going to be fine. Sure, her teacher is not Jaime Escalante, but I know the kid is sharp and intuitive and she'll be fine. She's way ahead of the game. What are we doing here other than wringing our hands about it? In fact she should have a couple shitty teachers to give her experience for all the shitty bosses she'll have." Lynette felt about this the same way she did when she wanted to get Sonny a tutor because he was behind in his reading. I said, "He's in first grade, how can he be behind? Is he reading at zygote level?" Apparently the class average on a reading test was eighty-six, but even though Sonny got an eighty-eight it wasn't high enough above average. I thought the boy was beating the curve and that was a good thing. Lynette thought I was an asshole.

The point is, whether you have a good teacher that you respond to or a bad teacher, it just doesn't matter. The parents are what matter. If you've got parents like Dr. Drew and his wife, you're going to be fine. There was no chance his kids weren't going to college. If you've got parents like some of the people Drew treats in rehab, then start getting ready for a career in the fast-food industry.

I like good teachers, but I don't think there are enough of them. Let's face facts. It's a low-paying gig, so you're not always getting the cream of the crop.

More importantly, the teacher is chasing the problem. We have to get in front of it. First thing you do is focus on the problem of broken families, then everything else falls into place. The other problems are satellites orbiting planet Broken Family—the school lunches, bullying, even obesity are all moons around planet Broken Family. I'm happy there are

good coaches and teachers who take kids under their wing, but they are temporarily filling a void created by broken families. It's like trying to fill a bucket with a hole in it.

So what should we do with all the bad teachers? Shit-can their asses. I'm tired of the teachers' union protecting them and constantly fighting progress. When Michelle Rhee tried to crack the whip in D.C., what was the first thing she did? She started closing schools and firing shitty teachers. And what happened? They ran her out of town on a rail. Their attitude was "How dare you come into our system and try to correct it? Hit the bricks, bitch. We had a good thing going. No one expected anything out of these kids, so we didn't have to work. We had pensions and vacations, now you want us to perform? Fuck that." The teachers' union represents the exact opposite of what teachers are supposed to be trying to instill. School is supposed to be a meritocracy where hard work, intelligence, and effort are rewarded. But good teachers and bad teachers get paid the same wage and benefits whereas good students and bad students don't get the same grades. The teachers' union is the height of hypocrisy; it is like a fat, chain-smoking aerobics instructor.

That's why I'm totally for charter schools. Every time you see one of these open up, you've got parents throwing their kids over the fence to get them in there. I love the idea of creating some competition. Get someone in there to run that school like a business. Look at some data and fire some asses.

But of course the teachers' unions go apeshit when this happens and try to shut charter schools down. Because they don't want the competition. They know they can't keep up. The job they're doing with these kids is literally killing them. They're dropping out and joining gangs. But if people come in with a little entrepreneurial instinct, they get protested, zoned, taxed, and otherwise nickeled-and-dimed out of existence. Because the teachers' unions would rather protect their own than protect the kids.

THE "SCHOOL-TO-PRISON PIPELINE"

A nice phrase that has popped up for this disaster we call an educational system is the supposed "school-to-prison pipeline." It's a fine phrase, but the people tossing it around aren't willing to look at all the reasons I listed above and fix this trend. All they know is that there is a school-to-prison pipeline and it has something to do with me being a racist. I got accused in an interview with the *Huffington Post* of "oversimplifying" the problem with broken families in the black community and its effect on education. How is me looking at root causes and trying to address the big problem oversimplifying? Thank you, sage from the fucking mountain, please let me hold your tablets while you point your finger at me. I think the oversimplification is shutting me down and saying I commit hate speech because I'm willing to call a spade a spade. (Okay, that was probably a poor word choice in this context.)

This is the narcissism of the left when it comes to the issue of education. You want to feel better by "defending" the poor people, but you won't actually spend your time doing something to help. I don't see you down at the crumbling schools in South Central volunteering your time. Please continue to preach to me about my racism while you drive your kids to a Santa Monica private school, you fucking hypocrite.

Well, guess what, I don't give a shit what you think of me, because I actually want to solve this problem instead of inflating my liberal cred. Here are some fucking facts.

Of those who entered ninth grade in 2006, 52 percent of black males graduated high school, 58 percent of Latino males, and 78 percent of white males. Jewish males had a 97 percent rate. Why? Intact families.

But not according to the CEO of the Schott Foundation for Public Education, who conducted the study. To him it was "evidence of willful neglect by federal, state, and local elected policy makers and leaders." Yes, it's all part the plan of getting young black males to drop out so we can get shot by one next time we get lost in the wrong neighborhood.

During the Chicago teachers' strike I saw a black reporter saying that the members of the teachers' union were "not going to be the scapegoats for public school education. Not when there are so many other factors that play into the performance of children, particularly in urban education. Poverty, crime, hunger, lack of social workers, etc."

Sure, let's not focus on the etc., that's the only part that matters. Let's conveniently skip over that. Hunger is not keeping black kids down. And it's not the lack of social workers because when you're doing well and you have functioning families you don't need social workers. Counselors, therapists, and social workers are like firemen, they are only necessary after shit has gone wrong. And crime doesn't stop you from learning unless someone kicks down your door and attempts to rob your algebra book.

Please, let's get at the truth. If you were a reporter and were reporting on malaria, you wouldn't ignore the mosquitoes. So why are you yada yada yada'ing the most important element—*the family*? How about the idea that what makes a good student is an environment that is light on the chaos and heavy on the discipline?

This is the black community not wanting to take a hard look in the mirror. And white people won't say anything because they're too scared of being called a racist. When I had California lieutenant governor Gavin Newsom on the podcast and brought up this issue, he tap-danced around it harder than Danny fucking Kaye. He was so afraid of losing his black and Latino constituency he even had the balls to say these folk "cared deeply" about education. I think the stats prove otherwise. And statistics aren't racist.

Recently the L.A. school board talked about reducing homework and the impact on grades because certain groups weren't able to keep up with the demands being made on parents. There were cries that the current level of homework was racist. Uh, what? Fuck that. Make the time. If you have a table you can make your kid do homework. That's all you need, a fucking table for them to sit at. It's not racist to expect you to sit

your kid down and make them do their goddamn homework. I'm sorry you're poor and you're working, but unless you want your kid to have the same fate, dig down and take a page from the Asians' book, demand excellence from your kid. If that notion makes me a racist, if not lowering the bar further makes me a racist, then well, I guess I'm a fucking racist. And by "racist," I mean truth teller.

That said, I'm actually behind the decrease-the-homework plan and will enact it through my Department of Education. I've always felt eight hours of school is enough to teach the kid something. When they get home, that's time to do a different kind of learning. They should watch Mommy cook and watch Daddy use a wrench on the car. I'm not saying kids should go home and eat a bunch of cotton candy and see how much of their fists they can put up their ass. But what it all boils down to is keeping families intact. All the Head Start, No Child Left Behind, early-intervention bullshit doesn't amount to a hill of GEDs. The most important thing you can teach your kid is what you show them, what they observe from you on a daily basis. If they see you obeying the law, holding down a job, keeping your home and yard well maintained, or respecting the person in front of you in line at the grocery store, that's what they will pick up. And more importantly, they need to see you internalizing and not blaming The Man. That's what we need more of in this society—discipline, respect, empathy, and grit.

Damn. That was some pretty good writing from a guy who had a 1.75 GPA.

THE DEPARTMENT OF WEIGHTS AND MEASURES

Let's either go metric or ban that system entirely. We're caught in between, in some kind of measurement no-man's-land. I'm tired of these Europeans making us think. Eventually the only people who'll know the metric system are going to be junkies.

And when it comes to time zones, here are my new rules. There is no longer Central or Mountain Time. It's too confusing. I'll do a gig in Chicago and have no fucking idea what time it is. And God forbid I want to watch a live TV event anywhere in the middle of the country. I have to take out a calculator to figure out what time it's on. From now on we'll draw a line right down the middle of the country and just have East Coast and West Coast time. If you're a state that falls right on that line you get to choose.

Daylight saving time is also going to be eliminated by my administration. That "fallback" part is great. Who doesn't want an extra hour to

sleep? But to have that robbed away in the spring is like a chick starting a blowjob and then, as soon as you're feeling pretty good, chomping down. I'll gladly lose that extra hour in November just to not feel that horrible gut punch in March. It's always confusing too. I never see it coming and it always pops up the day before I have to get up extra early. We'll always leap ahead the morning I book a 6 a.m. flight. It starts at two A.M., so you forget to change your clocks half the time and fuck yourself up. And some clocks adjust automatically, others don't. They all either need to be automatic or require me (and by "me," I mean my wife) to change them manually. I woke up wildly disoriented the morning after daylight saving time kicked in last year. The nineteen-dollar clock sitting in my bathroom changed automatically, but the one in my $95,000 Jaguar? No can do. That car has a seat warmer, satellite radio, can defrost the outside mirrors, but cannot change the time automatically. That car does everything but suck your cock, but can't change its own clock.

And I don't think we need it anymore. The whole point was about giving farmers more daylight time to do their thing. I don't know about you, but this most recent daylight saving time I did very little soil tilling with that extra hour.

I saw a hard-hitting *USA Today* snapshot a few years back about what people were going to do with their extra hour. First off, whether it's the *Peanuts* cartoon that isn't funny and barely makes sense, or these useless infographics, newspaper publishers need to admit that they have nothing useful to report and print a picture of a missing kid. It'll do a lot more good.

This one read, "How will you use the hour gained with the end of daylight saving time?" The first group was honest, 36 percent said they'd sleep. Seventeen percent said they'd "do chores." I know this is bullshit. I'm positive when the survey taker asked this question, the guy's wife was standing next to him. "Yep, I'm gonna do chores. I may not even wait until morning. Two thirty-five A.M., gonna fire up that leaf blower." Thirteen percent said read, 9 percent said watch TV. That's probably pretty

accurate, though I think many of the "reads" were lying too. Six percent said, "Visit with friends." What kind of relationship is that? You only have an hour a year to hang out and if you both lived in Phoenix you'd never see each other at all. But the one that pisses me off most is the last one. Coming in at 19 percent was "don't know/didn't answer." C'mon, asswipe, how uptight do you have to be? Spit something out. Can't commit? Playing it close to the vest with your plans that hour? What's the fear—Edward Snowden is going to get ahold of that information and leak it?

I also saw a *USA Today* infographic about "Favorite Comfort Food" that had the 16 percent "I don't know." How difficult a question is that to answer? What did your mom make you when you got a boo-boo? What did you eat yesterday? Doesn't everyone have a favorite comfort food? I feel like you could wake me up in the middle of the night and shout, "Favorite Comfort Food?!" and I'd say, "Lasagna," and roll back over.

During my presidency you must give an answer to every survey question, or there will be consequences. You won't need to worry about what to do with your extra hour of daylight because you'll be in the hole at Leavenworth.

I'm also going to direct the Department of Weights and Measures to make the craziest, funniest, and most semihomoerotic-yet-most-masculine dream I've ever had a reality. One night while tossing and turning, not fully asleep and not entirely awake, I came up with the following brilliant idea:

On the eighteenth birthday of every male in America, they will have to submit to a test. They will lie down on a quarter-inch-thick aluminum plate. This plate will have a hole in it for the young man to put his penis through and into a graduated cylinder full of water. The displacement of the water will be measured. Then every year after, on their birthday, men will lie on their bellies, put their dick through the aluminum glory hole, and get remeasured.

Here's where this idea gets really great. Once we have your measurement you will be issued a windbreaker with a number on the back. That number won't be the displacement; it will be your ranking. It would look like an ATF windbreaker, but it would have your position among the 112 million eighteen-plus males in America on it. If your number is readable from a distance, you're in pretty good standing because the median would be around 56 million. Anything below six digits would be a victory, and if you're in the single-digit club, you're definitely going to be making the rounds on the talk-show circuit.

All the males in America will be ranked by these criteria, and they'd be forced to wear these windbreakers the last week of June every year. So it's like a graduating class of 100 million where we name the vale-DICK-torian.

Remember, this is not about length; this is about displacement, so you could have a two-inch dick, but if it's the width of a paint can you're in good shape. If you move the most water you're the winner. The loser is your girlfriend or wife. At a certain point the length and the ranking would coincide. My guess is that would happen at around fourteen inches. But this would be a great equalizer in our country. There could be a guy working a forklift on a loading dock in Des Moines who comes in at a lower number than Tom Brady, George Clooney, and Mark Cuban. Regular schmoes could end up getting a lot more pussy because of this test. Though once you get into triple-digit rankings, the ladies would be looking at a real vagina breaker.

Every year, an event will be held to name the winner. This will be similar to the Heisman ceremony. We'd hand out the windbreakers to the top ten, there'd be commentary and analysis about immigration patterns and Asians throwing off the curve, Tom Bergeron would host the lead-up. It'd be like the finale of *Celebrity Apprentice*. We'd milk every minute into a two-hour live event and then name the winner. We could scout up-and-coming talent, because remember, every day thousands of young men turn eighteen, so even if you've kept the number one

windbreaker four years running, someone is always nipping at your balls. This would surely be a worldwide television event. It will be known as the HUNG-er Games.

But until we get the logistics worked out on this, we can at least standardize and codify the rules for penis measurement. In my America a penis is measured very simply and very honestly—from the center of the anus to just past the tip.

11

THE FCC

You can really judge a culture's decline by its entertainment. Rome fell around the time they started feeding Christians to lions and calling it good family fun. If you take a stroll through the thousands of channels currently being beamed into our homes, it's not hard to see that . . . well, we're fucked. The *L* in TLC stands for Learning. What exactly I'm learning about while watching *Honey Boo Boo* I'm not sure. Other than juvenile diabetes. Nothing about the *Real Housewives*, including their faces and tits, are real. How *Cajun Pawn Stars* factors into the history part of the History Channel beats me. And one thing I'm sure of is the family of rednecks with ZZ Top beards who make duck calls on A&E is neither art nor entertainment.

As a C-list celebrity, I believe that I can bring something extra to the presidency when it comes to encouraging a cultural course correction. I've worked with the hack producers and executives who constantly fill

our airwaves with this garbage, so I believe I can bring about some positive change in our mass media.

The biggest problem is that we've confused entertainment with schadenfreude. You know I love judging, but our current state of affairs goes beyond that. Every show these days is about people being kicked out of the tribe, not getting the rose, not making the cut, etc. It's about rejection. (Though I will say from experience: reality-show judge is the greatest gig in the world. You sit around like an emperor and order people to perform, and then dismiss them. And the show producers tell you to keep your response to eight seconds. So you spit out something like, "I thought it was good but not great," cash your check, and go home.)

And those are just the competition shows. The other "reality" shows are pure uncut schadenfreude. This is a pervasive problem in our society. We've all experienced the moment at a restaurant when you hear a glass break and everyone stops talking to gawk. Everyone except me. I'm smart, I know what happened. I'm sure a DC-10 didn't hit the building. I know it's just some twenty-three-year-old chick who's already mortified and doesn't need me looking. That's our shitty instinct. We want to put people down to push ourselves up. We are wired to think, "I'm a C student, but my brother is in juvie, so who's the favorite kid now?" I don't think any of the greats were wired this way. Think about the reality shows we used to watch versus those today. It used to be "champagne wishes and caviar dreams" on *Lifestyles of the Rich and Famous*. It was inspirational. Now it's a diabetic chick with festering bedsores who collects her own toenails in Ziploc bags. We've gone from "Life Styles of the Rich and Famous" to "Lice Styles of the Poor and Depressed." It's all geared and produced for the viewers to think, "Well, my life is bad but not that bad. They just cut back my hours at work but I'm watching a chick who will eventually be killed by the avalanche of her own hoarded newspapers." All we do is watch people with no teeth on something called *Midnight Moonshiners* saying, "My still sprung a leak but I shoved my three-year-old in there to clog it," and laugh at them. The carnival freak

show is alive and well, except instead of coming into town on a flatbed truck, it comes through your cable box. Well, fuck that, I want to see rich people on jets. Looking at shit beneath you is no plan for greatness. That keeps you there. Look up the mountain and keep climbing.

And what about the moral responsibility of the producer who's there filming the morbidly obese woman who's confined to her bed and can't reach her inhaler. Well, you could put down your latte and hand it to her, but that wouldn't be as good for your ratings, would it?

Daytime TV is especially guilty when it comes to this. We have the *People's Court, Divorce Court, Paternity Court, Judge Joe Brown, Judge Judy, Judge Mathis* . . . I'm fucking positive Judge Judy's goal was sitting on the Supreme Court, not sitting in judgment on someone who stiffed her hairdresser over a faulty weave. But we lap it up. No one is watching these court shows because they're a law student and want to pick up some tips. They're losers, sitting at home during the day when they should be out looking for work but instead are looking for someone worse off to judge and remove the burden of improving their own lot in life.

One of the worst offenders is Dr. Phil. He covers all of his bullshit with a thin candy coating of righteousness and tough love but it's all got a chewy, nougatey center of "let's judge these assholes and their terrible marriage." But if you really pay attention you'll notice that Phil's doctorate must have come with a side of fries because he has nothing to say. Daytime television is a festival of people who shouldn't be on TV spouting advice like they're geniuses. In fact I had a breakthrough the other day about one of Dr. Phil's daytime TV compadres/competitors. A real lightbulb moment. I realized that Steve Harvey is the black Dr. Phil. Think about it. They're both bald. They both have those mustaches and they're always wearing giant suits. But more importantly, no one really knows what they do. They write books and dispense a bunch of clichés disguised as wisdom that no one's really interested in. They both sit around and say things like, "Well, that dog just ain't gonna hunt" and "Let's take it down and break it down," and people just nod because they're afraid to

admit they don't know what the fuck either of them is talking about. There are no huge fans of either one of them, yet they're both billionaires. None of my black friends love Steve Harvey (I don't have any black friends), and none of my white friends love Dr. Phil, so it's not a race thing. Bottom line is that they're the same dude. I really think if we put them in a room together they'd explode. Or maybe they're just the same performance artist—a small Jewish man from San Francisco with great makeup.

I have to admit some hypocrisy here. I'm not immune to this. Typically I lie in bed on nonfootball Sundays and announce to Lynette it's time to watch our shows. I don't get ten seconds in before I need to pause it and break down the game film. We watch the *Real Housewives*, *Biggest Loser*, and one of my guiltiest pleasures, *Catfish*. For those of you not familiar, this is a show on MTV where the host helps guys who have been having online-only relationships finally connect with the women who, up to that point, they've just seen in pictures. Of course they're disappointed and disillusioned that the person they've spent four years talking to, who they conveniently could never meet face-to-face, isn't as advertised. If I had to describe the show in a tweet-length line, it would be "She's the love of my life. She's my soul mate. What, she's fat? Fuck that bitch."

It's all made worse by the fact that the host, a guy named Nev, is the skinniest hipster dude in the world. Not one of the fat chicks he deals with has an arm circumference that is equal to or less than his waist. The only thing that makes people look fatter is putting them next to someone superskinny. He's a waif model and his partner is a scarecrow with a camera. And not only is he emaciated, he's dark-skinned, which makes the pasty, bubble-armed, corn-fed fat chicks really pop.

Every now and again I'll also catch myself watching one of those ghost hunter TV shows, not because I enjoy them but because they make me mad. Every one of those shows is exactly the same. It's a chick you would have wanted to fuck twenty years ago saying, "Did you feel it get

cold? There's a presence here, I felt it get cold." That doesn't mean you have a ghost, it means you have a draft. The sweep on your front door is no good. These people are frauds. I would like to do one of those ghost shows except in my version when the crazy brother-and-sister team with dyed red hair spout their bullshit about spirits and energy and feeling a presence, I pull out a .44, put it to their head, and say, "Do you really believe?" I'm not saying there isn't unexplainable stuff out there. Ghosts could exist. I'm just saying they're not going to present themselves to incest survivors who are pretending the proof is a two-degree temperature shift or footage from a video camera with the same night-vision technology Paris Hilton used in her sex tape.

I'M NOT OKAY WITH ALL THE K'S

Speaking of sex tapes and the decline of our culture, let's talk about the Kardashians. Who knew we'd be talking about them this much? When that sex tape came out in 2007, Ray J was a much bigger star than Kim, and we'd never even heard of the other Ks in the Kardashian brood. Now we can't escape them. If you combined the TV time of the Kardashian sisters, you'd have the life span of a sea turtle. They're on Leno pitching fragrances, they're doing reality shows about marrying NBA stars, they're guest-judging reality shows as if they had some talent themselves. Someday there will be a President Kardashian. It's never-ending.

It sadly occurs to me that at this point Kim Kardashian has spent more time being famous than Jimi Hendrix, Janice Joplin, Jim Morrison, or Kurt Cobain. Andy Warhol said, "In the future everyone will be world-famous for fifteen minutes." And for a while Andy was right. But nowadays everyone's fifteen minutes of fame has become a three-day weekend. There's no way Andy Warhol could have predicted the Kardashians. Imagine going back to 1968 and saying, "Hey Andy, remember how you were talking about in the future everyone will be famous but only for fifteen minutes? Well, there's going to be a chick with a big ass

who gets fucked by some black guy, we're all going to watch it, and then she's going to be a billionaire. FOREVER." He'd take the brush he was using to paint a soup can, sharpen it, and stab himself in the throat. There is no expiration date on fame now. For the love of Christ, the fucking Octomom is still in the news. And of course she got into porn. A sex tape is no longer a scandal. It's a career move. That is now the default for anyone with any kind of fame, or more accurately infamy. Hell, the so-called Tanning Mom who put her six-year-old in a tanning bed is now going to do a porn. Who is this for? Is there any guy out there thinking, "I'd really like to see someone fuck a leather purse"? This bitch looks like a California Raisin, the only reason anyone would watch her sex tape is for the pure gawk factor. Whether it's Octomom, the Tan Mom, or the Teen Mom, we conveniently turn off our awareness that these are crackpots so we can all feel better about our own relative sanity and keep the perpetual motion machine known as TMZ going.

I was waiting to get my hair cut last year and saw the cover of a *Life & Style* magazine with Kim Kardashian on the cover. (I wouldn't usually read this crap but I go to the ten-dollar Mexican barber and the magazine selection is usually this and *Latina Entrepreneur*.) It read "Court Bombshell: The Proof Kim Cheated." Why the fuck should I, or anyone, give a shit about this? But more interesting was the subheading. "Her Dilemma: Settle for $7 Million or Suffer Public Humiliation." I thought, "Suffer public humiliation?" You're worried about your squeaky-clean image being tarnished by scurrilous accusations of cheating? I can pull out my phone right now, hop on the Internet, and within ten seconds watch a rapper nail you from behind. And second, *settle* for $7 million? You can accuse me of cheating for $7 million anytime. I'm sure Lynette would be just fine with it if I could bring home another seven million. Shit, I'd take it in the ass from Ray J for seven million.

AT LONG LAST HAVE WE NO SENSE OF DECENCY?

And since our new role models are people who we've all seen fuck on camera, it's game off as far as decency goes. I don't want to sound like Pops Carolla, but as a parent, I can't help but shudder when I see what this is doing to our kids. As president, I will do something about it.

Everyone lost their shit when Miley Cyrus did her whole twerking thing at the VMAs. For about ten minutes. Then we moved on to the next shiny object. We accepted it within a week. That's the slippery slope of the slutification of America. Porn is now prime time. Every pop-star chick is trying to one-up the others in the shock value department. A few years before Miley, it was Madonna and Britney at the VMAs making out. By the 2015 VMAs I fully expect to see Nicki Minaj performing analingus on Justin Bieber.

This sexual state of affairs must be a windfall for sixteen-year-old boys. When I was a kid we had to wait for someone to steal a porn mag from their dad and pass it around. Now if there's a pop star who gives you wood, just wait a week and a sex tape is going to come out, they're going to be grinding on Alan Thicke's kid at an award show, or you can catch a nice beaver shot of them coming out of a limo. For teenage boys nowadays, because of the Internet, the world and consequently your cock is at your fingertips.

When I was in high school my buddy Tom once invited me up to his place in the hills to watch Russ Meyer's *Beneath the Valley of the Ultra-Vixens*. Tom's dad was a hand surgeon and had some cash, so he had what was, at the time, a giant TV with this awesome new thing called "cable." Tom told me about this masterpiece coming on two weeks in advance and the anticipation was high. For those two weeks I eagerly counted down the days. If my family wasn't so pathetic we might have had a calendar where I could have diligently X'd out the days. After that long fortnight I dashed up the hill to gaze upon Mr. Meyer's lovely, busty ladies,

but when I showed up it turned out the whole thing was a ruse. It was the cover for my surprise eighteenth birthday party. It was a trap with *Beneath the Valley of the Ultra-Vixens* putting the bait in masturbation. There were 250 people from my high school there, all jammed into Tom's backyard in my honor. This would have been a high point in anyone's high school career and maybe life. But I was devastated. When they all screamed "surprise" I was crestfallen. Two weeks of titty anticipation only to get a case of birthday blue balls. At a certain point during the party I took Tom aside and asked, "But we're still going to watch *Beneath the Valley of the Ultra-Vixens*, right?" That's how desperate we were for porn when I was a lad. Now you just need to put on HBO for five minutes and you're going to see a couple sets of tits.

By the way, stop trying to get me into *Game of Thrones* with your "lotta tits on that show" argument. I've seen tits. I have YouPorn on my computer anytime I want. I don't need to wade through a bunch of gay shit about dragons and magic to see boobies. Jimmy's dad talked my ear off for twenty-five minutes recently about this show. It was like when someone comes to your door to talk to you about Jehovah. I'm not buying what you're selling. Move on. You might have gotten me back in high school when titties were scarce on TV and I had to suffer through hours of *I, Claudius* to catch a little side-boob. Now side-boob is on the front page of CNN.com. It's like someone who lived in a desert subsisting off grubs and cactus moving into a 7-Eleven.

Not only has sex gotten more pervasive, it's gotten more perverted. In a couple years when Sonny decides to pick up the family trade, he's going to have a porn-of-plenty anytime he wants. He'll be able to type in the name of any household object and watch a girl penetrate herself with it. If I showed my son a *Playboy* like his old man used to swap with his friends, he'd roll it up and beat me with it like a dog who chewed up a slipper. He'd be like, "No one is peeing on each other. This is an insult." Plus he's going to be in high school, have a crush on Becky and Suzy, and

then come home, talk to his computer, and say, "Becky and Suzy lezzing out." The computer will call up footage of that and Sonny will have at it. Or the computer will create a virtual version of it from the images on Becky and Suzy's Facebook profiles.

And now that I'm almost fifty and have a daughter, this tramp golden age is not so much a boon for me as it is horrifying, or should I say whore-ifying. I came home recently and found Natalia in a bikini in front of a full-length mirror combing her hair. I asked her what she was doing. She replied, "I'm making a Rihanna video. I'm doing 'Diamonds (in the Sky).' " She was going to film it on my wife's iPhone. I'm assuming she was planning to use a new app called Daddy's Little Whore. It's not just seeing my seven-year-old daughter in a bikini wanting to emulate the chick who went back to Chris Brown after he beat the shit out of her that gets me, it's that she has no idea that this video is forever. That shit is going to get dredged up eventually. With our constant Facebook- ing, Instagramming, tweeting, and Ustreaming, we forget that there is a future. It's all about now. She doesn't know that her future employer may see this and beat off.

You never saw footage of your parents fucking around, getting drunk, or screwing. My grandkids are gonna be able to find footage of their parents doing beer bongs and vomiting into potted plants, or worse, footage of themselves being conceived. When we were growing up all we had were grainy black-and-white pictures of our parents' wed- ding and a trip to the Grand Canyon. Our kids will have footage of every moment of their life, high-definition glossy footage of their graduation, fucking around on skateboards or on spring break, and then their kids will say, "Hey, there's mom at nineteen. She had a nice rack on her . . ."

My only hope is that it will all turn around. Maybe it will get so extreme that there will be a rebellion and kids will turn into bow-tie- wearing Mormons. Think about it. Punk rock gave way to preppies, which gave way to grunge. These things go in cycles. Maybe we've gotten

so debaucherous that the only way to rebel will be to drive a horse and buggy, make your own furniture, and grow a beard with no mustache.

Even stuff that isn't sex sounds like sex on TV now. The other night I was watching tennis. It was nine thirty, the kids were asleep, and the wife was upstairs. I think it was the U.S. Open, Serena Williams versus some Russian broad. The skinny Russian chick would let out this grunt whenever she'd serve or return, or when she was warming up, or really, all the time. I swear if a moth flew by and she swatted at it, she'd let out a hearty "UUUNNNGGG!" It sounded bizarrely sexual. My neighbors must have been thinking, "Carolla's killing another hooker in the den." I literally had to turn it down so Lynette didn't think I was watching Skinemax. But then I couldn't hear the announcers. So I changed the channel and switched to ESPN5 and they had the Strongman competition. A giant white dude named something like Magnus Von Magnusson was lifting four-hundred-pound boulders onto five-foot pedestals and making no noise. Complete silence. Think about that. Dead-lifting a four-hundred-pound boulder—not a peep. Swatting a three-ounce ball—the bitch can't shut her trap.

ManDate

My FCC will require a decibel meter on these female tennis players. It's distracting. From now on you can make some noises, but you can't sound like the Hulk taking a shit.

THE VAST WASTELAND OF KIDS' TV

When it comes to modern children and TV, I think another problem is that the entertainment bar is too high. When we were kids we'd watch an episode of some Claymation crap like *Gumby and Pokey* or *Davey and Goliath* and that would be enough. Or remember the circus? When we were kids the circus was just a guy standing on a horse or a formerly hot

chick who is now a little bit thick in the thighs holding a hoop for some poodles to jump through. Kids today cannot possibly be entertained by that. It's going to be crazy when I have to explain to my twins that when I was their age we thought shadow puppets were entertaining. Someone would hang a sheet, take the shade off the lamp, and make something that looked approximately like an ostrich head, and that was our fun. Now kids need to see Travis Pastrana jump a Ski-Doo over a pool of nuns on fire.

As a dad, I've obviously had an assful of kids' cartoons. It's really sad. I'll be sitting around with ESPN sports guy and fellow father Bill Simmons having a spirited discussion about *Ni Hao, Kai-Lan* and *Handy Manny*. We're adult males, shouldn't we be talking about the line on the Pats game and the latest edition of the *Fast and Furious* franchise? As a parent, you actually end up watching more of this crap than your kids. They only know when it's not on. They're usually not paying attention at all, but the second you turn off the *Sponge-Bob* to put on a little TMZ, they start wailing like stuck pigs. So you just surrender, and eventually you find yourself, again a grown-ass adult, picking the show apart and getting into it. You'll be watching it, complaining quietly to yourself, "There's no way a cat could bounce on its tail. This is such bullshit." And then you spend your whole day with the stupid educational songs in your head: "If you have to go potty, stop, and go right away. Flush and wash and be on your way." Oh good. I, a forty-eight-year-old man, definitely needed a refresher course on not shitting myself and then smearing it all over my hands.

And those are the kids' shows that piss me off most: the ones that purport to be educational. When Mitt Romney talked about ending the subsidy to PBS and everyone went apeshit, I was completely on board.

This is a plan I will enact in the Carolla administration. Why should my tax dollars pay for this? Shouldn't *Sesame Street* make enough off Elmo

merchandise alone to fund PBS for the next sixty years? No kid can get through childhood in America without getting an Elmo bedspread, a Cookie Monster lunch box, and a Big Bird backpack. Where's all that money going? Half of those episodes of *Sesame Street* are recycled shit from years past anyway. And how much writing really needs to go into one of those episodes? Do you need a team of people coming up with new ways to count to ten? "It's taken us all night but I think we finally cracked it. We'll count the oranges on a tree."

The part where they say "this is educational" is such a cop-out. I've seen my kids watching these shows. They're learning nothing. Mr. Moose is like, "Can you tell me which one of these is different?" Then he pauses for a 5 Mississippi and says, "Excellent. You're so smart." Meanwhile my kid hasn't said a fucking word. He just sits there like one of the heads from Easter Island.

In fact I think most of this crap is making our kids dumber. *Dora the Explorer* is an attack on our intelligence. It's for stupid people, made by stupider people. First off, she's obviously a lesbian. Just look at the shorts and the haircut. Second, she has a sidekick that's a monkey. That shit was fucked up in the sixties when Speed Racer hooked up with Chim Chim. Her other cohort is a Fox named Swiper. And guess what Swiper does? He steals stuff. How fucking clever. I didn't want my kids watching this crap, so I forced them to watch *The Simpsons*. Their nanny took me to task and told me it was too dirty. I said fuck that, I'd rather they be exposed to quality than some Hispanic bitch with a bob saying, "Can you find the apple?" and then pausing while they stare blankly.

There's a couple other offenders too. *Caillou* is awful. The color palette is completely off and doesn't make any sense until you realize it's coming out of Canada. And why the fuck is he bald? Am I making my kids watch a show about a Canadian boy with cancer?

The worst, the one that sent me over the edge, the one that caused me to lay down the law with my kids and say no more was *Wow! Wow!*

Wubbzy! There was a song on that show that epitomized everything that is wrong with kids today, and how we are ruining them. It's called "Mr. Cool" and here are some of the lyrics:

> *You don't have to talk a certain way*
> *There's nothing special you have to say*
> *Just be yourself every day*
> *And everyone will know you're the coolest*
> *You don't have to be like everyone*
> *Be yourself, you'll be number one*
> *And you'll feel like the coolest*
> *Don't forget the golden rule*
> *Be yourself and you'll be cool*

This is a horrific message to send to kids. "Don't try to excel at anything. Don't try to be special. Don't do anything. You'll still be the coolest! Whatever you do, you're the coolest! Fail out of school! You're the coolest! Live in your parents' basement until you are fifty. You're the coolest. Eat until you're morbidly obese and your liver shuts down. You're the coolest. Set a bum on fire. You're the coolest. Slaughter nineteen nursing students. You're the coolest!!!"

And that's not the golden rule. The golden rule is to treat other people how you want to be treated, not "Fuck what other people think. You're the best."

You condescending pricks think this is a positive message? Everyone is number one. Doesn't that mean someone else who's listening to this song is number two? What about their feelings? I'd like to knock you out with a frying pan and take a number one and a number two on your face.

It's the same message the pop chicks like Katy Perry sing. You're the best, don't change anything. Don't ever attempt to improve yourself at

all. Anyone who says you should do something different is just a hater (more on this disturbing trend coming up). Fuck that. Beat yourself up a little bit. Be better. That's the message from a couple old white guys who founded this fucking country. Benjamin Franklin said the Constitution only guarantees the right to *pursue* happiness; you have to catch it yourself. If *Wow! Wow! Wubbzy!* and One Direction founded this country with their "you're beautiful the way you are" and "you don't have to do anything to be the coolest" message, we'd all still be riding horses and dying from preventable diseases and the scourge of winter. Life is about improvement, the pursuit of better whether it's your body, your home, or your career.

MODERN MUSIC MAKES ME SICK

I was not educated in high school. I was educated by listening to talk radio on construction sites, and not only because there were no stations that would touch the good music of the eighties—John Hiatt, Joe Jackson, the Pretenders, etc. When I was digging ditches, I sought out talk radio because I wanted to hear alternative voices and ideas. I had plenty of time to hear the crap rattling around in my bean as I humped a wheelbarrow around. I needed new ideas and opinions to think about. Now radio is like beating off into a fan, it's just more of you splashing back in your face. We've decided we need to give everybody what they want, not expose them to new concepts. So what you end up with is a bunch of computers playing Rihanna records. There are no more DJs, no more talk radio, no more opinions, no more news. Just thumping techno with Auto-Tuned vocals about "You know you want me, boy, but you can't have me, boy."

But before I go off on another vitriolic rant about kids and how the music they're listening to is ruining them and consequently our country, let me start with a couple of palate-cleansing annoyances related to music

and take the time to name John Hiatt as my director of the FCC. I feel like it's the only way I'm going to get to hear his music on the radio.

I was watching the Grammys a few years back and saw a nice tribute to the Beach Boys. Of course they showed Mike Love, one of the founding members. I'm always driven nuts when I see him because he's constantly wearing a hat that says BEACH BOYS on it. You were introduced as the Beach Boys on the Grammys. Should we have thought, "What group is this, the Delfonics?" We get it, you're bald and you were in the Beach Boys. I understand you get a lot of swag in show business. I have some *Man Show* shirts, but I would never leave the house in one. Also, and this goes for Jimmy Buffett too, we need a moratorium on the Hawaiian shirt. Once you get past fifty-one it's time to hang those up, Jimbo.

This was at the 2012 Grammys, hosted by LL Cool J. Is there a federal law that LL Cool J must present or host every award show? If so, as president, I'm going to repeal it. I feel like I've seen him and his Kangol hat at every awards show in the last fifty years. If I watched the Oscars in black and white from 1959 with Bob Hope hosting, I'd see LL digitally inserted. I understand that's he's charismatic and charming but it's starting to feel required. Like having Jeff Ross at a roast. I bet when the Klan puts on the "Klannys," LL still gets a call. Don't get me wrong, I like the guy. I just feel like when my son gets his next participation trophy for t-ball, LL is going to be there to give it to him. But in addition to calling Bob Marley a genius (which I *strongly* disagree with), he did something that struck me as odd that night. He introduced Paul McCartney and called him his "homie." Normally I don't want to mess with guys built like brick houses, but no one, if you think about the word "homie," could be further from LL than a guy who was born in Liverpool while it was being bombed by the Germans.

And since I'm on this topic I have a quick message for Sir Paul. You're a legend and I'm a big Beatles fan, so I say this with love: it's time to put down the Just For Men and walk away. We know you don't have the same hair color you did when you played on *Ed Sullivan*. And you're

a fucking Beatle. You can still get laid anytime you want. You don't need to attempt and fail to trick us into thinking you're still rocking the auburn locks. Take your own advice and "Let It Be."

While I'm attacking legends, let me dig into Bob Dylan. This hack is completely overrated. He came along at the right time and carved his initials on the psyche of America. He can't play the harmonica, his guitar playing is pedestrian, and his voice is bad. I could get a bunch of cats, fill their stomachs with varying amounts of nitrous oxide, and then back over them with a car and produce something more pleasing to the ear than Bob Dylan's voice. I've argued with a lot of people who love Dylan and this is always my knockout punch: People doing Aretha Franklin impersonations don't sound better than the Queen of Soul. When someone does a Bob Dylan impersonation it always sounds better.

And my friend John Popper, king of the harmonica, thinks Dylan is shit on the mouth harp, so that's that.

I saw them wheel out Dylan on the Grammys a couple years ago to do "Maggie's Farm." Of course he had the Avett Brothers, Mumford & Sons, and about ten other guys whaling away on banjos behind him. When there is a wall of banjos propping you up and covering up your weasel-scratch voice, it's probably time to hang it up. And about the twenty-fifth time I heard him croak about not working on Maggie's farm no more, I thought, "Bullet dodged. That must be a relief for Maggie." Can you imagine what a shitty farmhand Bob Dylan would be? He'd end up passing out at the wheel of a combine and driving it into the living room.

The only thing he has to hang his hat on is lyrics, and I think people pretend to understand them but secretly have no idea what the fuck he's talking about. I listened to "All I Really Want to Do" and was struck at just how awful that song is. Dr. Seuss would think it was amateur hour. "I ain't looking to drag you down or drain you down, chain you down or bring you down." Awesome, Bob, you rhymed down with down. Twice. Genius.

Okay. On to the music of today. The shitty, shitty music of today. The teenage-girl garbage fest that passes itself off as music that has infected our culture. This shit is insidious. It has spread quicker and farther than AIDS in Africa. There's no escaping it. Traditional bastions of male-dom are being invaded by this teen chick music. I was in the chair at the aforementioned Mexican barbershop and they were pumping Miley Cyrus. Worse, I was at a sports bar in the San Antonio airport at nine A.M. trying to enjoy a preflight Bloody Mary and Lady Gaga was blasting from the speakers. Because there's nothing guys who frequent sports bars in Texas during prime hangover hours enjoy more than the music of Lady Gaga. My travel companion, Mike August, asked the bartender to turn it down. The bartender replied that he wasn't allowed to.

I can't even escape this crap in my own house. Natalia is nuts for this shit. She followed me around one day holding an iPad that was cranking out some Rihanna while I was trying to do the work that paid for that iPad. This is ruining my daughter. I read her a story two years ago about penguins and how baby penguins have a special song that they call out when they get lost and need to find their parents among the swarm of penguins on the glacier. I asked her what her special song would be if she got lost so Daddy could find her. Without thinking for a second, she said "Nicki Minaj." My soul died.

Do we have to hear Katy Perry at every moment of our lives? The whole world is not a twelve-year-old girl. It sounds inspirational but if you really listen it's "Fuck him, you're better than him, you're totally awesome just the way you are." The "anyone can be sexy, all women are beautiful" message is bullshit, and coming from Katy Perry it's completely hypocritical. She's literally shooting whipped cream from her D-cups in slow motion at Snoop Dogg while preaching girl power.

Convincing depressed dumpy chicks they're perfect just the way they are is not a great plan for the future. I want Beyoncé to come out with a song about shedding a couple of pounds and dressing up nice for your boyfriend or job interview.

The worst was last year when I was in New York doing a live show at Town Hall for the comedy festival. I was completely burnt from doing the show, plus two shows the night before, and had to be up at five the next morning to catch a flight. But my buddy Daniel was in town and we made plans to go out after the show to a high-end steak joint in Manhattan called STK.

Before we even sat down, I was annoyed. The jams were being pumped. I looked over and saw a live DJ on a riser at one end of the place. When the waitress came over to take our order, she had to shout the specials at us like you do at your deaf grandmother when you visit her in the home. "IT'S NOT A TRADITIONAL CRAB CAKE . . . NO, *CRAB* CAKE . . ." I shit you not, the techno was so loud I had to act like a UN interpreter between the waitress and the guy sitting next to me. "SHE SAID THAT ONLY COMES WITH TWO SHRIMP, SO WE SHOULD PROBABLY DO THREE ORDERS!" We all got a nice side order of tinnitus with our asparagus.

And they were not just any jams. No, this DJ was doing it mash-up style. So not only were we treated to Carly Rae Jepsen's "Call Me Maybe," but it was mashed up with the bass from "Roxanne." And to add insult to injury there was ten seconds of relief when they played the intro to Frank Sinatra's "New York, New York." I thought, "Oh, thank God. Finally, a little Sinatra in a New York steak house, the world is right again." And then came the Alicia Keys.

And that's the point. How about some Sinatra or jazz? Would people light the place on fire and throw chairs through the windows if you played a little Dave Brubeck? Is this a steak house or a fashion show? I came here for a porterhouse and some mashed potatoes, not a rave.

Of course I had to talk to the waitress about this. I asked, "Do people like the music so loud they can't hear the specials?" She gave me two very unsatisfying answers. First she said, "I know. Everyone complains about it." Then why don't you do something about it? Is there a city ordinance that the music must be louder than a jet engine? The second part of

her answer was worse. When I asked why the DJ cut Sinatra, she said the owners wanted it that way to make the place more friendly toward women. I thought, "Women or eleven-year-old girls?" Because that's who this "music" is appealing to.

This was not the first and definitely won't be the last time a live DJ ruined my life. I was at an event at the Tribeca Film Festival and the white DJ, who I've lovingly dubbed DJ CrackerJew, was pumping up the jams as if the room was full of thirteen-year-old girls with learning and hearing disabilities. I went up and asked him politely to turn it down and he said no. I asked, "Do you see anyone dancing?" He replied that he didn't. So I asked again if he could turn it down and he said no again. Then I snapped, "No one likes your shitty music." He said, "I do," and turned it up. I wanted to find this guy's parents and kick the shit out of them. Just never stop kicking them until my shoes were covered in teeth and blood. Can we get black people DJing again? White guys have too much to prove.

Seriously. Remember when party DJs were lovable black guys in Run-D.M.C. sweatsuits whose shoes were untied? (Unclear if they were trying to cultivate a look or if it was the morbid obesity that prevented them from doing so.) They played some Temptations, they played some Marvin Gaye, they dutifully honored the "Walking on Sunshine" request, and then went the fuck home. Now they're spindly, obnoxious white guys in front of a Mac laptop with their hats on crooked looking like a cheap Chinese bootleg of a Beastie Boy. This guy doesn't seem to notice he's in a room full of people whose average age is fifty-one and average skin color is Meryl Streep. This is just jacking off, they don't care what their audience wants to hear, as long as they look and feel cool doing it and get to take a coke break once in a while.

But that was in New York. It's an urban center where everyone is trying to be cool. So it's not a total surprise. The most egregious example of this shitty music permeating our culture was when I was in St. Paul, Minnesota, for a live show. I was playing at Garrison Keillor's theater. That is

the whitest building in the whitest city in the whitest state. Long story short, I was late for the gig and had to hop in a cab with my manager on the phone giving me directions. Meanwhile, the cabdriver named, no joke, Habib, was playing some form of music that was so grating and computerized I had to hang up with my manager and ask him what the fuck it was. I had never heard anything so annoying. Speaking to one of the neck rolls on the back of Habib's head, I asked, "What is this?" He replied through a heavy accent, "Soca. It is Soca music." I said, "Soccer?" No, Soca. "What is Soca?" I asked. My swarthy friend said, "It's for the young people, to dance the club and make love!" I thought, "What part of this looks like that? Our combined age is ninety-six and half and we're in a cab in St. Paul."

PUTTING THE MAD IN MADISON AVENUE

The pursuit of youth and "the demo" started with advertising. This never made sense to me. People will talk about trying to get people while they're young and have disposable income to "create brand loyalty," but when I was nineteen I didn't have a pot to piss in. So go ahead and youth up your commercials all you want, they're falling on deaf ears and an empty wallet.

If advertising is to be believed, we should all be attending rooftop parties with our young, perfectly racially balanced, one-of-every-color group of friends. I should be heading up to a rooftop with my black friend, my Hispanic friend, and my Asian friend to see DJ CrackerJew spin some records and drink a refreshing Dr Pepper. But the reality is that the majority of my friends are white and we've never been on a rooftop together. I don't think these parties actually exist. The only time I've ever seen a Mexican on a roof, he was rolling out tarpaper, the only time I've seen an Asian on a rooftop was with a rifle during the L.A. riots, and the only time I've seen a black guy on a roof was waving down the coast guard in the Ninth Ward.

And I've never seen an American Indian in one of these ads—especially liquor ads. African Americans are 13 percent of the population, but if beer and McDonald's ads are to be believed, they're 50 percent. American Indians are 1.2 percent of the U.S. population, yet never appear in any commercials. If you apply the same racial math Madison Avenue does with black people, every tenth beer ad should have a Mohican in it.

Everything has to be young and cool when it comes to ads, even the maxi-pad commercials. I saw a Kotex ad recently and the whole point was "This isn't your grandma's pad. This one is edgy and in-your-face. Wear them loud and wear them proud." The lead chick is walking by a faded ad on the side of a building for some boring old maxi pad. She goes into her bag, in which she is conveniently carrying a couple cans of spray paint. A Joan Jett knockoff song kicks up as she starts tagging up the billboard. Then all these other hot rock-and-roll rebel chicks—one of every ethnicity, of course—come out of the stores and schools and into the street with ladders and paint to team up and do a little graffiti about maxi pads. It ends with the tag line "Take a Stand Against Bland." Yeah, that's what chicks want, to advertise their menses. How dumb do they think women are? Just because they changed the packaging on your maxi pad to Day-Glo doesn't make you part of the Runaways. I'm no expert in this area but I've talked to my female friends and they don't have strong opinions about the color of their pad packaging. They think the more subtle the better.

As president, I'm going to decree that maxi-pad packaging should come in three styles—a beige one, a suede one, and a leather one so they blend in with your purse. This should help me land the female vote for my reelection.

And the younger the advertiser is aiming, the more annoyed I am. Because these ads are all about attitude. I saw a commercial where the kid was annoyed that his mother made him Pop-Tarts instead of Toaster

Strudels. Fuck you, you little turd. I would have sucked my gym coach off for a Pop-Tart when I was a kid. I wanted to reach into the TV and punch him in the face. Let's see how many Toaster Strudels you can eat with no teeth. We're empowering these little shitbags too much by catering to them and constantly telling them it's their world. But by ingraining that attitude, we're ruining ours.

The ad that's driving me nuts right now is a Pepsi campaign where they tell you to "Live for Now." Not only is there something slightly morbid about it—basically it's saying, "Fuck it, you're going to die, have a Pepsi"—but this is the opposite of what we should be teaching our youth. We should be telling them to save for later. Living for now is what collapsed our economy. A lot of people took out home loans they couldn't afford because they were living for now. Now they're living in tents under the freeway. You show me a student that lives for now and I'll show you an F. That's why Asians are handing our asses to us. We're telling our young people, "Sure, you have a book report due tomorrow but you want to play *Grand Theft Auto*. Live for now."

But I've noticed another disturbing trend in advertising. It's worse than the catering to kids, it's catering to lazy deadbeats.

I remember as a kid, I would tell my mom I was sick so I could have a day out of school. The joke was on me. I would sit around and be punished by whatever was on her thirteen-inch black-and-white Zenith. Every commercial I'd see in between scintillating segments of *Wagon Train* reruns was about how you could become a nurse or get a welding license. And there were many choices for schools to learn how to be a trucker. "Hi, I'm Wally Thorpe for the Wally Thorpe School of Trucking . . ." or "At the Dootson School of Trucking, we can get you your Class 7 license and get you behind the wheel of a big rig and making big money in three weeks. I should know, I'm Debbie Dootson." Nowadays what does every single commercial if you're home during the day sound like? "Did you slip and fall at work?" "Were you exposed to asbestos?" "Chronic pain from your transvaginal mesh? Call the law office

of Steven R. Johnson." The message used to be "What are you doing at home during the day? Get a job, you lazy fucker." Now it's "Don't get off your ass. Dial the phone with your fat sausage fingers, we're gonna get you some cash." This is a little pH strip for our society and how off the rails we've gone. Instead of getting a career and hitting the open road in your big rig and earning your pay, it's all about sitting on the couch with your Big Gulp and getting the grocery store you slipped and fell in to pay for your Doritos.

Another bad sign of the times are beer commercials. Every beer ad when I was growing up showed a bunch of guys walking into the bar covered in grime and wearing hard hats after clocking out. The voice-over would say, "You've worked hard all day, you've earned a cold one." They'd take a pull off it and let out a nice "aaahhh."

Now every beer ad shows the aforementioned multiethnic rooftop party full of twenty-three-year olds with DJ CrackerJew spinning the tunes. No one did anything that day except try to get laid. You used to work for your beer. Not anymore. A voice-over saying, "You read the *Huffington Post* on your Kindle and watched a biracial couple make out at a poetry slam, you've earned a cold one," doesn't quite work, does it? The guys who would knock off work and hit the bar for Miller Time after placing girders are gone, it's all skinny guys in scarves and porkpie hats who look like Adam Levine drinking sixty-four-calorie "ultra" beers. No wonder every bridge is falling down.

AND THE OSCAR GOES TO

Let me wrap this up with another example of how wrong we've gone as a society as symbolized by the media. Watching the Oscars this year, I realized two things. It used to be that the person who won would get up there and thank their agent, their wife, and the people who worked on the project with them. Now they have to go up and thank all the other nominees first. Back in the day John Wayne just got up there, thanked

the William Morris Agency, and went backstage to get shit-faced. Now the poor wife of the best actor doesn't even get thanked before the music is playing him offstage because he spent the majority of his speech talking about how everyone else in the category deserved the award instead of him. This is the culture we've crafted. No one wants to be excellent, no one wants to be part of the one percent. Because they know that only engenders envy. The American public no longer wants to look up to the people winning awards, they only want to look down on people for getting kicked off the island.

The language at the Oscars has even changed to suit this purpose. It wasn't that long ago that the presenter would open they envelope and say, "And the winner is . . ." Now it's ". . . and the Oscar goes to . . ." Because saying "winner" implies there's a loser and that can't exist because we're all equal and everyone is number one just like *Wow! Wow! Wubbzy!* said. Well then, why even have a fucking awards show at all? "The Oscar goes to . . ." sounds arbitrary, as if they picked a name out of a fishbowl backstage. We're trying to figure out who was the best, their peers voted to see who that was. This is the participation trophy generation coming of age and making changes.

ManDate

So I now issue the following executive order: We will continue the trend of not saying "and the winner is" but with a twist. Now the presenter will announce one by one the names of the other four nominees by saying "and the losers are . . ." allowing plenty of time for them to bask in their shame. Like all things in my America, I want talented people who bust their ass and do a great job to be rewarded, and the people who don't to receive a healthy dose of do-it-better-next-time shame.

12

THE DEPARTMENT OF LABOR

As we head into the final chapter in my campaign platform, also known as this book, I'm going to get a little extra-preachy. The problems with our work force and Department of Labor are something I feel uniquely qualified to rage about, and well equipped to fix. I was a laborer in the truest sense of the word. If you read my last book you know that my nearly twenty-year run of shitty jobs—cleaning carpets, digging ditches, installing closets, slinging hamburgers, and swinging hammers—is well documented.

As miserable as I was, I look back on that time as important. I learned a lot of life skills on those jobs, and I'm not talking about the proper operation and maintenance of a carpet wand. I'm talking about grit. Those jobs sucked. All working-class jobs break down into two categories. The first is mind-numbing. These are the jobs like being a night watchman. You're all alone, and besides a little talk radio, you've

got nothing to stimulate you unless a junkie tries to break into whatever you're protecting and stab you. Then there are the punishment jobs. Jobs that make you think you must have been a really awful person in a past life and your karma has come due. I was talking to Josh Homme, the lead singer from Queens of the Stone Age, who if you don't know is a giant pale redhead. He spent some time as a roofer in Palm Springs. He must have been a serial rapist in his last life because that's a tough pull. Scraping hot, dusty tarpaper off a roof in cloudless 120-degree Palm Springs when you're seven feet tall and have the skin tone of Conan O'Brien is torture.

But I think jobs like that teach you grit. I don't want to hang out with someone who didn't have a shitty job. I like a guy who walked in front of the asphalt spreader with a rake in Mississippi. He stuck it out and now appreciates the job with the air-conditioning and ergonomically correct seat. In America today we have decided that repetitive manual labor is something that needs to be farmed out to other countries. But you can learn something from that kind of work. You can build up that emotional callus, learn to take criticism and how to tough shit out. These guys know what work is.

And in a strange way I think it makes people happier. I'm sure if a copy of this book is floating around a construction site, the two white guys who can read English are disagreeing with this. But honestly, I believe the happiest people in the world are the ones who have something to do with their hands. It used to just be that the sun came up and you went to work in a field or down to the mill. Now the only thing we have on our hands is too much time, and we're turning on ourselves. Our jobs involve too much of our brain and not enough of our brawn. Our mind is devouring itself because it doesn't have the distraction of sweating and toiling.

Nowadays everything is so technical and digital you never really know if someone is working or not. It's not like they're holding shovels and pickaxes, they've just got the laptop open. You can't tell if they're

working on that spreadsheet you asked for or are on DraftKings checking their fantasy football league. And it's all done in air-conditioned offices with OSHA-certified chairs and desks. In my construction days the only reason to sit down was to pull a sixteen-penny sinker out of your Achilles with a pair of pliers. And even then the boss would call you a lazy pussy and say, "We've got a dime holding up a dollar."

As much as I complain about show business, it's not real work. My hardest day on any of my entertainment-related projects was easier than my best day doing earthquake rehab on, and often underneath, government-subsidized apartments in downtown L.A.

And it wasn't until I got into show business that I met the self-entitled generation whose main job seems to be ruining our culture, economy, and my afternoon. This is the generation who was so consistently told they were all winners and that no one was better than them that they don't recognize that in the workplace there are winners and there *are* people better than them. Those people are called bosses. They're called superiors for a reason. They have more experience, prowess, or expertise than you and you should listen to them if you want to be them one day.

But not these kids. I have run into plenty of them in my time, from the intern on *The Man Show* who got shit-faced at the Christmas party and decided to tell me I wasn't funny to the "dump button" guy at my morning radio show who needed to settle my hash in the hallway when I argued with him about one of his innumerable bad calls on what needed to be bleeped out. I'm sorry, I forgot you had two months doing radio at your junior college. I'm only the guy who took over for Howard Stern.

The worst, and one of the first, was on *Loveline*—Junior Junior Junior Junior Junior Junior Junior Junior (deep inhale) Junior Junior Junior Producer Lauren.

I asked her during a commercial break what she had learned from watching me do the show for several years. She said without hesitation, "Well, you don't have to prepare. You don't have to be educated, you get to leave early, and you can never be fired." Knowing she had another

bitch bullet in her insult Gatling gun, I asked if there was anything else to add. There was. She said, "It's all about luck and who you know."

The other mistake people make is only performing tasks that are interesting or have a payday. I saw this time and time again on all of my projects. If you assigned a guy a job that was no fun and had no glory for him at the end, guess which ball got dropped or what "fell through the cracks"? But if there was a job that gave him the chance to be on set with the Juggies or hang around the writers' room, he was on that shit like Letterman on an intern.

Unfortunately this sad fact haunts me outside of my work life too.

A couple years back I noticed a big scuff on the side of the very expensive car I lease for my wife. As you well know, I have hypervigilance and I'm a car guy, so I spotted it immediately. Not that I needed to be hypervigilant, it was a huge scuff. It looked like someone took a hockey puck and ran it along the side of her Jag. I told Lynette to get some rubbing compound and buff it out. (For you homos out there who don't know, this is not a big deal. A dollop of this stuff on a damp rag, a few swipes with your hand, and you're done. It's as complex and time-consuming as wiping down a counter. And by the way, rubbing compound is on my list of things that sound way better than they are. It sounds like a hand-job parlor. "I'm heading down to the Rubbing Compound.")

Well, like all things I desire, it didn't happen. I saw that scuff for the next week, commenting on it each day. Then once a week for a month with ever-increasing frustration I asked her, "Why don't you just do this? You have a $70,000 car that I'm leasing for you and it looks like shit." Eventually, with great effort, I let it go. Sometimes you've got to know when you're beat. It's her car (even though I'm paying for it), she can drive around with a shit streak across the side if she wants to. Moving on.

About four months later she came up to me and asked, "What was that stuff I need to wipe off that scuff on the car? Where is that?" I didn't think, "Great, finally," and I didn't say, "It's down in the garage on the shelf." I asked, "Why?" She said, "No reason." I'm not wired to accept

that as an answer. I knew something was up. Why after more than a month of me asking her to fix that swipe, and me quietly resenting her for not doing so, has she chosen on a random Sunday afternoon to clean it up? So I asked again. She tossed off a casual "Nothing, just wanna take care of it." I told her it was in the garage on the shelf, it said "3M" on it, and to just get a rag and rub it out. A little while later I saw her leaving and asked where she was going. She said she was driving to LAX. I didn't know about any travel plans, so I asked why she was making an airport run. She told me she was picking up Nils Lofgren, who was doing the podcast.

It all snapped into place. She had looked me in the eye and acted as if she finally got the message and took care of the scuff for the sake of doing so or because it was clearly frustrating to me. Nope. It was because a member of her beloved E Street Band was in town and needed to be personally chauffeured. That streak was on her car for more than a month of my complaining, stayed there for another four months of my quietly simmering resentment but was gone in five minutes as soon as she had a reason to do the job. Apparently her husband, the breadwinner and car leaser, going slowly insane was not enough to spark her interest.

Back to the kids. The problem in today's workplace is that these kids have had, since birth, an overinflated sense of self-importance. And they bring that mind-set with them into the office. They think the fucking building will fall down without them. The question they need to, but won't, ask themselves is "What happens when I don't show up on Friday?" If the answer is nothing, then make sure to show up Monday with doughnuts.

These people act as if the world owes them just for existing. You can really see this in action when their birthday rolls around. Not only do I think people shouldn't take a day off work for their birthday (another thing that will be illegal in my administration), I know people who take a couple days off. I'll see employees who take Friday off work because their

birthday is on Saturday and then they'll take Monday off too. They treat it like Ramadan.

There's this one. The staffer's birthday will be on a Sunday, so the office will throw them a party in the break room on Friday.

Not on my watch. You only get the shitty sheet cake and halfhearted, out-of-tune rendition of "Happy Birthday" if you are at work on your actual birthday.

Here's the thing about birthdays. Your dad didn't pull out. You didn't do shit. You didn't earn anything. I'll tell you who else has or had birthday celebrations each year: Charles Manson, Jim Jones, Osama bin Laden, Pol Pot, Jeremy Piven, and Ted Bundy. All the people you hate in life, all the pedophiles, all the murderers, all the IRS auditors have birthdays. I don't think we should celebrate Idi Amin's birthday and I don't think we should celebrate yours either.

Here's a major culture shift that is going to begin in my administration. We will phase out the birthday and incorporate the "worthday." This is a day of achievement that you celebrate annually. That would be more satisfying. It will add an element of drive. The day you got your Ph.D. or bought your first house will be your standing worthday until you beat it.

This will also encourage competition. You'll be at your neighbor's or relative's worthday party thinking, "He passed the bar and I've got a GED, I've got to buckle down and earn a better worthday." Think about it, one man's worthday is winning a Pulitzer Prize, and another's is finishing the Pig's Trough at Farrell's.

Now, I don't want to be cruel. It wouldn't be fair to put this on kids and rob them of the simple joy of a birthday party. So henceforward, thirteen is your last birthday; after that, it's worthdays. Unless you're Mexican, then you get up to the Quinceañera.

This "just showing up makes me a winner" bullshit was at the heart

of the Occupy Wall Street movement. This is as symbolic of the current shitty generation as Woodstock was to the hippies. It said everything you needed to know about an entire age group. Occupy Wall Street is the participation trophy generation in a nutshell.

For twenty years those kids were getting "You're #1" stickers for every #2 they produced. Now they're adults entering the work force and they can't take the real world. They've been shamed by life because they haven't been prepared for it. They've had so much smoke blown up their collective asses their minds are clouded and they can't figure out why everyone doesn't think they're as special and precious as Mommy said. They can't handle the fact that they're not the unique snowflake everyone insisted they were, that they're now just peon #27 who's putting in an application like every other schnook. So they don't get hired. But the plan is not to get more education or brush up on the job interview skills, it's to get a brick and throw it through the window of the business. And by that I mean a metaphoric brick in the form of a negative Yelp review. A real brick would be too active for these assholes.

But like their hippie ancestors, they drop out and start bitching about The Man keeping them down. Enough of them get together on the Internet and decide to head down to Wall Street, set up a pup tent, rip a couple bong loads, bang a couple bongos, and blame their fate on vague notions of corruption and "the one percent."

I'm also convinced half the guys there were just trying to get laid. "Yeah, the Koch brothers *are* evil. Wanna head to my tent and lose that hemp tank top?" I'm positive if there were no attractive young college chicks at those events it would have wrapped up in one afternoon. As soon as Occupy Wall Street became a sausage fest, the tents literally would have been folded up. None of those guys cared about any of that shit, they were just trying to occupy some pussy.

Or they wanted to meet celebrities because Kanye West, Russell Simmons, and a couple other millionaires headed down there to make an appearance as if they weren't in the same tax bracket as the fat cats these

assholes were complaining about. They went down there in solidarity then walked a couple blocks back to their Maybachs and drove to their eight-thousand-square-foot penthouses. Somehow it gets conveniently forgotten that these guys are rich too, because they dress down. Everyone is deathly afraid of being labeled a one-percenter. Why do you think millionaire Michael Moore is forced to dress like an unemployed lesbian trucker?

Eventually OWS just became a cool place to hang out and not work, which is what they wanted to do in the first place. If all of their demands were magically met and the system did change, that would mean they'd have to start occupying a cubicle and work, which would seriously cut into their tweeting and blogging about how corrupt corporations are.

The bottom line is these kids hate the rich because they're envious. This is a fairly new and seriously disturbing trend. Since the birth of this nation there has always been some ethnic group, family, or organization that had more than the other people in the town. It used to be that we'd look up at those people and think, "Look at him. He lives in a big house up on the hill, drives a Duesenberg, and he wears a fur coat, top hat, and monocle. Maybe if I work hard and study, one day I'll have what he has." It wasn't envy, it was admiration. That's what society was until the 1970s when the Free to Be You and Me generation was born. Now the line of thinking has become, "That guy's got a big house up on the hill. Why does he need a house that big? Why is it fair that he can have a house on the hill while I have to live in a shitty apartment?" It shifted from "I want to be like to him" to "I resent him, he shamed me."

And there's going to be a lot more of it because "progressive" politicians continue to fuel this fire.

I've had enough of the congressmen and pundits on the left talking about how the rich aren't paying their "fair share" because of loopholes. They're not loopholes, they're deductions. You created a system, I'm just using an accountant to navigate that system. That, and calling people who make more than $200,000 "wealthy." This is a code word to piss off people who don't make that much, and incite class warfare.

That's how these politicians get reelected. They stir up envy and resentment and then claim to be the ones who can make that go away.

At the 2012 Democratic National Convention, Massachusetts senator Elizabeth Warren said, "People feel like the system is rigged against them. And you know what? They're right. The system is rigged."

This is a horrible message. When you are told the system is rigged against you—whether it's chess, football, or life—you give up. She was essentially encouraging people to curl up and die.

How about this message, Liz? You were born in 1949 in Oklahoma to a janitor. You went on to become a Harvard Law professor and now you're a senator. Sounds like you did just fine in our rigged system. How did you do it? You worked in a restaurant, went to school, cracked a lot of fucking books, burned a lot of midnight oil, and pulled yourself up. That's the message. Stop telling people the system is rigged and that the deck is stacked against them. Tell them to forget the deck and focus on themselves.

But you won't convey that message because if you tell your constituency to actually do something for themselves, they won't elect you to do it for them. You have to keep preaching how the system is rigged and that they'll never get a fair shot so they'll elect you to unrig it. That's how your party stays in power, a perpetual-motion machine of hopelessness.

And then they bring race into it. There was an episode of *60 Minutes* in 2013 that exposed representatives and senators abusing campaign funds to enrich themselves. A representative from California named Grace Napolitano got nailed by Steve Kroft for loaning her own campaign a couple hundred grand at 18 percent interest. She had the audacity to claim that she needed to do this because she could not get a loan for her campaign from a bank because she was Hispanic and a woman. Yes, because there is nothing a bank hates more than loaning money to someone with a couple hundred grand in equity who is a congresswoman.

This type of comment always brings me to my favorite question—stupid or liar? In this case I'm going with liar. This is just a line you're feeding your constituents so they remain hopeless and helpless. That way you can come in as the nonwhite knight and claim to protect them when in fact you're filling your pockets with their contributions and not doing shit for them. Keep shoveling this bullshit so it just becomes their mentality and then becomes their excuse for not doing anything with their life. I didn't get that job because I'm Hispanic and a woman. That drunk driver hit me because I'm Hispanic and a woman. Fall turned to winter because I'm Hispanic and a woman. The only one who can help me has to be Hispanic and a woman.

This outlook is what creates all the corrupt preachers, activists, and community organizers who parasitically feed off the people they claim to help. Why would the Al Sharptons and Jesse Jacksons of the world ever do anything to help their brethren? If they did that, they'd be out of a gig.

And let me say this quickly about "community organizers." We sing the praises of "community," but why is it the more that word appears in your life the worse off you are? If you go to a community clinic, community college, or are represented by a community organizer, you're in tough shape. The only time you want the word "community" to describe part of your lifestyle is when it has the word "gated" in front of it.

These people are always telling their "community," a.k.a. the people they want money from, that we live in a racist society full of so-called white privilege. First off, we have a black president, how racist can we be? Obama was elected twice; he didn't climb down the chimney of the White House and squat the Oval Office.

Not everything is about race. There was a study that showed that yes, when it came to receiving bank loans, white people did get more than black people. That means the bank is racist, right? Well, guess who got more loans that white people? Asians. The bank doesn't give a shit what

your skin color is, they're just looking at FICO scores and the Asians are kicking whitey's ass. The bank is not a dude with a hood on a horse, it's an organization that assesses risk and lends money based on analysis.

And as far as "white privilege," speaking as a honky, I got none. In fact, if I had been black or Hispanic I might have done better. I might have gotten a scholarship and gone to college, I might have gotten that firefighter job I applied for, I might have gotten a leg up from one of the Democrats trying to "level the playing field." I might have had a bigger penis too. But anyway . . .

The fact is the playing field is never going to be level. It's mathematically impossible to create this. You're born in a certain class, of a certain race, to certain parents, at a certain time in history. This could be good or bad. It's not the government's job to level the playing field, it's your job to get yourself up, or get your kids up, to the next level. Some chicks are born with an A-cup and some with a D. The one with the D is more likely to get the job as the steakhouse hostess. Should the government go around collecting money from all the D-cups to get the chicks with A-cups a tit job? (By the way, a level playing field is a pretty good way to describe a flat-chested woman. "She's got a pretty face but the playing field is level.")

I'm just saying, don't sit around and hope some politician will level the field. If the field is tilted, just climb harder, bitch.

That's why as president, I vow I will NOT raise the minimum wage.

What the left doesn't understand is that yes, as Gordon Gekko said, greed is good. Greed is motivation. We can pretend that there's no such thing as human nature and that we're all not just shaved apes competing for resources, but that's ignorance.

It's built into us. Just like male sexuality. If you try to stem that tide, you're going to fail. Can the male libido be bad? Yes. While it has the

potential for abuse, on the whole it serves a purpose. Same with greed. You need forces to contain and shape it, but you'll never get rid of it.

So why not accept that the human desire for more money can be harnessed for good? We had a massive construction project here in L.A. to tear down a bridge and build a new one over the 405 Freeway. This meant shutting down an eleven-mile stretch of the main artery through the city. This was going to cause such havoc with traffic the local press began calling it Carmageddon. Kiewit, the construction firm that was hired to do the job, were told they would receive bonus money for completion before the deadline and penalties of $72,000 for any delays past it. Well, surprise fucking surprise, they finished eighteen hours ahead of schedule, earning an extra $300,000. They were motivated to work harder and more efficiently to earn more money. Greed was good.

That's why I went nuts during the 2013 State of the Union when President Obama said, "Today a worker making minimum wage makes $14,500 a year. Even with the tax relief we put in place a family with two kids that earns the minimum wage still lives below the poverty line."

First off, what is someone making minimum wage doing having two kids? That job is not supposed to be for adults supporting children. Those jobs are for children. And the reason they pay shit is because you can easily be replaced. Anyone can do that job. You are not a commodity. Anna Nicole Smith's corpse could perform that task.

You're not supposed to make a career of working the fryolator. You're supposed to get an education and find a better job and climb up the ladder. If we put a nice comfy beanbag chair on that lowest rung of the ladder, what's to motivate you to keep climbing? This would be like saying we're going to hollow out barbells to make them easier to lift.

I worked at McDonald's and made $2.43 an hour. If I had made ten dollars an hour, instead of talking about the value of hard work in my third book I'd be talking about the value menu over my shoulder. I'd still be there.

The minimum wage is not supposed to be comfortable. People always ask me why I got into comedy. It's because I was in construction. I spent my days toiling in the San Fernando Valley with stucco dust clinging to me because I was soaked in sweat. I came home looking like a white car after a brush fire. I wanted better. Discomfort is what this country was built on. Our granddads were uncomfortable in factories and coal mines and wanted better for their kids, so they worked their asses off to send them to college. The fucking Pilgrims were uncomfortable in wherever they were in Europe, so they sailed over here on the *Niña*, the *Pinta*, and the *Santa María*. (Okay, history's not my strong suit, but you get the point.) You don't want to hunker down and call it a life.

All this social welfare stuff seems progressive and well intentioned, but doesn't foresee the crippling consequences. Whether it's welfare, disability, food stamps, or raising the minimum wage, we're removing the motivating factor of being poor and miserable. I always compare it to rent control. I have a couple friends who rented nice places near the beach in Santa Monica when they were in their twenties, have rent control, and now are in their forties still living in the same two-bedroom with a cat and no kids because they don't have the space. And they'll never leave. These people will never be homeowners because their rent has been artificially lowered, thus removing the motivation. If their monthly check to the landlord were the same as a mortgage payment, they'd want to buy a house, get some equity, and not have to get the all clear from an Armenian dickhead when they wanted to paint a room. But when the rent is half of what the free market would dictate, that means you're never moving out.

Ultimately success is all about motivation, internalization, and delayed gratification. I break this down into three easy-to-remember phrases.

1. DON'T DO IT FOR ME, DO IT FOR YOU.

Some people are hard workers—when they think the boss is looking over their shoulder. But the people who really go on to success are the ones who work like that all the time.

An example of this is when I have Artie Lange on the podcast. The guy always brings it. Are we paying him to be on the podcast? No. Am I his boss? No. Could he get away with half-assing it? Sure. But he doesn't. He brings his A game every time, much like David Alan Grier, Dana Gould, Jo Koy, Jay Mohr, Alonzo Bodden, and many other repeat guests. And consequently that's why they're repeat guests. They know if they do well on the show they move tickets for their own shows or sell CDs or get more clicks to their website or more Twitter followers to sell their wares to. So they show up.

Many employees just work for the paycheck. The put in the B-minus it takes to not get fired and keep their benefits and then stagnate until retirement or death. That's one of the few ways show business and carpentry are the same. That's one of the skills I brought from the construction site to the radio studio and sitcom set. Your reputation was all you had to go on at the jobsite. I was honest, drove a truck, and didn't charge for gas. I was good, probably too cheap, and didn't steal your prescriptions or rifle through your panty drawer. If I fucked something up I would stay and fix it, gratis. That meant I got more gigs. I was the guy who when you called I might not be able to make it out there for a while. That's what you want, not the "I can start right away" guy. You want the one with a ton of referrals who you're going to have to pay a little more to get.

It's the same work ethic I have with doing *The Tonight Show*. I'm good, I always bring a bit, and show up for rehearsal. Then they want me back. And then I get to plug this book talking about how I get to go on *The Tonight Show* plugging this book about becoming president. It's the circle of life.

Your reputation is everything. My buddy Oswaldo, who I worked construction with and some of you may know from my first movie, *The Hammer*, called me last year and said we needed to talk in person. That was my signal that not only was this going to sap my energy, it was going to drain my bank account. Ozzie is constantly borrowing money that I might as well just use to toast marshmallows at a campsite. If I loan him money I have a better chance of seeing Bigfoot fuck a chupacabra than one penny of it.

We met at the studio and he started his usual refrain of how he needed money because he had no work. I said to him, "You ever wonder why you're not working?" He said, "There's no jobs." I said, "No, there's no jobs for *you*. You've been gouging people for years. We let it slide for a while but now no one will hire you. Word got around. You've got a reputation. People know you're lazy."

He got pissed, I got pissed, but I eventually agreed to the financial favor du jour. And then to unconsciously prove my point as he was walking away, he took two steps, turned around, opened the fridge, and grabbed two Cokes before he left. One for now, one for the road. Not *his* Cokes he brought from home. The ones I purchased for my podcast guests. I was walking away at the time too. If he had waited another 4.2 seconds I wouldn't have seen it. I can't tell if this was brazen or ignorant. Either way it was a perfect indicator of how our relationship works.

I'm not joking about Ozzie's reputation. We all like the guy personally, but no one in town will hire him. We were taking a break around the shop not too long ago and deciding where to do the lunch run. I said, "We can't go to the kebab joint, that place takes too long. Last time Ozzie went it took two hours."

Everyone laughed. We all knew when Ozzie would get sent on lunch runs he'd take that time to do his errands.

Someone said, "Yeah, he was running a scam." I agreed. Yes, he was running a scam . . . on himself.

We were all sitting there gainfully employed enjoying lunch while he was out looking for work.

People love these temporary victories, feeling like they got one over on the boss or the company. Sure, when you go out for lunch you can say, "I got a flat tire" or "They only took cash and the ATM wasn't working, so I had to drive around," and scam an extra paid half hour into your check. But by the third time around the person/boss you're scamming figures it out. And guess who doesn't get promoted or called back when that guy is hiring again? Even if there are no consequences immediately, there are long-term. This would be a great plan if we all lived to twenty-three, but if you're planning to make it to eighty, that kind of bullshit is going to catch up with you. As a boss, I can tell you for sure, your boss notices when you're lazy, fucking up, and padding your hours. It all gets noted.

With all things in life, especially in the work force, you will be your own undoing. It will be brought down upon you by your own hand. There are no bosses out to get you, no teachers out to get you, no probation officers out to get you. If you feel like they're on your ass, it's because you deserve it.

By the way, I used to enjoy when we'd get *Loveline* callers who'd say their man was in the joint and I'd ask what for and they'd reply "probation violation." As if there wasn't a prior offense, like everyone is born on probation.

I would love a fifty-hour montage reel of dumb people's excuses as to why they got fired. The scenes would go something like, "You got fired from your gig? It had only been three weeks." "I worked too fast. Boss had it out for me. Saw me nipping at his heels." Yeah, a boss always hates it when a guy comes in and does the work of ten, but only takes home one paycheck. This is the narcissism and grandiosity of this generation, they all think they should be the boss, but aren't willing to put in the time, effort, and self-reflection necessary to become the head honcho.

And unfortunately, as a society we fall right in line behind these people and empower them with excuses and externalization. We nod along: "Yeah, times are tough . . ."; "Yep, those one-percenters on Wall Street . . ."; "Mitt Romney . . ." We allow them to blame everyone but themselves. But ultimately, who do you know that is really good at their job, hardworking, motivated, able to internalize *and* unemployed? Now think about all the people you know who are out of work right now and how many joints you've watched them roll while they bitched about their boss and the economy.

⭐ 2. DON'T DO YOUR BEST, DO MY BEST.

For today's generation, effort counts as much as results. But if you're not getting results then you're not putting in enough effort. I've had the situation where I assigned an assistant or underling a simple task, like call the cable company and have them come out and fix the box. I eventually follow up on this request, and the answer is "I called them three weeks ago." "And?" "I left a message." So we're in the exact same spot we were three weeks ago. To the lackey the task has been completed. I asked them to call. They did. Done. To me nothing happened. I might as well have not even asked.

But I really lose my shit when I call that employee out and they say, "I tried my best." If you fuck something up and say you tried your best, then you need to be relieved. If you're trying out for quarterback, take the ball out of the shotgun and drill it into the ass of one of your lineman, and say to your coach, "I did my best," then guess who isn't making the team? You throwing the ball up the rectum of one of your interior lineman is not going to earn you a place on the squad. A better answer would be "Sorry, Coach, I'm drunk, the ball slipped out of my hand, it's covered in vermouth." That would at least leave room for improvement.

You should never say to a superior, "I did my best," when you fuck up, because you are then declaring you *are* a fuckup. Your best is fucking up.

If that's the case I'd hate to see you on a bad day when you were only putting in 50 percent. The answer is not "I did my best," it's "I'll do better."

So the phrase I've drilled into my employees is "Don't do *your* best, do *my* best."

⭐ 3. DON'T DO IT FOR NOW, DO IT FOR LATER.

Every loser I hung out with in high school would live for the day. They had zero foresight. They would have lived by the code "carpe diem" if they didn't think that had something to do with a fish. If the sun was shining and they could scrape together the money for a six-pack, it was time to head to the reservoir. The ethos was "I could sit here in Mrs. Tawney's algebra class or I could go to the reservoir, smoke some butts, drink a sixer of Stroh's, and try to feel some boobies." So none of those guys were ever destined for college. To them that was just four more years of high school and homework. To my buddies, that was a nonstarter. And what really didn't start was their lives. They now live in shitty apartments by that reservoir.

Having a good sense of delayed gratification is the best gift you can give your kids. The ability to not eat the M&M in front of you now so you can have two later is very valuable, and hard to come by these days.

The paramount example of this is my new Secretary of Labor. He is a man who understands hard work not paying off now but down the road—Mr. Jimmy Kimmel.

Though I'm not sure he'll want the gig. It will definitely be a pay cut. And that's the point. Kimmel is now a millionaire and the new king of late night, but when I met him he was making peanuts as Jimmy the Sports Guy on morning radio here in L.A. You'd think making no money he'd have no motivation. Opposite. He knew that if he was going to make money he'd have to work for free. Jimmy never asked for a raise. He got fired and moved a hundred times before landing in L.A. I would

see him at KROQ at three thirty in the morning editing *other people's bits*. Not his own, he was pitching in to help other people for the good of the show, because if the show succeeded he'd succeed with it. He never complained, never wanted credit, he just busted his ass. So now who's up against Letterman and helped bring down Leno, who's hosted the Emmys, roasted President Obama at the White House Correspondents' Dinner, and is dear, dear friends with Oprah—is it Jimmy the Sports Guy who killed himself every day for pennies without a complaint or is it Michael the Maintenance Man who got fired for insubordination and then sued claiming racism?

Jimmy exemplifies everything I have just told you—he thought long term, was a team player, he never made excuses, when he fucked up he owned it and figured out how to be better next time.

All that and he is quite a tender lover. He's as hardworking and giving in the bedroom as he was in the workplace.

Perhaps I've said too much. It's time to wrap this up.

CONCLUSION: THE STATE OF THE UNION ADDRESS

The following is the full text of President Carolla's final State of the Union address:

PRESIDENT CAROLLA: Thank you. Please be seated.

(TWENTY-TWO-MINUTE STANDING OVATION EVENTUALLY SUBSIDES)

Mr. Speaker, Mr. Vice President, members of Congress, and my fellow Americans. It is the duty of all presidents to report to Congress yearly on the State of the Union. I stand before you now reporting that the state of our union is stronger than ever. America is back on top again because of me.

(APPLAUSE)

Our children are now going to schools where competition and toughness are encouraged. Schools where a little light bullying is a good thing and not everybody is a winner. And you know who's not going to those schools? Dads. They're out working and not getting dragged into every pageant, play, and participation trophy award ceremony.

(APPLAUSE)

Teacher tenure has been eliminated. If you suck, you can be fired. If your school sucks, it will be turned into an outlet mall. Not that that is an issue anymore because my measures, mandates, and decrees have increased the number of intact families, which was the fucking problem in the first place.

(APPLAUSE)

The air travel industry is now one of our most profitable sectors due to my improvements. Airport security is more efficient and the entire flying experience is once again pleasant due to my no-bare-feet and no-service-dogs policy.

(APPLAUSE)

Our roads are safer, cleaner, and faster. Commute times are down on our graffiti-free highways and citizens are able to drive like champions because of my Chickenshit Ticket Reduction Act. And American-made car sales are up due to my automotive innovations.

(APPLAUSE)

If you're watching this address on your television, then you know the state of our mass media has improved. As a culture we stopped gathering

together around the TV to gawk and laugh at losers. We've shut off the schadenfreude and turned on our brains again.

(APPLAUSE)

Ads no longer ooze attitude, depict unrealistic racial balance, or encourage couch dwellers to stay fat, lazy, and on the dole. Enrollment at the Wally Thorpe and Dootson Schools of Trucking are through the roof.

(APPLAUSE)

And music has returned to its roots. Gone are the days of sports bars pumping Katy Perry and barbershops blaring Bieber. I made a campaign promise and I've kept it—Foghat in every strip club and Sinatra in every steak house.

(APPLAUSE)

Our national parks system continues to be the envy of the world and my dictates to our Department of Agriculture have increased our exports and eliminated the scourges of zucchini and mouth-roof burns from scalding nacho cheese. Obesity rates are down and stew and casserole consumption rates are up.

(APPLAUSE)

The medical establishment has heard my decrees and now hospitals are efficient, friendly, untagged utopias. Medical professionals are just that, professionals, only dispensing vaccines and Big Pharmaceuticals, not holistic hippie bullshit. And my renewed focus on mental health awareness and unwanted pregnancy has drastically reduced crime, dropout, poverty, and drug abuse rates.

(APPLAUSE)

And the state of our planet is better as a result of my tough love with the rest of the world. While the Middle East continues to be a shit-show, it is no longer our mess to clean up. My efficiency mandates and "Fuck Alaska" campaign have gotten us off of foreign oil entirely. Plus female graduation rates are up 39 percent since I banned the hair dryer.

And now that our Israeli allies have taken over Baja, we have a strong trading partner south of our border instead of a piñata full of poverty.

(APPLAUSE)

Our homeland is more secure from both terrorists and holiday joggers. Our drone production is up and our bracelet production is down.

(APPLAUSE)

Our economy is better than ever because our products and services are better than ever—from socks to strip clubs, my mandates have created wealth, warmer feet, and better boners for all of our citizens.

And we finally have a work force worthy of our forefathers. The Occupy Wall Street protests have ended, never to be repeated, and the youths of America are laboring with dedication, long-term thinking, and self-reflection rather than laboring under the delusion that the world owes them something simply for existing.

My government stepped in only when necessary and got the fuck out of the way when it wasn't. I fixed the stuff you couldn't, but let you take responsibility for your own lives and for the country we all share. It's amazing how far we've come in so short a time. All we needed was a little direction, a few new ideas, a lot of grit, and, every now and again, a swift kick in the ass from President Me. When you stopped looking for the government to solve all your problems, you realized you could solve your own; when you

stopped looking in the mirror long enough to realize you share this society with others, things got a hell of a lot better; when you stopped trying to pull others down and to instead pull yourself up, the whole country got pulled up. When I took office there was an America in my head. Now it exists.

Thank you, God bless America and God bless me.

(PRESIDENT CAROLLA HAS A LONG, SELF-SATISFIED SNIFF, DROPS THE MIC, IS CARRIED OUT OF THE CHAMBER ON THE SHOULDERS OF THE VICE PRESIDENT AND THE SPEAKER OF THE HOUSE TO RAUCOUS APPLAUSE AND BEATLEMANIA-ESQUE CRYING. HE IS TAKEN TO AN F-22 RAPTOR PILOTED BY A REANIMATED GENERAL JAMES DOOLITTLE, WHICH FLIES TO MOUNT RUSH-MORE FOR THE DEDICATION OF HIS FACE IN ITS RIGHTFUL PLACE ABOVE WASHINGTON, JEFFERSON, LINCOLN, AND ROOSEVELT.)

ACKNOWLEDGMENTS

I'd like to acknowledge everyone from It Books and HarperCollins—Lynn Grady, Brittany Hamblin, Mandy Kain, Heidi Lewis, Sharyn Rosenblum, Michael Barrs, and Paula Szafranski.

I should also thank Lynette; Sonny; Natalia; my agent, James "Baby-doll" Dixon; my lit agent, Dan Strone; and especially my editor, Carrie Thornton, for making me write these acknowledgments when I wanted to leave this page blank and move on with my life. It's that dedication and attention to detail that made this book great.

mL 6-14